THE ROCK ART OF ARIZONA

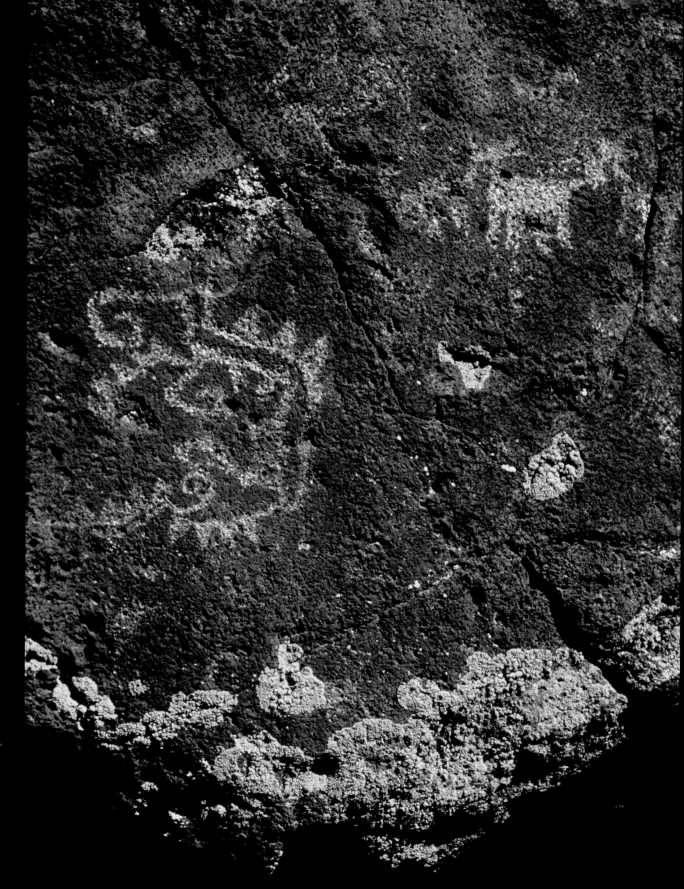

1 **Central Arizona Petroglyph Tradition.** *Tiny quadrupeds and a delicately wrought geometric design share this lichen-covered rockface. Yavapai Co.*

THE ROCK ART OF ARIZONA

ART FOR LIFE'S SAKE

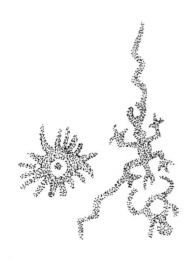

TEXT AND PHOTOGRAPHY BY
EKKEHART MALOTKI

ILLUSTRATIONS BY
MARY JORDAN

CONTRIBUTIONS TO TEXT BY
DONALD E. WEAVER, JR.

FOREWORD BY
JANET NAPOLITANO
GOVERNOR OF ARIZONA

KIVA
PUBLISHING, INC.

Library of Congress Cataloging-in-Publication Data

Malotki, Ekkehart.
 The rock art of Arizona : art for life's sake / text and photography by
Ekkehart Malotki.
 p. cm.
 Includes bibliographical references.
 ISBN-13: 978-1-885772-38-1
1. Indians of North America—Arizona—Antiquities. 2. Paleo-
Indians—Arizona. 3. Rock painting—Arizona. 4. Petroglyphs—
Arizona. 5. Paleoart—Arizona. 6. Arizona—Antiquities. I. Title.
 E78.A7M26 2007
 560.75'309791—dc22

 2007014736

Text and cover design by Rudy Ramos
Printed in Hong Kong

9 8 7 6 5 4 3 2 1

07-07/ 2.5M/ 2007

KIVA PUBLISHING
21731 E. Buckskin Drive, Walnut, CA 91789

CONTENTS

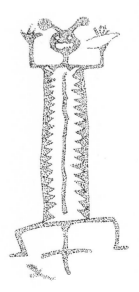

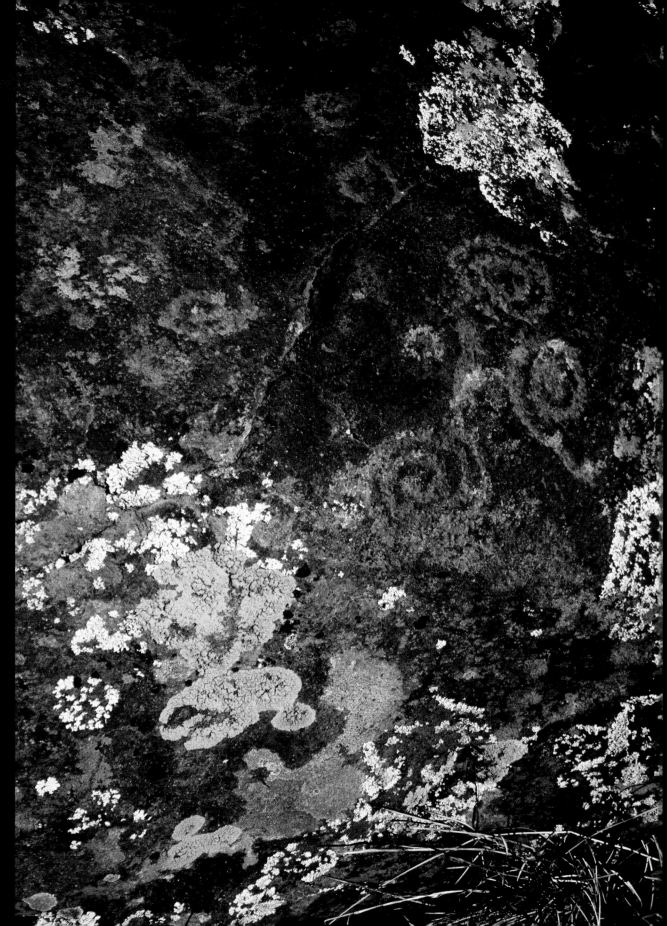

VI

▼

2 Western Archaic Tradition. *These simple curvilinear lines, thousands of years old, demonstrate how Arizona's most ancient people enculturated the landscape. Gila Co.*

FOREWORD

Arizona is rightfully famous for its physical, geological and cultural resources. Only recently, however, has one of our state's preeminent cultural treasures—its wealth of rock art—been given the attention it deserves. Preserving this bounty should be of great concern not only to the residents of our state and nation, but to all citizens of the world.

The prehistoric peoples who lived in the extreme environment of Arizona's deserts and mountains left behind rich displays of rock art—some dating back thousands of years. We must protect this legacy and the opportunity it affords to glimpse into the minds of those who lived in Arizona so long ago. The ancient images continue to inspire and delight us, while compelling our genuine reverence and respect.

In two previous books Ekkehart Malotki captured the rock art images of the Colorado Plateau and the Petrified Forest National Park. Dr. Malotki introduced readers to previously unknown rock art sites throughout the region. Now, with this thoughtful, beautiful, and comprehensive book, Dr. Malotki covers for the first time rock art found in every corner of Arizona. The spectacular photographs and incisive text reflect Dr. Malotki's lifelong study of the rock art of the American Southwest. This book continues the journey of an artistic expression that began millennia ago and endures to this day.

As a friend of the arts, I am happy to acknowledge this important new work that spotlights Arizona's rich cultural heritage and helps foster its preservation for future generations.

JANET NAPOLITANO
Governor of Arizona

1
▼

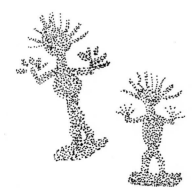

PREFACE

Arizona is a dream destination for millions of people around the world. Many come to the state to enjoy its impressive deserts, mountains, and canyon landscapes, some of the most scenic of which have been set aside in national parks and monuments. Others, motivated by their interest in archaeology and anthropology, are drawn to the area to visit prehistoric cliff-dwellings of Arizona's Native American forebears or to experience the ceremonial dances of today's tribal cultures. Little awareness exists, however, even among the state's permanent residents, that the region is also home to a wealth of open-air "art galleries" consisting of world-class rock paintings and engravings.

The first documented reference to Arizona's rupestrian art is found in the diary of Jacobo Sedelmayr, a German Jesuit missionary/explorer who, while traveling through the Gila Bend area in the mid-1700s, made mention of the rock art in the range known today as the Painted Rocks Mountains. Over the next century and a half, various individuals associated for the most part with land surveys and United States army expeditions, referred occasionally to this and other paleoart in Arizona. In 1886, Garrick Mallery published the first general survey of North American rock art, which contained some of the earliest descriptions and illustrations of rupestrian markings from the Territory of Arizona. It was not until the 1930s that Harold S. Colton and Mary-Russell F. Colton researched rock art sites in northern Arizona and attempted to interpret the images on the basis of ethnographic information, assigning many of them to specific prehistoric and historic cultural groups. Yet, despite fairly intensive and widespread archaeological excavations in the state over the years, the documentation and recording of rock art fell primarily to amateur aficionados who, with a few dedicated professionals, dominated rupestrian studies in Arizona through much of the later 20th century.

A lifelong interest in art and my love of the "outback" regions of the American Southwest, as well as years of ethnolinguistic work among the Hopi, have led to my ever-growing passion for photographing rock art. This has resulted in two publications showcasing petroglyphs and pictographs of the Colorado Plateau. Although several other books on rock art in specific areas of Arizona have been published in recent years, unlike neighboring Utah, New Mexico, and California, Arizona does not have a comprehensive statewide survey of its rock art heritage. The present book is intended to remedy that shortcoming.

There is no question that Arizona, together with the other Four-Corners states of Utah, New Mexico, and Colorado, constitutes one of the premier rupestrian theaters in the world, featuring imagery at many locales that truly has the power to awe. Curiously, recognition of this fact is not well established beyond the rock art community. Nor is the impressive body of Arizona's rock art patrimony receiving the official recognition and protection that it is due. To be sure, a number of rock locales, ranging from entire archaeological districts to small individual panels, can be found on the National Register of Historic Places. But many more are deserving of this status. Indeed, there are several sites in Arizona whose high concentration of aesthetically superior imagery and other outstanding attributes warrant nomination to the UNESCO World Heritage List. Paramount candidates, in my view, include Petrified Forest National Park and the adjacent lands of the Palavayu region, a series of rock art shelters adorned with strikingly visionary paintings on the Esplanade of the Grand Canyon, and the Gila River Triad, the magnificent rock art assemblages at Sears, Quail, and Hummingbird Points. Sadly, as of

this date, not a single rock art site in the entire United States has found its rightful place on the World Heritage List. It is hoped that by highlighting Arizona's rich and complex Native American rock art, the prospect of preserving this fragile and vulnerable heritage will be greatly enhanced. Because increased awareness may heighten the risk of vandalism and other threats to the art, specific site locations are not revealed here; only the counties are indicated.

The main purpose of this book, thus, is twofold: As one who enjoys a photographic dialogue with rock art, I wish to showcase the entire gamut of Arizona's stunning rock art paintings, engravings, and ground figures. Obviously, due to space considerations, this objective can be achieved only through selective samples. Nearly all major rupestrian traditions and styles, however, from their earliest manifestations in post-Pleistocene times until their last occurrences in the early 20th century, are presented in the photography. Needless to say, the photographs and illustrations are a significant feature of this book, not only to tantalize the reader with the aesthetic masterpieces of Arizona's rock art, but also to instill greater respect for it.

As a scholar of rock art and one primarily interested in its symbolic and cognitive aspects, I also address the challenging yet intriguing question of interpretation, with such important issues as description, classification, and cultural affiliation of the art playing only a minor role here. In prioritizing my goals in this way, I hope to shed new light on what motivated Arizona's earliest artists to produce the art and what function it had in their lives. In this endeavor I am inspired by novel ideas derived from the field of evolutionary psychology, in particular as applied to the arts, and by the concept of human universals as specifically relevant to rock art studies. By drawing especially on the work of Ellen Dissanayake, who contends that the arts, in conjunction with ritual, have been essential to group survival, I argue that rock art, too, is fundamentally "art for life's sake," and it is foremost against this premise that Arizona's rupestrian wealth will be viewed and analyzed.

This book owes its existence to the contributions of many people. I consider it a privilege to name them publicly and express to each of them my sincere gratitude for sharing their ideas and goodwill, as well as physical and moral support. Work for this ambitious undertaking involved challenges on two fronts, perhaps best characterized as "desk" and "field." In compiling the manuscript, I wish first to acknowledge Don Weaver. I spent many hours with him, usually during joint field trips, strategizing how best to approach and organize this enormous task. It was his suggestion, for example, to divide the entire state into seven districts, later renamed "provinces" by Ken Gary. Don initially also provided draft versions of the majority of Arizona's rupestrian styles and traditions.

For checking the accuracy of the data of the Riverine, Southwest, and Southeast provinces, I am indebted to Henry Wallace, an archaeologist and expert on rock art in southern Arizona. In addition to welcoming me into his home during a week-long field session in the Tucson region, he also made valuable comments on the interpretive portions of this work. Don Christensen, one of the foremost rock art researchers in Arizona's northwest corner, deserves thanks for revising the content of the Northwest Province. Dave Wilcox, thoroughly familiar with the prehistoric cultures of mid-state Arizona due to his research into fortified hilltop sites, educated me about the area of central Arizona and helped define the boundaries of that province. Mary Jordan, eminently qualified as art teacher and rock art enthusiast, liberally gave of her time to generate the majority of the black-and-white illustrations that complement my color photographs. The rest, used in conjunction with the Palavayu Anthropomorphic Style, were contributed by Pat McCreery. Finally, I must single out two close friends, Ken Gary of San Diego and Nancy Adam of Seattle. Ken, in addition to acting as a sounding board for the overall project, brought his artistic skills to bear and, in endless rounds of e-mails, telephone conversations, and computerized

page layouts, helped me sketch out maps, devise charts, and test ideas for the general design of the book. Most gratifying for me in working with Ken was his never-failing willingness to embrace every new assignment as a welcome interruption of his daily routine. Nancy, new to the field of rock art, was ideally suited to question my rupestrian jargon, ask for clarifications, or point out inconsistencies in my writing. Even more important, her positive attitude and encouragement helped me stay the course and see this project to fruition.

While writing has always been a hair-pulling chore for me, being out in the field with my camera in search of rock art is my most exhilarating pastime. Over the last three years alone, in visiting the majority of sites featured in this publication, I spent a total of 272 days in pursuit of Arizona's paleoart. Field excursions ranged from one to nine days, including a twenty-mile-long river trip along the Upper Gila River, and an expedition on horseback for which Apache-Sitgreaves National Forest archaeologist Charlotte Hunter kindly provided the animals. I remember with fondness my four-footed friend Jay who willingly and surefootedly carried this novice equestrian on a sixteen-mile round trip over terrain that otherwise would have required an exhausting two-day backpacking venture. As a rule, nights during my outings were spent tent- or car-camping, but on occasion I was able to enjoy the comfort of a friend's home. Besides Henry Wallace mentioned above and his wife Cindy, I would like to express my gratitude to Don and Gayle Weyers, Warren and Judi Beck, and Paul and Grace Schoonover, all of whom, in addition to a hot shower or a relaxing jacuzzi, provided some terrific meals. On many occasions while hiking, I enjoyed the companionship of other rock art aficionados; some also agreed to take on the tedium of long-distance driving. In addition to Don Weaver, I gratefully acknowledge Bob Mark and Evelyn Billo, Harold Widdison, Scott Thybony, Tom Weiss, Shirley and Bill Freeman, Rick and Sandy Martynec, Paul Roetto, Ilona Anderson, and Larry Midling.

Larry deserves a particularly warm thank-you. In addition to offering his driving services on often extremely rough dirt roads, his strength and endurance are such that he never hesitates to scout out even the most remote rock outcroppings or to scale the most formidable cliff in search of a possible glyph or painting. He has now become so intrigued with the art that on his own or with the help of Ilona Anderson he has discovered dozens of hitherto unreported sites. Mainly of an Archaic vintage, some of them are featured in this book.

Last but not least, I am obliged to a great many people for a variety of reasons: for sharing specific site locations, informing me about pertinent publications, helping me carry a ladder or anchor a rappelling rope, for holding my reflector, or opening a padlocked gate. Not mentioned here by name are many of the landowners who granted me permission to visit a site on their property but prefer to remain anonymous for fear they might be inundated with similar requests. The following people, although listed alphabetically, contributed in many different ways, all of which were helpful and very much appreciated: Mary Allen, Sandra Arnold, Ed Asher, Brantley Baird, Michael and Mari Barnard, Sue Baughman, Paul Bergemann, Cheryl Blanchard, Peter Blystone, Todd Bostwick, Fred Briuer, Jerry Brody, Jeffrey Burton, Elias Butler, Adam Copeland, Bob and Kathy Corbell, Judy Darbyshire, Mike Davis, Wayne Donnay, Amy Douglas, Jim Duffield, Ike Eastvold, Jerry Ehrhardt, Lila Elam, Steve Faust, John Fountain, Mary Fredona, Phil Garn, Dolores Gauna, Bill Gillespie, Warner and Wendy Glenn, Chris Goetze, Gough Galal, Marc Gaede, Ross and Maiya Gralia, John Gunn, Dixie Hagerth, Jeremy Haines, Gayle Hartmann, Wes Holden, Mike Hollister, Anthony Howell, Jennifer Huang, Thomas Hulen, Gary Hund, Bill Jeffers, Boma Johnson, Kevin Jones, Stan Jones, Matthew and Janelle Kelley, Gay Kinkade, Kevin and Irene Komadina, John

Kurth, Tony Kuyper, Jan Lawson, Steve Lekson, Keith Lyons, Linda Martin, Linda Matthews, Ken Mellinger, Penny Minturn, Jerryll Moreno, John and Joan Murphy, Doug Newton, Ann Ogg, Tom Palmer, John Parsons, Alex Patterson, Ella and Roy Pierpoint, Peter Pilles, Louie Pope, Richard Quartaroli, Anna Rago, Adrianne Rankin, Shelley Rasmussen, David Ricker, Mike Riddle, Dwight Riggs, Abigail Root, John Rose, Steve Rosenstock, Denise Ryan, Ernie Schoep, Marilyn Sklar, Charles Slaymaker, Phyllis Smith, Jeff Snyder, Dixon Spendlove, Connie Stone, Clifford Straitor, Richard Thompson, Travis Scott, Sharon Urban, Neil Weintraub, Geoff Wingfield, Pete Winn, Bonnie Winslow, Don Wolfe, Scott Wood, Robert Wright, and Beatrice Zueger. I sincerely hope I haven't omitted anyone unintentionally who, with all those mentioned above, deserves my utmost thanks.

In the course of my writing, the convenient access to Bob Mark's and Evelyn Billo's up-to-date rock art library was a great boon. Equally helpful was the professional staff of the Special Collections branch at Northern Arizona University's Cline Library. Shawn Fowler, an NAU art history major, worked with me in producing high resolution scans of numerous photos and provided other invaluable computer assistance. Brian Carnahan, computing specialist at NAU's Information Technology Services, kept my hardware and software upgraded and expertly steered me through a couple of cyber-crises. I am very grateful to both.

Extra-special thanks go to publisher Stephen Hill of Kiva Publishing, not only for recognizing the importance of showcasing Arizona's rock art treasures in an aesthetically stunning book, but also for his direction that helped crystallize this project. Having set a high standard for the presentation of rock art imagery with the publication of *Stone Chisel and Yucca Brush: Colorado Plateau Rock Art,* it is especially gratifying for me to acknowledge his willingness to once again include a large number of color illustrations to promote awareness of the exciting topic of rupestrian art.

Finally, a few caveats to the reader: It is the nature of the rock art field that statements regarding classification of styles and traditions, estimates on dating, and ideas about motivation and function are constantly in flux. Thus, nothing presented in this book is "cast in stone." It is my hope that others will be inspired to survey areas of Arizona for new sites (helping to fill in gaps in the archaeological record), will continue to fine-tune ideas on classification, and, by engaging in debate on the "deep structure" of the art, will generate a heightened understanding of Arizona's priceless heritage.

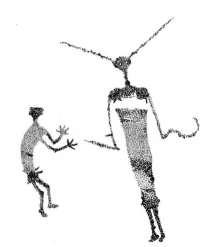

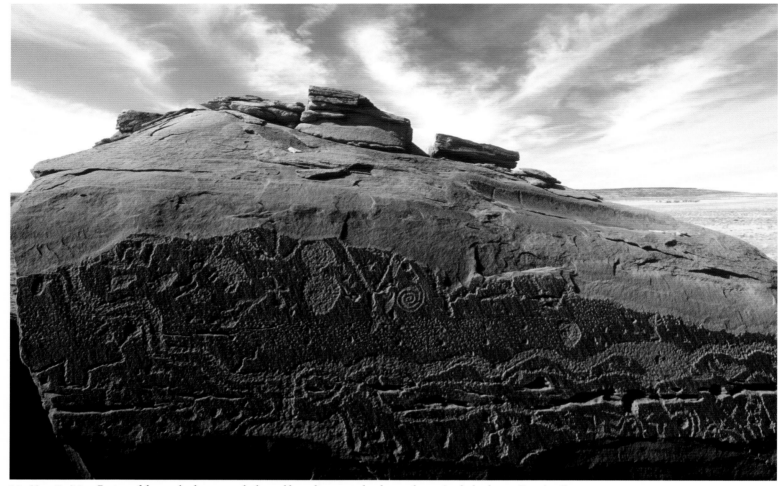

3 Puebloan Tradition. *For tens of thousands of years, people the world over have created rock art to humanize the landscape. Coconino Co.*

INTRODUCTION

Rock art, an essentially pan-global phenomenon, is one of the great cultural achievements of our early ancestors. Testifying to humankind's imagination and creativity, it constitutes a striking visual aspect of our collective patrimony. Believed to have originated some 40,000-50,000 years ago with Cro-Magnon man, the immediate ancestor of fully modern humans, rock art reflects the beginnings of "our artistic sensibility, of the basic human impulse to communicate, to create, to depict, to influence the course of life" (Clottes 2002:3). As such, rock art can be characterized as the largest archive available to us for the study of early human intellectual development, in particular "the ability to form abstract concepts, to symbolize, to communicate

at an advanced level, [and] to develop a notion of the self" (Bednarik 1998:5). It has truly "left a legacy of humankind's conceptual journey" (Anati 2004:1).

With the exception of Antarctica, where no rock art is found, a preliminary survey from all other continents has shown that "about 70,000 sites of rock paintings and engravings are known throughout the world, with an estimated 45 million images and signs on record" (Anati 2004:2). However, these estimates may be far too conservative considering that Arizona alone houses approximately 6,000 to 8,000 sites. Many of these are of "world-class" quality and are an integral part of the rock art theater of the

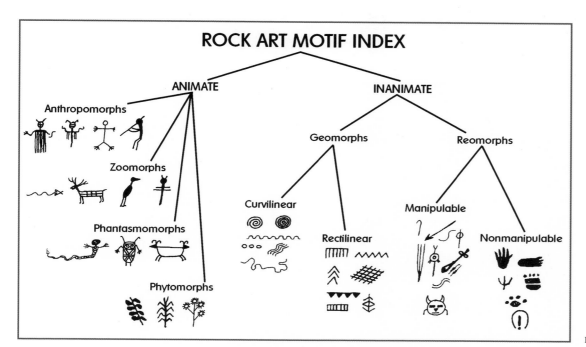

ROCK ART MOTIF INDEX

ANIMATE

Anthropomorphs

Zoomorphs

Phantasmomorphs

Phytomorphs

INANIMATE

Geomorphs

Curvilinear

Rectilinear

Reomorphs

Manipulable

Nonmanipulable

Figure 1. *Rock Art Motif Index.*

American Southwest, an area that ranks as one of the great epicenters of paleoart in the world.

But what could have motivated our earliest ancestors to produce rock art? And, for that matter, is "rock art" really "art"? Considering that the social and environmental world of early people would have been, in its harshness, unimaginable to us, did the making of an image on rock and its possible use by early humans help them survive in a demanding environment? These are questions rock art researchers continue to debate as awareness of rupestrian art in Arizona and around the world grows among the general public, and as the discipline matures as a field of study.

Once almost exclusively the domain of avocational archaeologists and dedicated aficionados, rock art research is now a scientific discipline in its own right, with recording, study, and interpretation of the art currently dominated by specialists trained in the fields of anthropology, archaeology, art history, semiotics, computer science, and related fields. This transformation is demonstrated by the increasing frequency of research-oriented articles in academic journals and the growing number of monographs and books devoted to the topic. Professional influence is further evident in the introduction of

innovative methodologies for analysis, interpretation, strategies for conservation, debates over nomenclature, and lengthy discussions about the ultimate nature and place of the new discipline of Rock Art Studies in the academic curriculum.

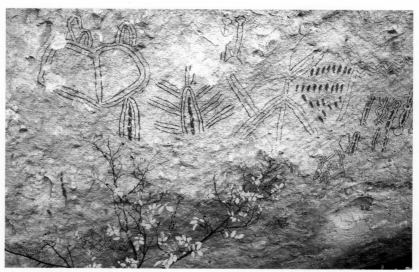

4 Tusayan Style. *Making art, as a behavior, is an innate human universal, deeply rooted in our psyche. Coconino Co.*

As the field of rupestrian research has progressed, more emphasis has been placed on interpreting the images—postulating a range of possible functions and motivations for the art. Useful aids are found in general anthropological theory and in scientific insights garnered from such diverse disciplines as neuroscience, evolutionary psychology, and human ethology. Also relevant are human universals, "those features of culture, society, language, behavior, and psyche for which there are no known exceptions to their existence in all ethnographically or historically recorded human societies" (Brown 1999:382). Commonly known examples of these universals are the use of language, including kinship and gender terms, concepts of time and space, religious beliefs and rituals, and aesthetic standards as seen in bodily adornment, dance, music, and visual art. Thought to have evolved from necessities all humankind has faced to ensure social and physical survival, "human universals" are not static but are, rather, dynamic and ever-changing ways of coping with certain human needs and desires, as varied as the gamut of social organizations throughout the course of history. Thus, while the specific content and realization of these universals may vary from group to group, the fact that they exist "underlies the essential reality that modern humans are of one biological family and one species" (Scupin 2003:57). Although the notion of universal psychobiological and cultural underpinnings is a subject of debate, Brown (1991:141)

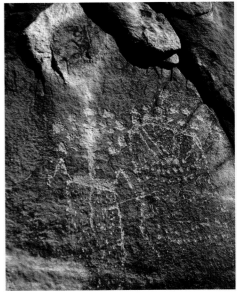

6 Palavayu Anthropomorphic Style. *Ethnographic analogies are useful aids in finding answers to possible functions and motivations for rock art. Navajo Co.*

nonetheless feels that "anthropology has scarcely begun to illuminate the architecture of human universals."

The Concept of Rock "Art"

The use of the discipline's central term, *rock art*, has itself been the subject of controversy for some time. Many in the rock art community have addressed its appropriateness and questioned whether any form of so-called primitive art, including rock art, can be considered "real art." A few researchers have concluded that rupestrian paleoart does not qualify for this designation (Thiel 1995:1), at least not with reference to the narrow definitions of "high" or "fine" art that have governed Western thinking for the last two centuries. To this end, opponents of the phrase "rock art" have advocated replacing it with appellations such as "rock pictures," "ideograms," or "symbolic graphisms." Emmanuel Anati (in Gibson 2002), for instance, has proposed the term "rock art graphemes." Others have suggested adopting "rock graphics" (Diaz-Granados and Duncan 2000:3) or such simple terms as "rock paintings," "rock engravings," or "images" (Bahn 1998:XIII).

From a Western perspective, art (often spelled with a capital A) is seen as an embellishment that may have no function beyond the aesthetic. As a superfluous addition to life that is an end in itself and generally of no utilitarian value, it has been appropriately summed up as "art for art's sake." Ellen Dissanayake (1992b:170-171) calls this Western conception of art "anomalous" and "unprecedented" in that it has divorced the modern viewer from the time-honored utilitarian, social, and religious benefits of a work of art and replaced it with a "world-in-itself" made exclusively for the occasion of detached aesthetic expe-

5 Western Archaic Tradition. *Cupules or cup marks, small hemispherical pits ground into the rock surface, are among the world's oldest artistic expressions. Maricopa Co.*

rience. One curious by-product of this development is that, increasingly, art specialists are considered not only helpful but essential, primarily to explain to the public what makes a given artwork good or bad and even what it "means." Or as Steven Pinker (2002:414) observes, art theorists and critics do not merely evaluate art, they supply the art "with its rationale." Linked to an artworld 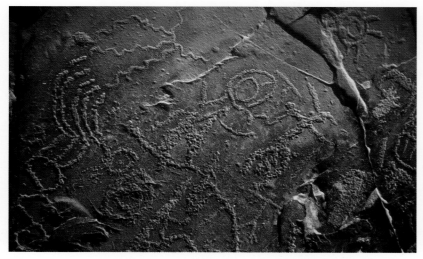 composed of critics, dealers, gallery owners, curators, and art magazine editors privileged to confer "the status 'work of art' onto objects," the elite high art of the West is fundamentally "profit- or commodity-centered" (Dissanayake 1992b:173).

In stark contrast to this narrow and isolating concept of art, Dissanayake (1992a:XIX), insisting that humans are intrinsically artistic animals, advocates a "species-centered" perspective that essentially declares that art "must be viewed as an inherent universal trait of the human species, as normal as language, sex, sociability, aggression, or any of the other characteristics of human nature" (1992b:169). While conceding that some modernist theorists have acknowledged art's "life-enhancing" function, she much more forcefully and convincingly argues for a "life-sustaining" role for the arts (1992a:XVI). Because all humans, cross-culturally and over thousands of years, have

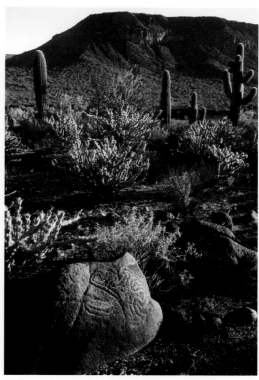

8 **Hohokam Tradition.** *Arizona's priceless rock art heritage comprises an estimated 6,000 to 8,000 sites. Yavapai Co.*

created and continue to create and respond to various forms of art, it must have been of great importance to them. According to her, therefore, all forms of art such as dance, music, ritual, poetry, theater, and the graphic arts, hailing from technologically simpler societies, are not peripheral phenomena, but rather constitute a behavior that must be vitally connected to human evolution. Postulating that "a behavior of art is a biologically endowed proclivity of every human being," she defines this behavior as a tendency to "make special" that had survival value and evolved to become a psychobiological necessity (1992a:11, 57). Art, in this vein, is not perceived as a *l'art pour l'art* whim, but as "art for life's sake" (Dissanayake 1992b; Conkey 2001:272).

Irenäus Eibl-Eibesfeldt (1988) similarly contends that humanity's sense of aesthetics is ultimately biologically influenced. Edward O. Wilson (1998) claims that art is an innate universal, and Pinker (2002:408), speaking of "our instincts for art," posits that "a universal human aesthetic...can be discerned...across cultures." Joseph Carroll (1998:481), in discussing people raised with no exposure to the arts, goes so far as to say that such individuals would probably be severely impaired in "their capacity for responding in creative ways to the demands of a complex and changing environment." Maintaining that art is more a by-product of the desire for status and the pleasure and novelty of making or experiencing special objects or situations, Pinker (2002:404-405) nonetheless agrees that "art is in our nature—in the blood and in the bone" and "is deeply rooted in our mental faculties." He insists, however, that while the arts function to promote community solidarity and a sense of the sublime, among other

9

7 **Western Archaic Tradition.** *The overwhelming majority of Arizona's rock art consists of petroglyphs, images pecked, incised, abraded, or drilled into the rock surface. Navajo Co.*

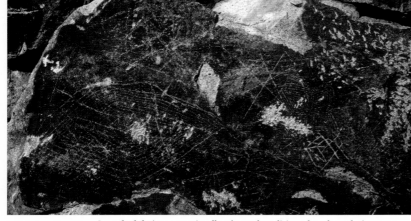

9 Hohokam Tradition. *Scratched designs occur in all styles and traditions, but the technique was primarily used by Native American artists during historic times. Pima Co.*

lar rock art sites, is a veritable treasure house of outdoor art. Many sites, whether isolated or in clusters, are of extraordinary quality, not only due to the sheer numbers of images, their pristine natural settings, and striking aesthetic appeal, but also in terms of their cultural information. With the growing awareness and popularity of rock art in Arizona and around the world, discussion and highlighting of the state's entire body of rupestrian art seems in order. This book, while recognizing the extensive information detailed in *Rock Art of Arizona* for the Arizona State Historic Preservation Office (Thiel 1995), seeks to further enhance the public's knowledge of and interest in Arizona's art, primarily through the visual and interpretive aspects of the imagery. Ultimately, by showcasing the state's prehistoric art through stunning photography and intriguing interpretive insights, it is hoped this dual approach will not only provide a greater understanding and appreciation of the art, but also instill a heightened sense of awe and respect for this unique yet extremely fragile and vulnerable part of Arizona's cultural heritage.

things, they "are not adaptive in the biologist's sense of the word" (1997:524-526); that is, they do not promote "survivability of one's genes, the key criterion for an evolutionary adaptation" (Pinker, personal communication 2005). I, too, reject the obviously Eurocentric view of art that denies not only the early history of Western society's own art but also the entire development of so-called primitive art, and feel that from an evolutionary point of view, the arts, including rock art, are an innate universal, essential for "the business of living" (Biesele 1986:202).

On etymological grounds, too, the component "art" in "rock art" is completely justified. To the Latin-speaking Romans, the noun *ars* (with stem art-) simply denoted "skill," and there can be no doubt that rupestrian engravings or paintings are "skill"fully executed "art"ifacts. Human-made and the product of culture, pictographs and petroglyphs could as easily be called "humanfacts" or "culturefacts." For this and the other reasons advanced above, there seems to be no need to jettison the phrase "rock art."

Rock Art in Arizona

The state of Arizona, with its wealth of highly varied and often spectacu-

Techniques for Making Images

For the purposes of this book, the genre of rock art is defined as man-made markings on rock surfaces produced by means of subtractive or additive processes, resulting in petroglyphs, pictographs, and ground figures, respectively. Petroglyphs, the most numerous form of paleoart in Arizona, are found in every region of the state where suitable "canvases" exist. They are made on relatively smooth rock surfaces by direct or indirect percussion. The most prevalent method used is pecking,

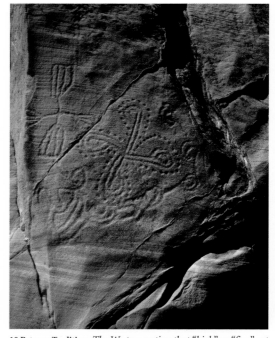

10 Patayan Tradition. *The Western notion that "high" or "fine" art has no function beyond the aesthetic does not apply to rock art; rather than being "art for art's sake," the latter is best understood as "art for life's sake." Maricopa Co.*

10

11

▼

11 Central Arizona Petroglyph Tradition. *Anthropomorphs and zoomorphs are among the most frequently depicted motifs in Arizona's rupestrian paleoart. Yavapai Co.*

although images also result from incising, scratching, abrading, or drilling, among others. Occasionally, a single design uses two or more manufacturing techniques. Most early images are now overlaid with a dark coating or patina known as desert or rock varnish. Pictographs (painted images), on the other hand, are not very prevalent in Arizona and, while there are regions of high density, especially in areas with cliff overhangs, rock shelters, and caves, their distribution is quite uneven. The paint, generally made from naturally occurring pigments such as charcoal, red and yellow ocher, hematite or kaolin, is applied in a variety of ways—using brushes, fingers or hands, or by spraying or spitting. To ensure adhesion, organic binders such as blood, urine, tree sap, or animal fat are added to the paint mixture.

A third category of rock art, ground figures, made directly on the desert surface rather than on rock, is found predominantly in the southwestern quarter of the state, especially along the banks of the lower Colorado and Gila Rivers. The majority of Arizona's earth works are geoglyphs (or intaglios), produced by scraping aside desert gravels and pebbles, thus creating low berms along the edges of the figure. A second technique involves tamping or compacting desert soil by repeated stomping, creating a somewhat sunken image. Occasionally a single design employs both methods. A rock alignment (or petroform), another example of a ground figure, involves arranging large rocks in configurations suggestive of iconic or noniconic motifs. A few Arizona ground figures have been documented manifesting all three construction techniques.

A Word on Interpretation

Interpretation is the most challenging and controversial aspect of the study of rupestrian images. In order to meaningfully interpret any form of art, the investigator must focus on its maker and attempt to understand his or her cognitive universe, needs, and motivations. Because the original creators of prehistoric rock art died long ago, however,

12

▼

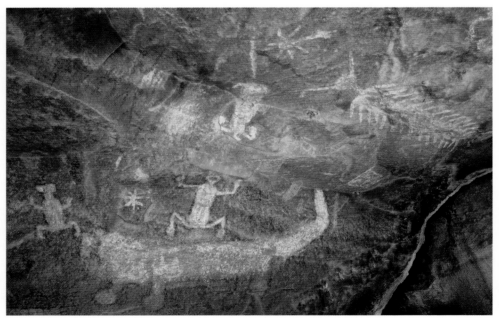

12 Central Arizona Petroglyph Tradition. *Painted petroglyphs, known as pictoglyphs, constitute an extremely rare subclass of rock engravings. Yavapai Co.*

13 Puebloan Tradition. *Rock paintings or pictographs, which occur much less frequently than petroglyphs, require the protection of overhangs or caves to endure in the outdoors. Navajo Co.*

the meaning of these images will ultimately remain a mystery. Meaning can, therefore, only be inferred in the form of hypotheses and speculative concepts that will never be testable or verifiable. For this reason, the question of meaning is often avoided by researchers. There is no universally applicable blueprint for deciphering meaning and, while researchers can record, classify and compare images, simple measurement will never reveal the intent of the artist. Yet, in order for rupestrian research not to remain a sterile endeavor, efforts must be made to transcend mere description. To this end, a broad spectrum of explanatory ideas have been advanced, ranging from the nonsensical and bizarre to the probable and plausible, some of which have been applied in a monocausal manner. It is unrealistic, however, to expect that a single global model is capable of covering a body of art that encompasses such a diversity of images created over hundreds, if not thousands, of years.

While many may react to rock art imagery impressionistically, as to inkblots in a Rorschach test, all of us bring to our viewing preconceived notions and biases from our own societies. Visual perception is highly subjective, conditioned by an individual's cultural, religious, and educational background. All too often, interpretation is dealt with in an eye-balling approach that operates with the principle of free association, and meanings that are "read into" an individual image or scene in this fashion seem to be limited only by the viewer's imagination. Any semantic appraisal of rock art must, therefore, be offered with a great deal of caution.

Ideally, fathoming the meaning of an image would entail understanding what it meant to its original creators and viewers, but in the absence of any ethnographic insights into most of Arizona's paleoart, this remains an elusive, if not futile, endeavor. Motivations and functions can be gleaned, however, from ethnographic analogy with present cultures and universal features underlying human cognition. Thus, worldwide, we can observe a multiplicity of rock art manifestations which may differ radically in their iconographic and thematic surface details but are anchored in a deep structure of thought that is substantially the same for all human minds. These images are but a universal graphic attempt to communicate, most likely to some perceived supernatural force, humankind's deepest desire for sufficient food,

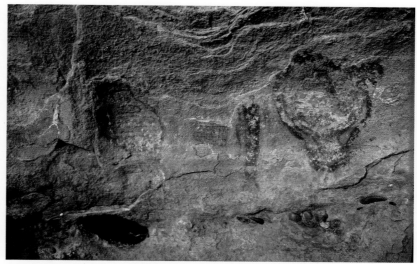

14 Grand Canyon Polychrome Style. *Taxonomy is fundamental to human thinking; hence rock art researchers classify the imagery according to motifs, styles and traditions, manufacturing techniques, degree of repatination, and other such parameters. Mohave Co.*

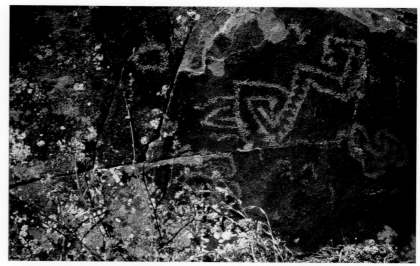

15 Central Arizona Petroglyph Tradition. *The meaning of a particular rock art image is ultimately unknowable; thus, we can only infer speculatively and hypothetically what these geometric elements may have signified. Maricopa Co.*

shelter and water, good health, safety, and other necessities related to the survival of the species. In seeking a fulfillment of these most fundamental of human needs, the function of rock art embraces Dissanayake's idea that art, as an evolutionary phenomenon, is truly art for life's sake. Thus, on the question of interpretation, the best I, as an author, can hope for is to provide an explanatory framework for the reader in the form of a broad list of possible functions and motivations for the art.

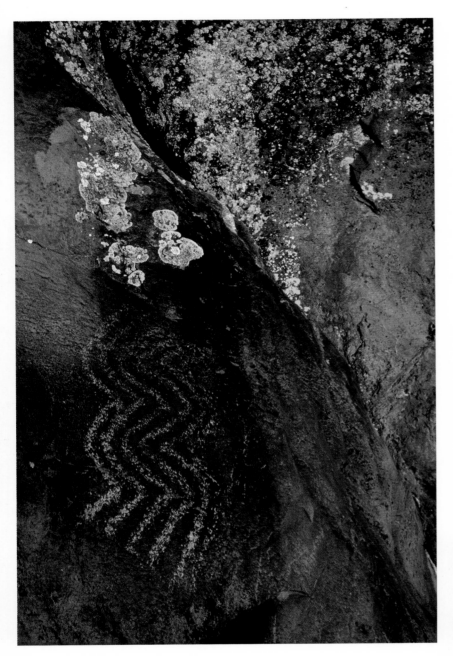

Dating Rupestrian Art

With most scientifically based rock art dating methods still in their experimental stage, held unreliable, or essentially discredited, "nearly all of the world's rock art remains effectively undated" (Bednarik 1998:8). Although sophisticated accelerator mass spectrometry (AMS) radiocarbon analysis now allows for the possibility of more confidently dating pictographs containing organic residues in their pigments or binders, no comparable approach exists for petroglyphs and geoglyphs. Traditional techniques—differential repatination and weathering, superimposition, image content, apparent direct association with other datable archaeological remains, and positioning of the rupestrian elements on cliff walls—thus remain the most widely favored in regional investigations. Based on unverifiable assumptions, these indirect methodologies provide only general relative dating clues and hence must be applied with great caution. Although such methods are bolstered by insights garnered from stylistic comparisons, there is presently no way to validate the accuracy of the general temporal frameworks and the chronologies referred to in this book. At best, they must be viewed as educated guesses subject to revision if and when truly exact, scientifically grounded, chronometric techniques are developed.

In order to deal here with the immense body of Arizona rock art in a reasonably manageable way, the chapters that follow are presented in two sections, Archaic and Post-Archaic, divided by a somewhat arbitrary time line of 1000 B.C. To further facilitate reference to

16 Puebloan Tradition (above). *All people have aesthetic standards, a human universal that applies to both the rock art creator and the modern viewer. Coconino Co.*

17 Hohokam Tradition (right). *The emotional response of the contemporary observer to a design can be profoundly affected by its setting in the landscape. Pima Co.*

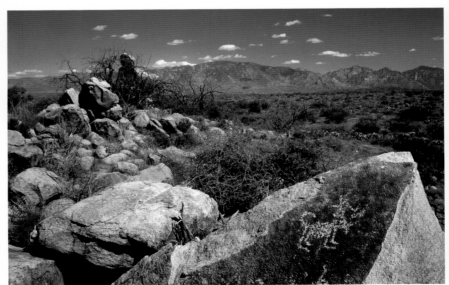

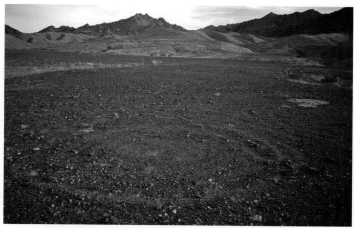

the multitude of styles and traditions with their varying time spans, I employ the temporal framework first introduced in a previous book on the parietal art of the Colorado Plateau (Malotki and Weaver 2002:XIX). Consisting of temporal blocks devoid of cultural affiliations—Paleoiconic (?– 6000 B.C.), Archeoiconic (6000–1000 B.C.), Mesoiconic (1000 B.C.– A.D. 800), Neoiconic (A.D. 800–1550), Protoiconic (A.D. 1550–1850), and Historioiconic (A.D. 1850–2000)—it is applied here to the entire state of Arizona. Due to the many new styles and traditions that developed in the post-Archaic period, it became impractical for me as an author to treat the state as a single geographic unit. For this reason, seven later chapters of the book each discuss a given geographical area termed a Rock Art Province. These chapters summarize the rock art corpora found in their respective geographic areas.

18 Ground Figure Tradition. *Monumental earth art in the form of intaglios or rock alignments is another category of Arizona's body of rupestrian art. Yuma Co.*

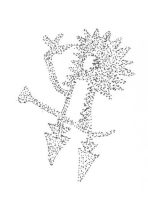

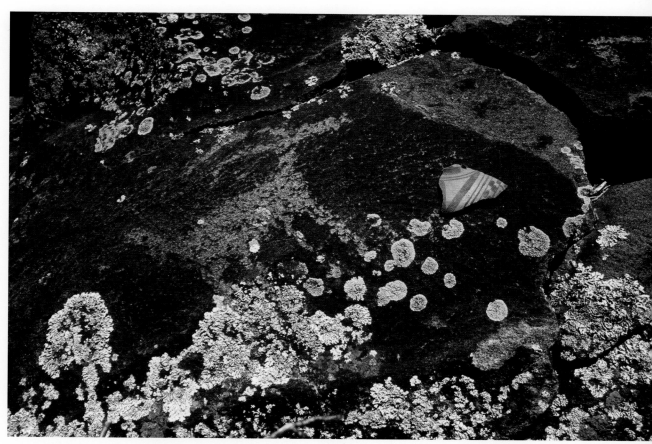

19 Puebloan Tradition. *While scientific dating of petroglyphs is currently not possible, archaeological artifacts, when found in proximity to a rupestrian site, may be helpful in establishing age estimates for the art. Coconino Co.*

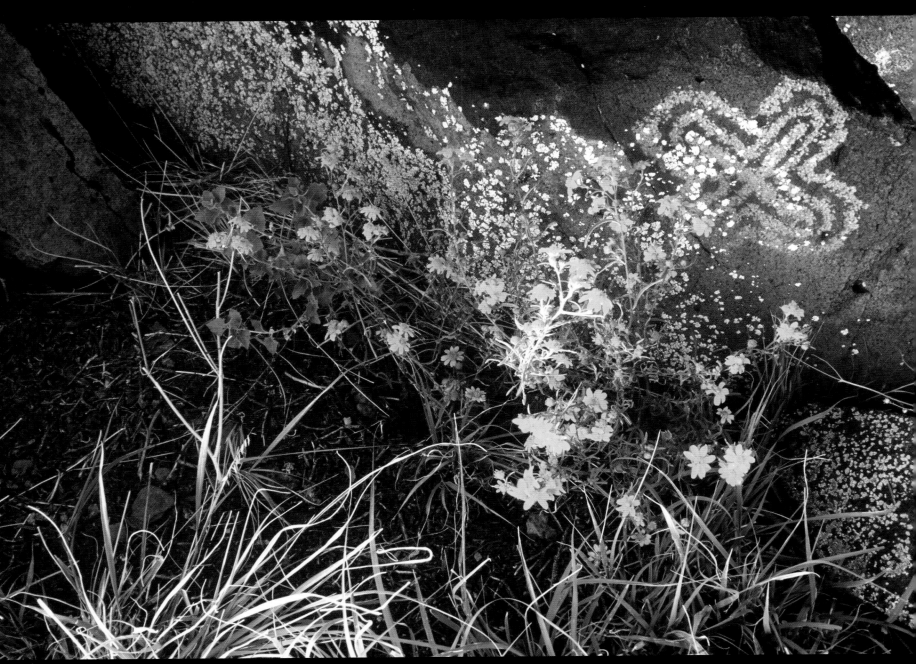

20 Central Arizona Petroglyph Tradition. *The discipline of Rock Art Studies operates with its own jargon and terminology. The motif of the equilateral or equidistant cross, for example, is also known as outlined, enclosed, or quartered cross. Yavapai Co.*

Style and Iconography

Borrowed from art history, style as a concept is the primary organizational tool used for all forms of the visual arts. In the context of rupestrian studies, style definitions usually include references to recurring similarities of design and motif, technique, distinctness of expression, overall aesthetic quality, artistic attributes, and material considerations. Traditions, in turn, are of longer temporal duration, usually embrace multiple styles, and may cut across cultural boundaries. In recent years, however, the notion of style has come under mounting criticism. The perception of what comprises a style is in constant flux, and attributes of a given style are heavily influenced by subjective evaluation. This is especially true when applied to art outside the reach of ethnographic documentation. Because of these shortcomings, stylistic assignments are generally regarded as nonscientific, that is, not falsifiable or easily replicated by independent researchers.

Unfortunately, high expectations in the rock art community for a "post-stylistic era" (Lorblanchet and Bahn 1993), no longer dependent on stylistic analyses and comparisons for the dating of rock art, have not materialized, mainly due to the general unavailability of absolute dating methods (Clottes 1993). Admittedly, in dating pictographs, claims of substantial progress have been made with the development of new techniques; however, the resulting dates still must be considered provisional. Indeed, Bednarik (2003:2) argues that direct dating is no more useful than traditional stylistic or archaeological methods because neither technique is immune to human error. What makes the former preferable, though, is that it "produces falsifiable results, which are thus scientific." Because, in Arizona, petroglyphs far outnumber rock paintings, discarding style altogether as a taxonomic device and analytical tool is not an option. Most rock art researchers recognize that the notion of style will continue to play a major role for a long time to come. Indeed, more recently, some (Pettitt and Bahn 2003:134) have strongly endorsed a coexistence between direct and stylistic dating, on the grounds that the two approaches can complement one another and be instrumental in exposing inconsistencies.

Understanding a given iconography within a postulated style is finally best accomplished by a set of standardized descriptive terms. To this end, I devised for the regional Palavayu Anthropomorphic Style of Arizona a motif index which I believe can be used for any rock art style in the world (Malotki 1998:7). Somewhat expanded for this book in the illustrations, it is presented in Figure 1. All relevant categories—anthropo-, zoo-, phyto-, phantasmo-, geo-, and reomorph—are defined in the glossary.

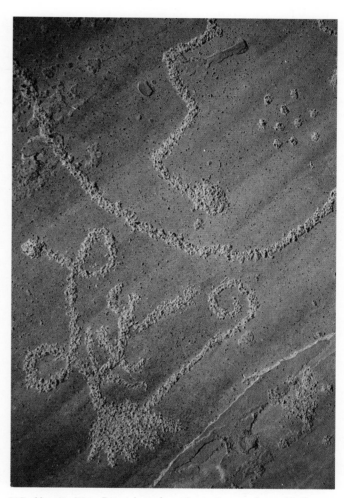

21 Puebloan Tradition. *Rupestrian paleoart is a testimony to humankind's creative imagination. Coconino Co.*

THE ARCHAIC ROCK ART OF ARIZONA

Within the field of archaeology, the term Archaic is applied in Western North America primarily to a span of human history that follows the Paleoindian (here named Paleoiconic) period and comprises the five millennia from approximately 6000 to 1000 B.C. In addition, it is used to designate particular lifeways adapted to the various environmental conditions of the American West. As a rule, the Archaic lifeway, distinguished by nomadic bands searching for seasonally available food and material goods (Cole 1990:10), lasted much longer than the accepted time frame for the Archeoiconic period of rock art. This is true at least for much of western Arizona, where a hunting and foraging mode of subsistence produced "Archaic"-type rock art in the form of the Grapevine Style well into the protohistoric and even historic era. Although the two

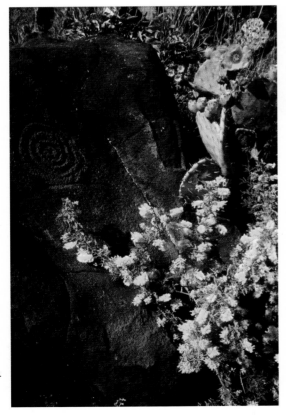

22 Western Archaic Tradition. *The term Archaic, as used in this book, generally designates any rock art believed to be older than 1000 B.C. Maricopa Co.*

23 Western Archaic Tradition. *Archaeologists also employ the term Archaic to designate a lifeway characterized by hunting and foraging which, in some parts of Arizona, lasted into historic times. Yuma Co.*

above-mentioned time periods (Paleoindian and Archaic) are still used, the latest archaeological research deemphasizes the originally sharply formulated differences between them. For this reason, and for the purpose of this publication, the label Archaic has been extended to cover both the Paleo- and Archeoiconic rupestrian periods. This means that the term Archaic will chronologically allude to any rock art older than 1000 B.C.

There is solid archaeological evidence that the earliest occupants of the American Southwest were specialized big-game hunters, generally referred to as Paleoindians. Most recently described as broad-spectrum hunter-gatherers, they roamed Arizona prior to 7000 B.C., although time frames as early as 15,000 years ago have been suggested for the initial colonization of North America. Even earlier dates

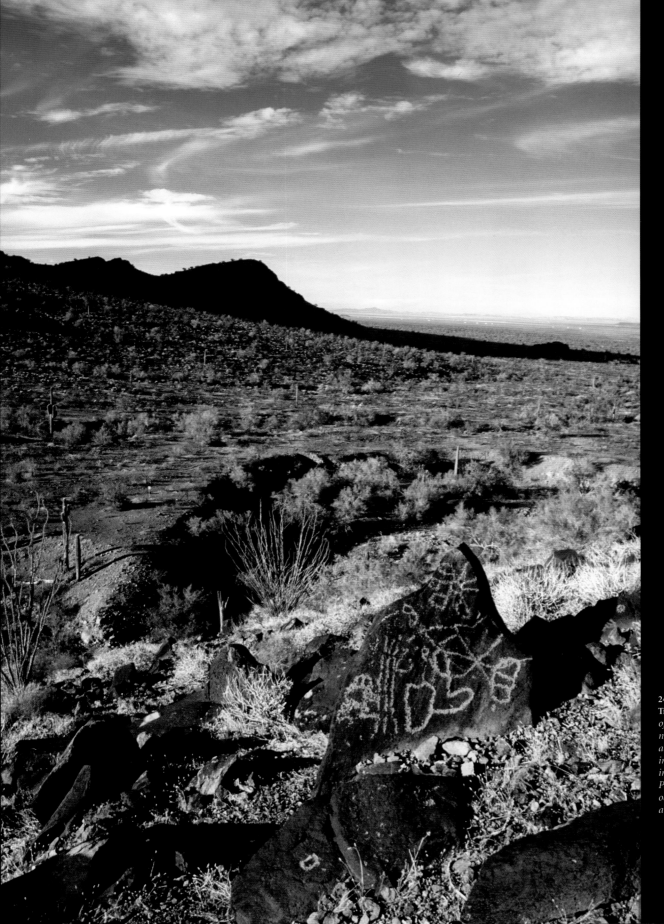

24 Western Archaic Tradition. *Due to the lack of reliable dating techniques and the complete absence of images depicting Pleistocene fauna, it is impossible to say whether Paleoindians, the earliest occupants in Arizona, created rock art. La Paz Co.*

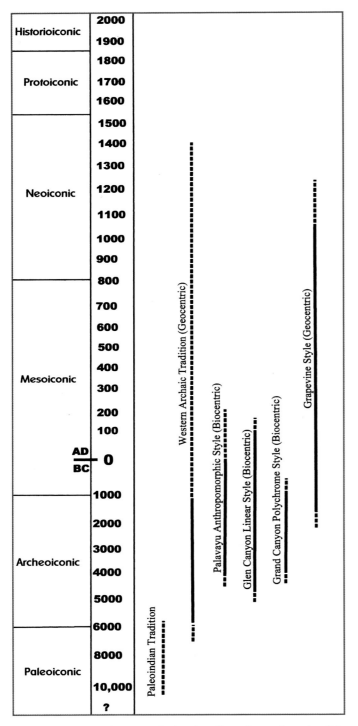

	2000		
Historioiconic	1900		
	1800		
Protoiconic	1700		
	1600		
	1500		
	1400		
	1300		
Neoiconic	1200		
	1100		
	1000		
	900		
	800		
	700		
	600		
Mesoiconic	500		
	400		
	300		
	200		
	100		
	AD 0 BC		
	1000		
	2000		
	3000		
Archeoiconic	4000		
	5000		
	6000		
	8000		
Paleoiconic	10,000		
	?		

Figure 2. *Approximate time spans of Arizona's earliest rock art styles and traditions.*

have been advanced by Johanna Nichols (2002: 291), a linguist who, using comparisons of grammatical structures and their geographic distribution from nearly 150 native language families, argues that the first entrants into the Americas arrived at least 20,000 years ago.

While rock art scholars have always assumed that Paleoindians painted or engraved images on rock faces, until now the search for examples of this most ancient layer in North America's rock art stratigraphy has met with little success. Most investigators have been looking, and continue to look, for images diagnostic of extinct Pleistocene fauna. Such images, if found, would of necessity date to the Paleoiconic period, because by about 9000 B.C. all Pleistocene megafauna had completely disappeared from North America (Elias 2002:18). Thus far, however, no verifiable depictions of mammoths or mastodons have been discovered, although there is ample fossil evidence, including mammoth kill-sites with associated Paleoindian artifacts, that these pachyderms once inhabited large areas of Arizona.

Why Paleoindians did not depict these big-game animals, when there is clear evidence that they hunted and ate them, will probably always remain a mystery. Since all earliest Arizona rock art consists almost entirely of nonfigurative motifs, a determination of whether some of them are of Paleoindian provenience can be accomplished only if more reliable dating methods for petroglyphs become available. It is, of course, entirely conceivable, although probably very unlikely, that they did not produce any rock art at all. It is also quite possible that, unlike the Paleolithic groups in Europe and Asia, Paleoindians had strict taboos against the creation of realistic game animals or humanoid figures, which accounts for their production of primarily abstract-geometric designs. Finally, the possibility cannot be ruled out that such big-game depictions existed, but that they are no longer preserved because the surface of many types of rock weathers off at rates faster than 7-10,000 years. The wetter climate during some of this span may have accelerated rock surface destruction. At any rate, to my knowledge, no rupestrian element actually datable to Paleoiconic times has yet been scientifically confirmed for Arizona (or, for that matter, anywhere in the United States).

One of the most burning questions when confronting rock art pertains to its function and meaning, two major goals of interpretation. As to the immediate meaning, there is a well-established consensus that it is unknowable because all the creators are now gone and can no longer be debriefed as to what literal, metaphoric, or symbolic message they intended to convey. Nor did the early cultures that produced the art leave behind any ethnographic or ethnohistoric accounts that might be consulted for interpretive information. This is especially true for Arizona's earliest art—both in its "geocentric" (geometric abstractions) and "biocentric" (representational life-forms) manifestations (Figure 2). Possible interpretations are achieved mainly by investigating the markings themselves in terms of their iconographic make-up, associations, and placement in the landscape. As pointed out in the introduction, such disciplines as neuroscience, evolutionary psychology, and human ethology provide clues to what motivated the production of rock art, as does the study of human universals. Of paramount significance in this context are the realms of art/aesthetics and religion/spirituality, which are among the most fundamental characteristics of human culture.

21 ▼

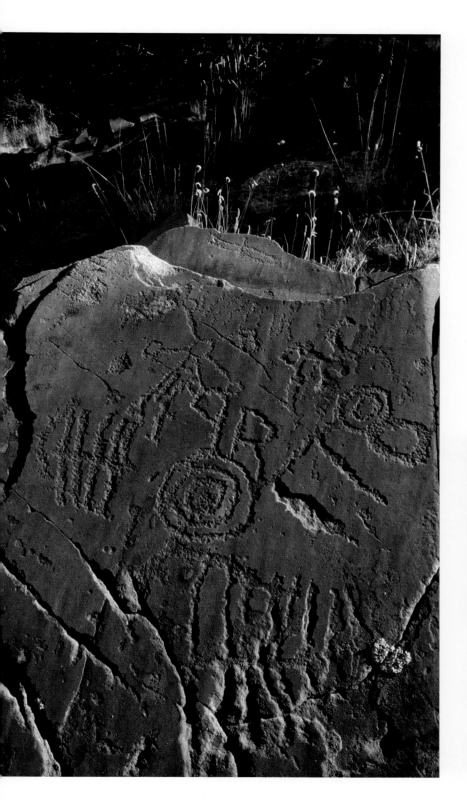

25 Western Archaic Tradition (left). *Archaic rock art is predominantly "geocentric;" that is, it emphasizes nonfigurative, abstract-geometric elements. Coconino Co.*

26 Western Archaic Tradition (right). *While the overwhelming majority of Arizona's earliest rupestrian imagery is engraved, Archaic paintings also occur throughout the state. Cochise Co.*

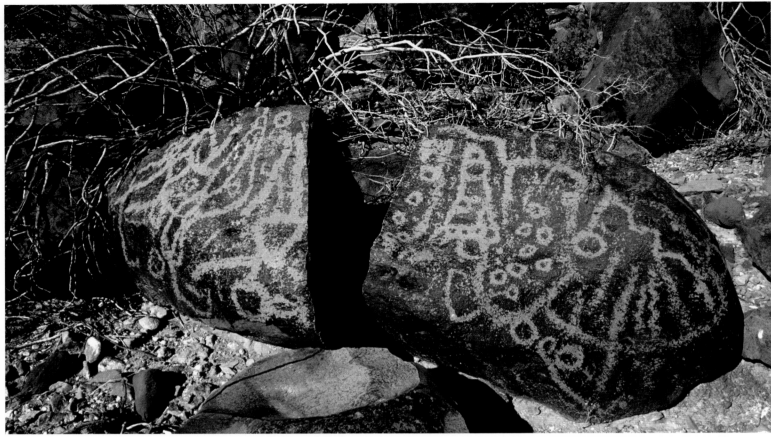

27 Western Archaic Tradition. *On a global scale, all prefigurative art is surprisingly uniform, has an infinite variety of configurations, and may derive from a limited number of form constants in the human brain. Pima Co.*

THE WESTERN ARCHAIC GEOCENTRIC TRADITION

As noted earlier, the most ancient of Arizona's rock art is thought to have been made between roughly 6000 and 1000 B.C., an era characterized by a new adaptive lifeway pattern involving the gathering of wild foods, supplemented by the hunting of smaller animals. The overwhelming majority of this most ancient art consists chiefly of abstract-geometric markings. Still, figurative elements such as atlatls, foot- and handprints, bird tracks, and possible vulvalike designs occur, as do occasional anthropomorphs and quadrupeds. For this reason, Arizona's oldest rock art substrate, traditionally subsumed under a broadly conceived Western Archaic Rock Art Tradition

(Hedges and Hamann 1993:65-67; Wallace and Holmlund 1986:84-86), is best characterized in the context of this overview under the designation of "Western Archaic Geocentric Tradition." Sites exemplifying this tradition are widely dispersed across Arizona and are divided into two easily distinguishable subsets: a petroglyphic one, where rock surfaces are pecked, incised, abraded, or scratched, and a pictographic group, where pigments are used. Labeled here the Western Archaic Geocentric Engraved and the Western Archaic Geocentric Painted Traditions, respectively, both show an overriding preference for imagery likely derived from phosphenes, autogenous

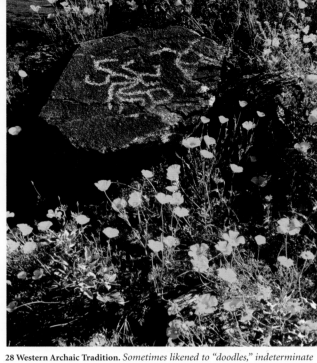

28 Western Archaic Tradition. *Sometimes likened to "doodles," indeterminate markings occur too frequently not to have had specific significance to the maker. Maricopa Co.*

Tradition are less common in Arizona, occurring predominantly in the southeastern and southern portions of the state. However, they have also been observed in the vicinity of the Grand Canyon, north of Payson, and near Kingman. Painted motifs, most of which are similar to those of the Geocentric Engraved Tradition, are rendered in red, black, white, orange or yellow, or sometimes in multiple colors, invariably under protective overhangs and rock shelters without any associated habitation remains. As with the Geocentric Engraved Tradition, figurative images are extremely rare.

Early Explanatory Hypotheses

Only a few serious efforts have been made to explain Arizona's earliest geocentric rock art traditions (Hedges and Hamann 1993; Wallace and Holmlund 1986; Wallace 2006). In adjacent areas, including northern Mexico, California, and the Great Basin, on the other hand, a number of interpretive studies have focused on similar, predominantly prefigurative petroglyphs and pictographs. Thus, Julian Hayden (1972), citing studies of the shell trade between tribes in southern Arizona and groups near the primary sources of shells along the Gulf of California in Sonora, Mexico, suggested that

and involuntary abstract-geometric form constants that are hardwired into the mammalian visual system and are produced by the human brain without external stimuli (Hedges 1987). It has been theorized that, the world over, nonfigurative or noniconic motifs in paleoart preceded representational images, and all motifs created prior to iconic ones are based on phosphenic elements (Bednarik 1994a).

Markings fitting the Western Geocentric Engraved Tradition are found throughout Arizona and are overwhelmingly distinguished by deeply carved lines on boulders, flat-lying slabs, and/or low cliffs. Elements are heavily revarnished, often seriously eroded and, when found in clusters, appear to be roughly contemporaneous. Motifs include a myriad of abstract figures, both of the curvilinear and rectilinear kind: circles, spirals, lines, arcs, grids, meanders, squiggle-mazes, rakes, ladders, zigzags, lattices, sets of parallel lines and the like. Major sites fitting this tradition are found in the Tank Mountains, the Growler Mountains, the Picacho Mountains, and the Hedgepeth Hills. A multitude of smaller sites exhibiting the same stylistic affiliation exist in many other parts of the state, for example in the Ash Fork-Seligman area, near Prescott, Camp Verde, Bullhead City, Cave Creek, Morenci, and in the Chiricahua Mountains.

Elements believed to belong to the early Geocentric Painted

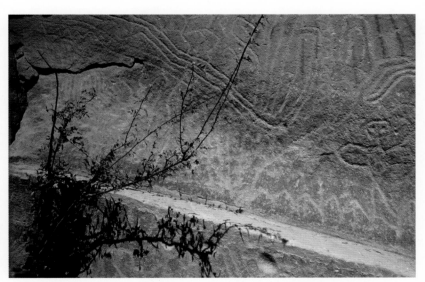

29 Western Archaic Tradition. *The extremely sparse life-forms of this tradition are estimated not to exceed 5% of the total. Coconino Co.*

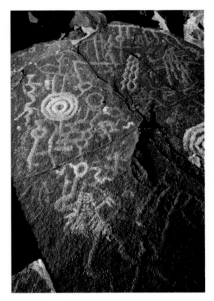

enclosed grids, also common in southwestern Arizona, might symbolize stylized sea shells as records of shell expeditions. However, his highly specific hypothesis, centered on a single motif, has not gained wide acceptance. In California, Robert Heizer and William Clewlow (1973), resorting to situational information for abstract petroglyph sites, inferred that the manufacture of such nonfigurative graphics involved rituals focused on food-gathering and related activities. Similarly, in the Great Basin of Nevada and eastern California, Heizer and Baumhoff (1962), also relying largely on locational data, strongly argued that the early abstract rock art, as well as later representational styles, was created as a form of hunting magic. Claiming that the art was mainly found along game migration routes and near hunting blinds and depicted game animals in the context of hunting scenes and fertility themes, this general theory proved highly popular at first, with a number of subsequent studies providing additional supporting evidence.

More recently, however, the hunting magic hypothesis has been seriously questioned (Bahn 1998:234-235). Angus Quinlan and Alanah Woody (2003:374-376), for example, do not subscribe to it as a monocausal explanation in light of the fact that many previously known and recently documented Great Basin and Arizona abstract rock art sites are situated near dependable water sources and/or habitation sites, including both villages and temporary camp sites. In my view, it is the nonrepresentational character of Arizona's earliest art that speaks most strongly against the plausibility of the hunting-magic hypothesis. The validity of this hypothesis, however,

increases considerably when applied to predominantly figurative rock art of the post-Archeoiconic period, which is distinguished by frequent depictions of game animals.

Phosphenes as an Explanation

On the question of art origins, Robert Bednarik (1994a) formulates a preliminary model that is of direct relevance for the earliest rock art production. Based on global evidence that is, according to him, surprisingly uniform in its repertoire of geometric markings, he argues that most known Pleistocene graphic art, with the exception of that found in southwestern Europe, is noniconic, in that it lacks "two-dimensional figurative depiction" and shows striking resemblances to a rather restricted suite of motif types called phosphenes (1993a:1). Also referred to as "psychograms" (Anati 1981), "primitives" (van Sommers 1984), "visual archetypes" (Bednarik 1994b), or "entoptic phenomena" (Lewis-Williams and Dawson 1988), phosphenes are experienced by all humans, including blind people, and can result from a wide range of

30 Western Archaic Tradition (top). *This rock canvas array displays several degrees of repatination; a Patayan artist may have added the spread-eagled bird. Yuma Co.*

31 Western Archaic Tradition (below). *Why nomadic hunter-gatherers in North America did not depict mammoths or other Pleistocene fauna, which they clearly hunted, will probably always remain a mystery. Maricopa Co.*

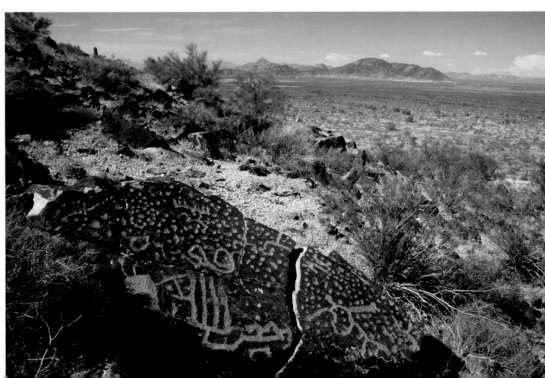

24
▼

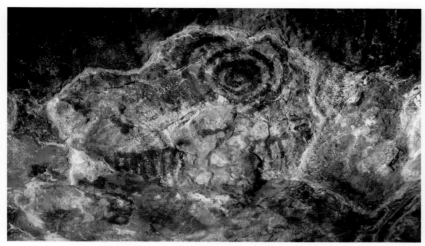

32 Western Archaic Tradition. *On this weathering cliff only a rake and concentric circles remain, typical motifs of the human archetypal design repertoire. Gila Co.*

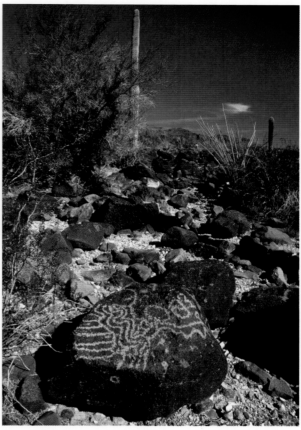

33 Western Archaic Tradition. *This composition may have involved both art and ritual, two human predispositions used by early people to socialize the landscape. Pima Co.*

causes such as hyperventilation, fatigue and hunger, migraine headaches, meditation and intense concentration, ingestion of hallucinatory drugs, and even pressure put on the closed eye. Believed to constitute fundamental universal elements of early art, they cannot be influenced by cultural conditioning and are considered ontogenetically stable (Bednarik 1994b:153). Indeed, Bednarik (1994a:176) claims that the phosphene theory, as proposed by him, is the only rupestrian hypothesis that is scientifically testable and falsifiable. It would be significantly weakened only "by the discovery of a major art body of non-phosphenic marks predating the introduction of two-dimensional iconic art" (Bednarik in Hodgson 2000:18).

Researching electrically induced phosphenes, M. Knoll and J. Kügler (1959) posited a set of fifteen phosphenic types that, according to Rhoda Kellogg et al. (1965), also determine the scribblings of children 3-4 years of age before they begin to draw figuratively. This set of basic graphic elements is corroborated by the doodling behavior of adults who, in their repetitive, "subconscious" scribbling become mere spectators to their own spontaneous graphic depictions (Bednarik 1994a:177). Due to its homogeneous global ubiquity, the elemental repertoire of the visual arts, consisting of arcs, dots, grids, circles, triangles, sets of parallel lines, radials, spirals, meanders, and squiggles, in an infinite variety of arrangements and constructions, seems to indicate "a kind of universal, innate visual grammar" (Engel in Fein 1993: back cover).

The Shamanistic Hypothesis

The 1988 publication of "The Signs of All Times" by David Lewis-Williams and Thomas Dowson marked the beginning of an interpretive approach to parietal art that, in its theoretical premises, combines insights derived from both shamanism and neuropsychology. The shamanistic aspects of this exegetic paradigm are grounded in a consensus among the majority of scientists, particularly those devoted to the understanding of Archaic ontology, that, the world over, hunter-gatherers, whether of prehistoric antiquity or still extant, practice a shamanistically oriented brand of religion. This can also be assumed to have been true for the earliest immigrants into the Americas. According to La Barre (1972:273), all evidence, whether archaeological,

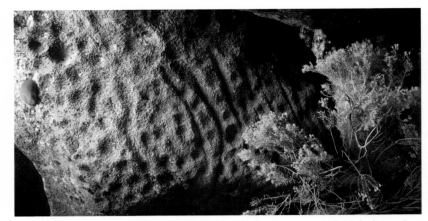

34 Western Archaic Tradition. *These cupules and adjoining grooves probably had a magico-religious rather than a utilitarian function. Yavapai Co.*

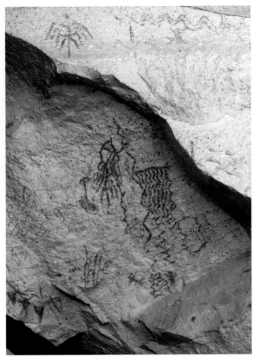

35 Western Archaic Tradition. *We may typically see abstract images as unidentifiable and perplexing, but they undoubtedly had symbolic meaning to their creators. Greenlee Co.*

linguistic, cultural or folkloristic, is in concord with the prevailing physical-anthropological view that "the American Indians were unspecialized Mongoloids bearing a late-Paleolithic and Mesolithic paleo-Siberian hunting culture and religion." As they reached the New World via the Bering land connection, they brought with them shamanism as the *ur*-religion of all hunting peoples. At the core of this shamanistic ideology stands a ritual specialist who, on behalf of his band, acts as an intermediary between the world of mortals and the supernatural realm, healing the sick, influencing the weather, controlling game, assuring human, animal, and vegetal fertility, and restoring lost harmony by harvesting supernatural power from the spirit world.

In its neuropsychological application, the model suggests that the shaman, in his communication with the otherworld, exploits the universally shared biopsychological phenomena of dreams, trances, and hallucinations, all acknowledged forms of altered states of consciousness (ASC). Lewis-Williams (1996:126), in a series of criteria that he considers central to a generic characterization of hunter-gatherer shamanism, indicates as the defining attribute the fact that it is based on "a range of institutionalized ASC." According to Erika Bourguignon (1974:231-232), a cross-cultural survey of nearly five hundred societies from around the world determined that 90% of them had established forms of ASC. More to the point of this chapter, it is significant that in her survey the incidence of institutionalization of ASC for North American societies (Indian and Eskimo) was 97%.

The neuropsychological model, as the hypothesis proposed by Lewis-Williams and Dowson (1988:202-204) is generally referred to, is said to unfold sequentially in three stages and to operate with a series of categories of fundamental geometrics that the authors call entoptics. Consisting of grids, sets of parallel lines, dots and flecks, zigzags, nested catenary curves, filigrees and meandering lines, these phosphenic elements are thought to be the first that the human brain-mind generates during the initial stage of trance. Modified and mentally manipulated into iconic forms when trancing subjects attempt to inject sense into the entoptics from their storehouse of experienced world-reality, they ultimately take shape, in the third and deepest stage of trance, as actual hallucinatory images, often of a fantastical nature. According to the proponents of the hypothesis, shamanic specialists, after emerging from their trance state, commemorated their visionary experiences by creating rock art replicas of their hallucinated images. In addition to preserving their trance visions in the more permanent medium of rock engravings or paintings, the fixed images would also have allowed them to return to their vision-quest locales at a later time and to reconnect with the potency-charged imagery.

The neuropsychological model, which claims universality based on its biological roots and neuroscientific research of the brain, has shown that in trancelike states the human mind generates a broad range of hallucinations. The most significant of these, in the context of rupestrian production, are visual. Thus, the appeal of the model rests on the fact that it has revealed commonalities in human behav-

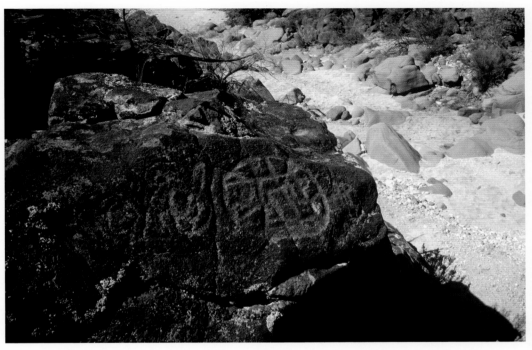

36 **Western Archaic Tradition.** *While called by some a proto-alphabet, no group of abstract geometrics meets the stringent consistencies of a writing system. Yavapai Co.*

ing the art to the status of ritual communication, even if it can no longer be understood." However, as pointed out above and corroborated by children's scribbles and the doodlings of grown-ups, almost the entire noniconic design repertoire mimics hard-wired mental images arising from the universal human nervous system. No shamanic trance or drug-induced hallucinatory visual experiences are required to produce them. For this reason, it is understandable that opposition to the neuropsychological model is increasing (Bahn 1998; Bednarik 1990; Francfort and Hamayon 2001; Kehoe 2000), especially when embraced as the sole cause for the entire spectrum of rock art manifestations. In particular, Patricia Helvenston and Paul Bahn (2005:27) severely critique what they call the "Three Stages of Trance" model. They refute its appli-

ior and symbolic expression that hold for all *Homo sapiens sapiens*. Although this model was first developed in South Africa, its resonance among many rock art researchers has been extremely positive, and its explanatory potential has been hailed not only for Upper Paleolithic paintings and engravings in Europe (Clottes and Lewis-Williams 1998) but also for many of the rupestrian arts of hunter-gatherer vintage in the United States, especially in Texas (Turpin 2001), California (Whitley 2000), and the Southwest (Cole 1990; Schaafsma 1994).

Although the neuropsychological-shamanistic origin hypothesis for rock art in the United States is primarily applied to explain the representational styles of the Archeoiconic period, many investigators, including myself, have also used it to account for the earliest, phosphene-based iconography (Malotki and Weaver 2002). Solveig Turpin (2001:363), for example, posits that phosphenes, "because they are often engendered during trance state common to many religions,...form the bridge between rock art and religious belief, elevat-

cation to Upper Paleolithic cave art, claiming that the model is compatible only with hallucinations produced by the intake of mescaline, LSD, and psilocybin. According to their findings, none of these psychotropic substances were available in the Old World. Thus, they insist "that the entire rationale for trance-inspired Paleolithic cave art in Europe collapses" (Helvenston and Bahn 2005:48).

A different situation existed in the American Southwest, however, since these hallucinogens were obtainable. Thus there is no need to discard altogether the neuropsychological hypothesis for this part of the world. As Helvenston and Bahn (2005:27) themselves

37 **Western Archaic Tradition.** *Thousands of years separate these graffiti and the underlying abstract markings of ancient artists. Maricopa Co.*

▼

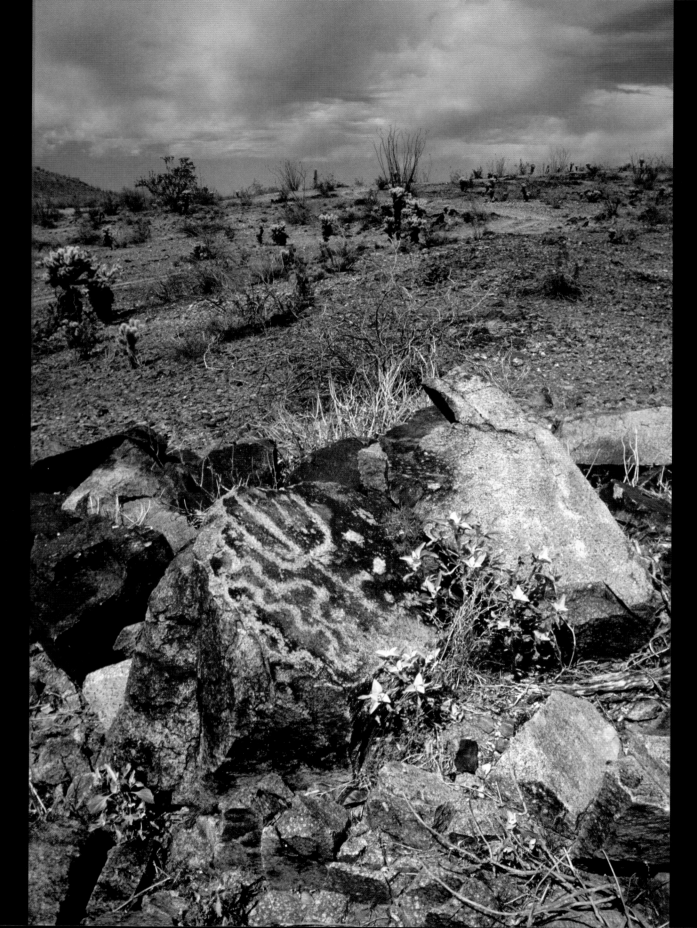

38 Western Archaic Tradition. *Because abstract signs range across temporal and cultural boundaries, they are difficult to assign to a specific style, especially when repecked, as seen here. La Paz Co.*

state, mescaline, the alkaloid ingredient in the Peyote cactus *Lophophora williamsii*, is "widespread throughout the Southwestern U.S. and northern Mexico." LSD-related compounds 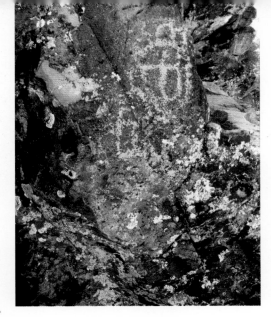 occur in morning glory seeds, a plant used profusely by the Aztecs of Mexico (Furst 1976:65-66). Psilocybin, the active component in a number of mood-altering mushrooms, also existed in the Americas as evidenced by mushroom images and idols in Mesoamerica thought to be at least two thousand years old (Furst 1976:77). Moreover, the mushroom species *Psilocybe coprophilia* is found in east-central Arizona, an area that houses the Palavayu Anthropomorphic Rock Art Style (Malotki 1999). There is a slight possibility, therefore, that some of the abstract-geometric elements making up the iconographic repertoire of Arizona's earliest rock art could be trance-related due to the consumption of mescaline-, LSD-, and psilocybin-containing plants. It must be noted, however, that if the neuropsychological model does not hold in the Old World as claimed by Helvenston and Bahn, its applicability in the New World is considerably weakened. Thus, if Archaic phosphene-inspired imagery can be explained without resorting to shamanism, then perhaps we should hesitate to invoke the shamanistic hypothesis.

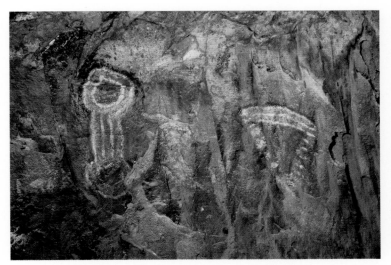

39 Western Archaic Tradition (above). *Creating geometric forms may have allowed early artists to shape and control a small part of their environment. Mohave Co.*

40 Western Archaic Tradition (top right). *Even the simplest motif is unfathomable because we cannot penetrate the minds of prehistoric people. Mohave Co.*

Abstract Geometrics: A Protolanguage?

One intriguing theory shedding light on the earliest nonfigurative signs comes from James Harrod (2003:116). Trying to explain why hominid artists used the phosphenic markings on a nearly world-wide scale, he argues that a subset of them, at least in Upper Paleolithic Magdalenian times, may have constituted a protolanguage. "Phosphenes were used in art because they were good to think. They could be organized into a conceptual logic and thence into a protolanguage" (2003:116). It is crucial, at this juncture, to emphasize that protolanguage should not be equated with protowriting. Colloquially, rupestrian images are frequently characterized as "rock writings." Likening them to a primitive script, however, is completely unwarranted. All writing systems that humans developed in the course of their history rely on only one of three basic strategies. These differ in the size of the speech unit captured by the written symbol. To this end, the logographic approach used the word as an entity, the syllabic approach the syllable, and the alphabetic one, the most user-friendly of them all, the phoneme or functional sound. Every writing system, therefore, is entirely language-based, that is, represents spoken language. Assemblages of petroglyphs or pictographs, on the other hand, are far too random and diverse to meet the stringent consistencies required of a writing system.

While as a linguist I have to reject the use of the word "language" in terms of a "writing system" as intimated by Harrod, I can accept the notion of rock art as visual communication, especially when directed at a supernatural world. Communication, whether verbal, gestural, or graphic, is perhaps the most fundamental of all human universals. One explanation for these nonfigurative glyphs could thus have been their creators' belief that the controlling entities of some perceived other-world were thought to relate to abstract essences and concepts more

29

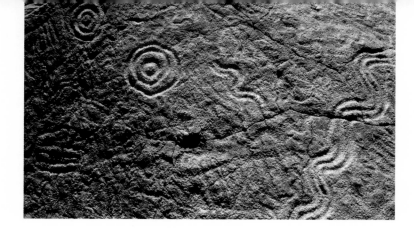

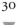

41 Western Archaic Tradition (top). *Abstract forms of this kind are found on every continent, possibly indicating a universal blue-print hardwired in the human brain. Maricopa Co.*

42 Western Archaic Tradition (bottom). *A complex abstract design resembling an intricate labyrinth. Maricopa Co.*

readily than to realistically portrayed objects. However, it is difficult to conceive that this motivation could have been adhered to cross-culturally in a uniform way.

Abstract Images: For Only a Chosen Few?

Another proposition to explain abstract images, recently advanced partially to account for the long-lasting dominance of abstract-geometrics in Great Basin parietal art, is based on their documented close proximity to habitation sites and the margins of settlement (Quinlan and Woody 2003:374). Obviously, such rock depictions would have been visible to virtually everyone in the local social group. Since it is assumed that the subject iconography was directly linked to essential rituals promoting preservation of the existing social organization and the underlying power structure, the two authors speculate that it was therefore advantageous for those in positions of leadership and authority to limit access to the function and meaning of the art by resorting to abstract geometrics. In this way, the purpose and symbolism of the graphic elements would have been disguised, and only a few privileged initiates would have been privy to their actual significance. Similar conclusions have been reached for the widespread and long-lived abstract rock art styles of Atlantic Europe (Bradley 1997:215). It remains to be seen, of course, whether this explanatory theory of "access-limited-to-special-interest-groups" is applicable and useful in Southwestern rock art studies. The fact that the oldest Arizona rock art, regardless of placement, is so consistently uniform and homogeneous in its nonfigurative aspects seems to speak against this explanation. Also, as was pointed out above, in light of the fact that all earliest paleoart is noniconic, this hypothetical assumption would require that world-wide the same ideological rationalization drove the impulse for abstract-geometric marks and patterns, a notion that is really not conceivable.

Obviously, there is no way of definitively knowing what cultural significance, if any, was projected into an iconographic symbol inventory that, in light of the human propensity for abstract expression, exists on all continents. Nor will the symbols ever yield to us insights as to what prompted their creation in the first place. The abstract signs may simply have functioned to enculturate, that is, humanize, socialize, or sacralize

the existing landscape. Thus, the abstracts may have served the pioneering hunter-gatherer bands as territorial boundary signs or as topographical markers of numinous places or ceremonial ground.

Rock Art: A Way of "Making Special"

Finally, a more plausible answer to the "abstract enigma" may be gleaned from Ellen Dissanayake's discussions of art. Arguing (1992a:11) from an ethological standpoint that art is not merely a peripheral epiphenomenon but a biologically endowed behavioral proclivity of every human being, she (1992a:39-63) defines the core of art as "making special" and builds a strong case for it as having been necessary to human evolution, and as being, until now, an undescribed universal characteristic of humankind (1999:27). In subsequent writings (e.g., 1995a:99), she also uses the term "artification" to emphasize her contention that the arts are something that people do, thereby emphasizing the process of making or doing rather than the resulting product (1995b:43). In her view, artification (making special) is an innate human predisposition in certain circumstances to transform the ordinary, "natural," or mundane into the extraordinary, "super-natural," and unusual, thereby creating a meta-reality (1992a:49-50). These circumstances have to do with the important subjects of ritual ceremonies, which are intended to assure good outcomes to such uncertain biological necessities as finding food, assuring safety, prosperity, and fertility, healing, avoiding evil, and assisting transitions in biologically important life stages such as puberty, childbirth, or death. In small-scale societies these are overwhelmingly the occasions for artifications and, she contends, the "aesthetic operations" that characterize making special (formalization, repetition, exaggeration, elaboration, and manipulation of expectation) are all ways of shaping or controlling anxiety about the perceived uncertainty that motivated the ceremony (Dissanayake 2006). In addition, her making special generally involves an aesthetic component. The latter leads to her central characterization of humankind as *Homo aestheticus* (1992a: XIX). Not surprisingly, "aesthetic standards" are listed in Brown's (1991:130-140) catalog of absolute human universals shared by what he calls the "Universal People" and are considered by him fundamental to human cognition.

Geometric configurations, in the context of this definition of the arts, are seen by Dissanayake as abstract, nonnatural shapes imposed by humans on the natural world that provide a cultural "super"-order and a way of manifesting command of space. "Regularized, repetitive geometric ornamentation seems to deliberately counteract the random or untidy look of natural forms. Careful decoration...can

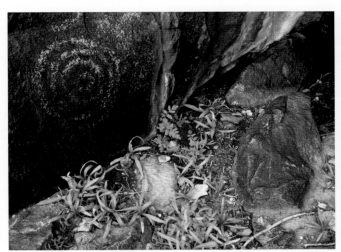

43 Western Archaic Tradition. *Concentric circles may reflect to some a long-lasting symbol tradition; others attribute them to the mental imagery resulting from altered states of consciousness. Mohave Co.*

44 Western Archaic Tradition. *A long vertical line bisected by a small ellipse or circle generally portrays an atlatl or spear-thrower, a diagnostic motif for Archaic imagery. Coconino Co.*

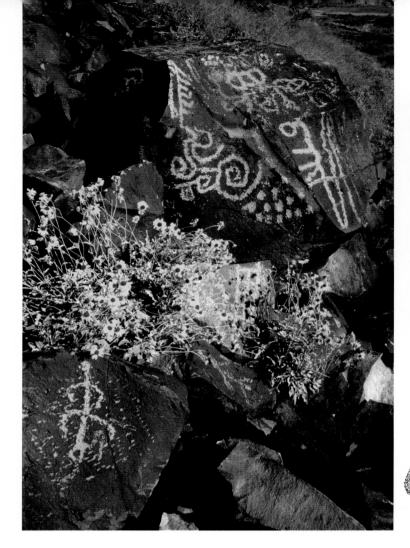

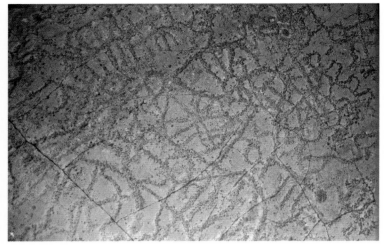

45 Western Archaic Tradition (left). *Hunter-gatherers typically produced non-iconic images; later agriculturalists depicted more representational forms, such as this Hohokam figure. Maricopa Co.*

46 Western Archaic Tradition (right). *Turning the ordinary, natural, and mundane (as with this sandstone slab) into the extra-ordinary, supernatural, and unusual is an innate predisposition of human behavior. Coconino Co.*

be interpreted as an imposition of system or order, perhaps as vicarious regulation and control" (Dissanayake 2000:115).

Similar notions are expressed by Derek Hodgson (2000:4-5) when, in placing art within an evolutionary context, he states that repetitive mark-making and geometric shapes are appealing to us because they are "an integral feature of the brain" and, due to their continuity or repetition, "would have signified what was safe, secure, and 'understood,' whereas change (or novelty) represented threat." In line with these arguments, he defines art as "an attempt to render permanent and tangible that which was formally intangible and fleeting, the seeking of order in the midst of disorder, the expression of the sense of pattern, harmony and symmetry synthesized from the immediate, ambient confusion."

Dissanayake goes a step further when she states that the "production

and repetition of geometric shapes, like the repetitions and patterning of sounds or movements, seems to be a fundamental psychobiological propensity in humans that provides pleasurable feelings of mastery, security, and relief from anxiety" (1992a:84). Ultimately, the imposition of cultural forms on nature may constitute "an attempt to influence the nonhuman world in order to obtain vital necessities" (Dissanayake, personal communication 2005).

One important implication in emphasizing the creative process over the final result for the earliest art of Arizona is that, in the end, it is not the quality of the finished pictograph or petroglyph that counts, but its manufacture. Thus, the myriad of archaic geometrics, many of which are executed with great aesthetic sensibility, also contains a large number of abstractions resembling wild or aimless scrawls. They may strike a modern viewer as crude and/or lacking aesthetic standards and could be likened to a "babbling of art" (Fein 1993:23). Nonetheless, they deserve our respect and understanding as much as those perceived as aesthetic masterpieces. After all, if Dissanayake is correct, even these scrawls may represent the desire of

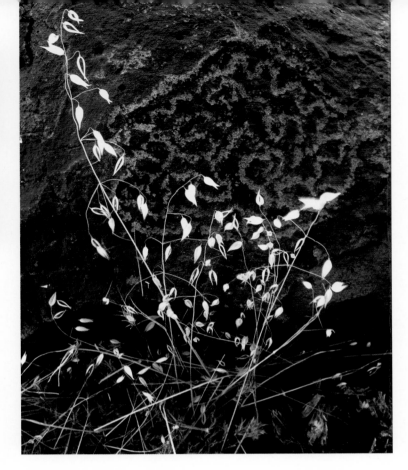

47 Western Archaic Tradition (above). *Geometric designs are universally recognized, but what they mean is culturally determined. Mohave Co.*

48 Western Archaic Tradition (right). *Aesthetically satisfying in itself, this abstract design likely had meaning beyond the decorative. Maricopa Co.*

the early hunter-gatherers to make certain locales in their environment special or extra-ordinary and thereby render them ritually effective. Imbuing the landscape with markings of magic and power and thereby creating rock art "shrines" may have helped early humans feel that they exercised a certain control over an unpredictable and dangerous world. In this manner, "artification" and the creation of ritual ceremonies, as a twin set of universal human predispositions, become inextricably intertwined. Indeed, as Dissanayake says (2006), ritual ceremonies, whatever else they may be, are "collections of arts" and "without arts, there is no ceremony." In this vein, art, when recognized as bestowing group meaning, enhancing communal activity, and galvanizing group solidarity, is perceived as "art for life's sake," that is, a deep-rooted necessity that had adaptive and selective survival value (Dissanayake 1992a:35).

Randall White (2003:13-15) essentially concurs by saying that "material representations"—and this includes rock art—"must have had adaptive value" and "conveyed some kind of selective advantage to those human groups that possessed them." After all, as he asks, "Can humans experience social solidarity in the absence of shared representations...? Can religion even exist without icons and visual images?" While it is true that two well-established religions, Islam and Judaism, forbid imagery that might be mistaken for idols, it is generally accepted that in ancestral societies ritual and the arts were intimately linked. In fact, ceremonies were the occasions par excellence in which early humans were able to respond to their fundamental need for "artification." Among the tangible products of these "artifying" endeavors that have survived into modern times, rupestrian art, of course, figures eminently.

Archaic Rock Art: How Often Made, How Often Seen?

Not so obvious, however, is the question of how Archaic rock art of an abstract-geometric nature may have functioned in a ceremonial context. After all, rock art sites of this kind, while found all over Arizona, are scanty and usually separated by large spatial intervals. This issue has gained new prominence in light of a modeling exercise that Henry Wallace (2006) has conducted with regard to petroglyphic production, an approach that breaks new ground. Operating with three variable parameters—temporal span of a given rock art style, number of rupestrian elements, and population size involved in their manufacture—Wallace illustrates his point by applying them to the Western Archaic Geocentric elements of the entire Picacho Mountain

northeast of Tucson. Allowing for an estimated total of 400 petroglyphs incised during a 3,800 year span from ca. 3000 B.C. to A.D. 800, he calculates this as an average of .1 design elements per year or 10 elements per century. Doubling or tripling the resulting figures for environmental loss and degradation, and taking into consideration that the images were probably made over a considerably longer time span than estimated for the statistical exercise, does not appreciably change the results. Ultimately, after contrasting these remarkably low production rates with the archaeological evidence for a rather

lengthy human occupation in the Picacho Mountains area (beginning perhaps as early as 9000 B.C.), Wallace arrives at conclusions that have serious implications for the function of rupestrian paleoart, both in the study area and elsewhere. "If I am correct," he sums up his findings, "...then many hundreds of generations of early hunter-gatherers in the area did not hammer out any designs at all, and we can hardly consider petroglyph production a *ritual tradition* [emphasis mine]. I wonder whether most people ever knew who made the designs or where they came from" (Wallace 2006:47).

Similar modeling exercises could be undertaken for other regions in Arizona, indeed, for entire Archaic rock art corpora—for example, the petroglyphic Grapevine or the pictographic Grand Canyon Polychrome Styles. The results would probably not differ significantly. Wallace's insights thus compel a reappraisal of certain aspects of the above-stated linkage between ritual and the arts. This reassessment, while not denigrating the act of making the art or its symbology, nevertheless suggests that greater heed must be paid to human interaction at established rupestrian sites. Once a particular place in the landscape was consecrated by "extra-ordinary" markings, both in painted and engraved form, because of its physical durability it may have proved useful through many generations. Rock art sites could

34
▼

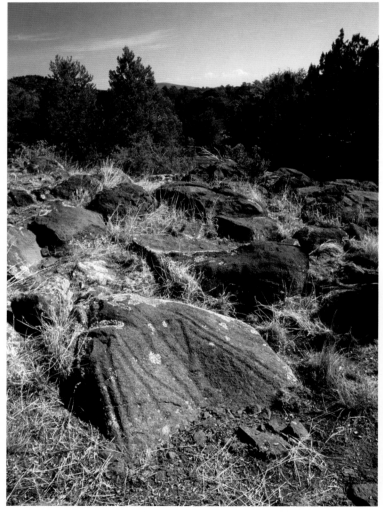

49 **Western Archaic Tradition.** *Deeply cut grooves and associated cupules, here incised on volcanic rock, survive from Arizona's earliest paleoart. Coconino Co.*

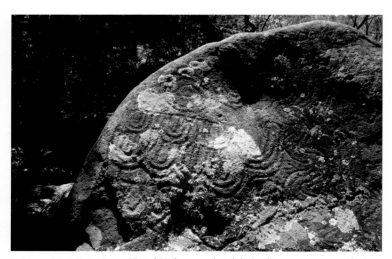

50 **Western Archaic Tradition.** *Nested U-shapes and undulating lines can convey aesthetic harmony, perhaps to impose a sense of order in an otherwise chaotic world. Yavapai Co.*

51 Western Archaic Tradition. *While this complex of circular designs may look "crude" to our eyes, its creation in the context of ritual is thought to have been more important than its final aesthetic impact. Yavapai Co.*

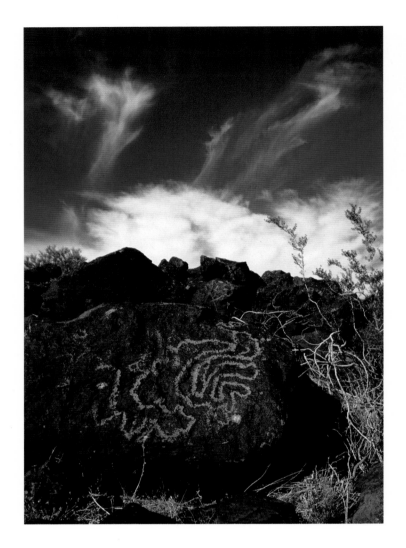

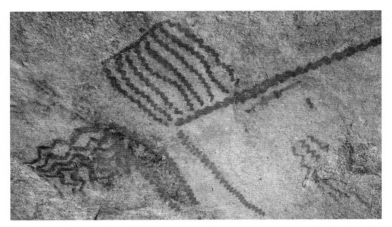

36 ▼

52 **Western Archaic Tradition (left).** *Phosphenes or form constants may have inspired nearly the entire motif repertoire of Arizona's earliest rock art, including the filigree pattern seen here. Maricopa Co.*

53 **Western Archaic Tradition (right).** *For early hunter-gatherers, arranging motifs in harmonious patterns may have produced a sense of order in the world. Cochise Co.*

As Wallace (2006:49) argues, the Western Archaic Geocentric Style, always visible and constituting a reservoir of design information, "did not disappear from the collective cultural consciousness" and "may have kept the meaning of at least some of the symbology alive...and contributed to the longevity of certain ritual practices."

The emergence of new explanatory propositions regarding non-figurative rupestrian art, including those described above, testifies to the fact that more and more researchers are gravitating toward the general conclusion that rock art, even in its earliest forms, was a multi-functional phenomenon. It is highly unlikely that a single hypothetical postulate will explain it all. Rock art, at any given time, had not only many functions and motivations but many meanings as well.

Due to the lack of dependable direct dating techniques, it is imperative to note that very few, if any, reliable age determinations exist for any of the various manifestations of Arizona's Archaic rock art. With the exception of style superpositioning, which does at least provide a degree of relative dating, most clues for temporal placement are thus essentially circumstantial, relying nearly always on stylistic criteria. It may be that in spite of the general homogeneity of the Western Archaic

then have served hunter-gatherer societies as permanent shrines, both publicly or privately, where individuals or entire groups might have performed ceremonial activities relating to their physical and spiritual needs. In the case of ritual activities involving multiple participants, one can envision multimedia performances of a proto-theatrical nature. These could have involved a wide range of special activities: praying and reciting poetically and/or rhetorically enhanced speeches, meditating, dancing, chanting, attempting cures, depositing offerings, connecting with the images in trance states, renewing the potency of the images through repecking or overpainting, conducting initiations, celebrating rites of passage, and others.

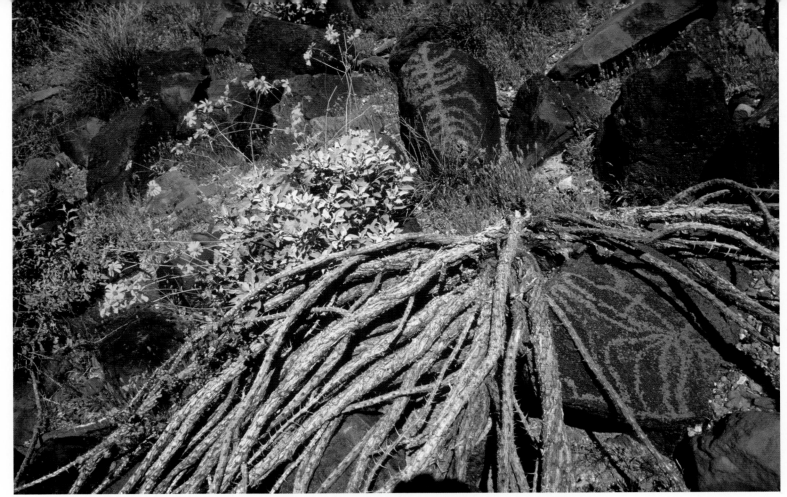

54 **Western Archaic Tradition.** *Because all societies, past and present, have produced art, it may have been essential to human survival. Pima Co.*

Geocentric Tradition, a number of distinctive styles may eventually be identified. One clear example already discernible is the Grapevine Style. While geocentric images changed to more biocentric depictions in most regions of the state where agriculture became established, the predominantly geocentric Grapevine Style, albeit somewhat altered over time, lasted for thousands of years among groups who continued the hunter-gatherer lifeway.

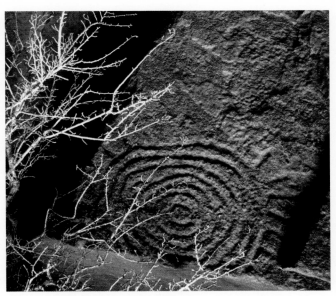

55 **Western Archaic Tradition.** *These circles adorned with short radiating spokes may have served as territorial boundary signs or as topographical markers of sacred places. Coconino Co.*

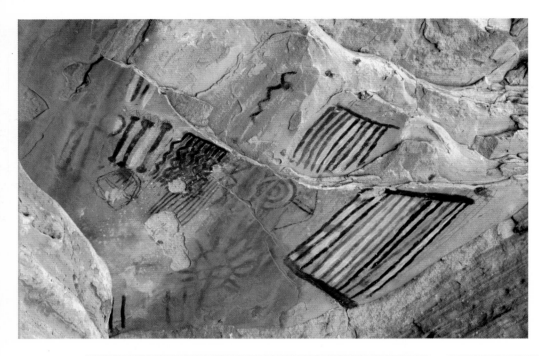

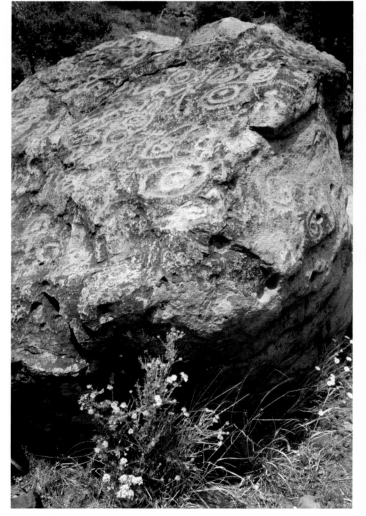

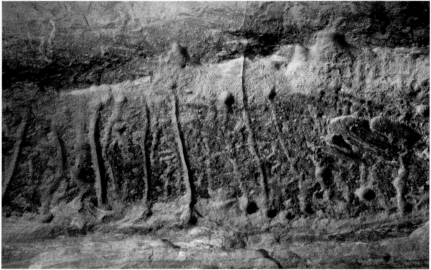

56 Western Archaic Tradition (top). *While tens of thousands of individual elements make up the engraved portion of this tradition, painted images comprise only a small fraction. Coconino Co.*

57 Western Archaic Tradition (left). *The psychobiological need to make art may help explain the ubiquity and homogeneity of rock art motifs worldwide. Yavapai Co.*

58 Western Archaic Tradition (right). *These heavily gouged grooves and cupmarks betray deep antiquity; without precise dating, however, a Paleoindian origin cannot be determined. Mohave Co.*

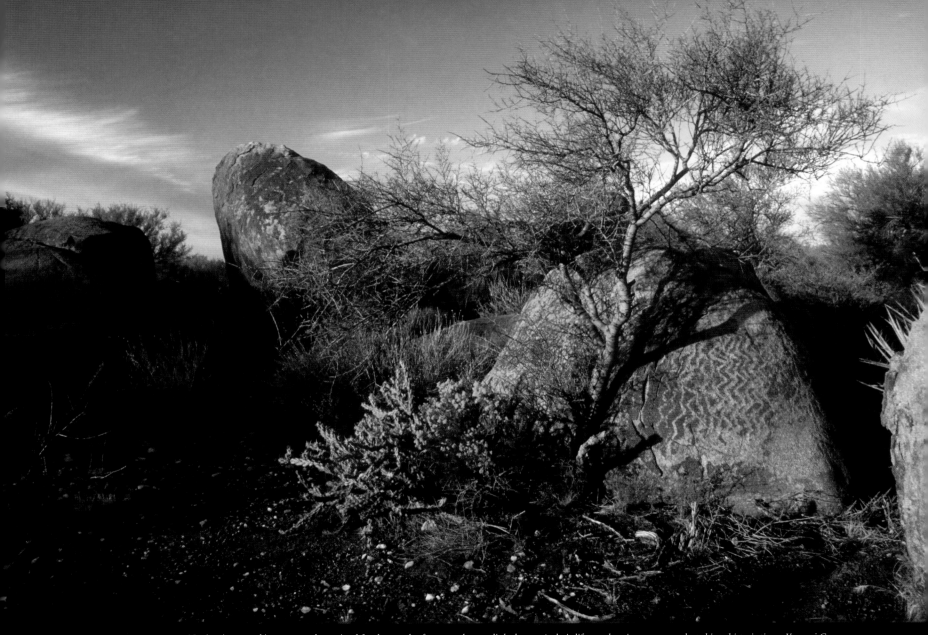

59 Western Archaic Tradition *Noniconic art-making apparently persisted for thousands of years and seems linked to an Archaic lifeway that, in some areas, lasted into historic times. Yavapai Co.*

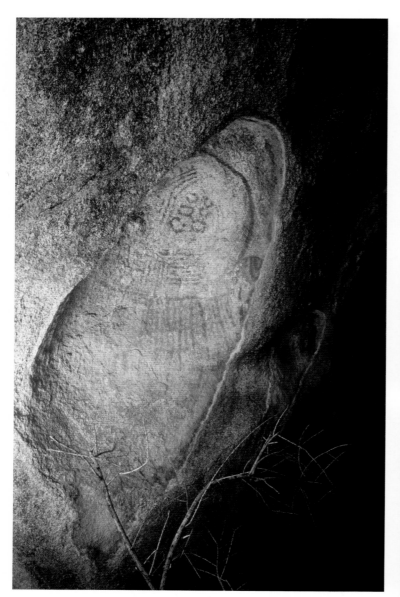

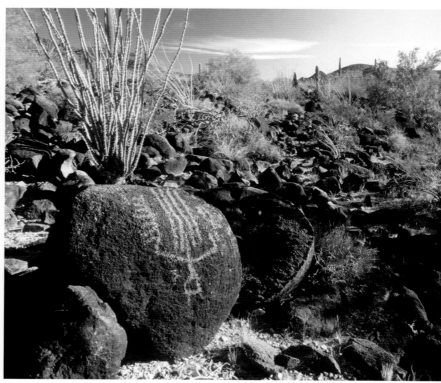

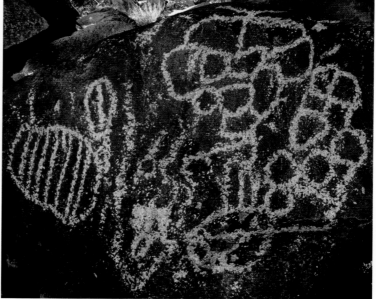

60 Western Archaic Tradition (above). *Art-making may be a universal human behavior as typical as language or tool-making. La Paz Co.*

61 Western Archaic Tradition (top right). *A horned anthropo-morph with a parallel-lined torso holding a rake. Pima Co.*

62 Western Archaic Tradition (bottom right). *The idea that certain noniconic designs symbolize traps for malevolent spirits or the souls of the deceased is intriguing but merely speculative. Pima Co.*

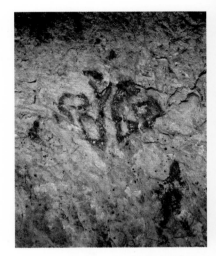

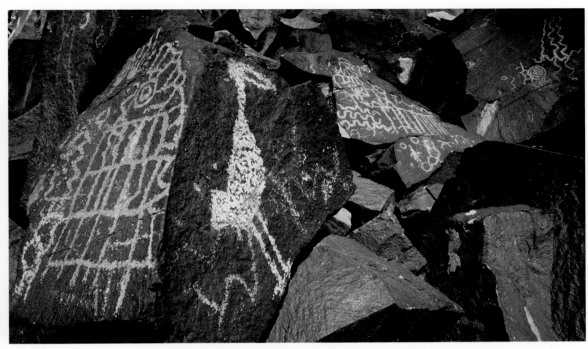

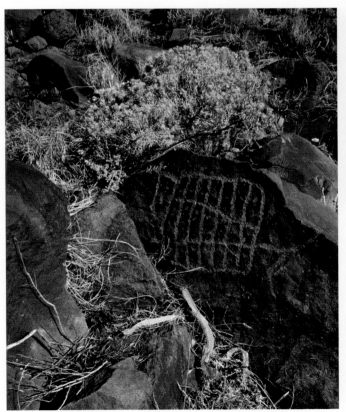

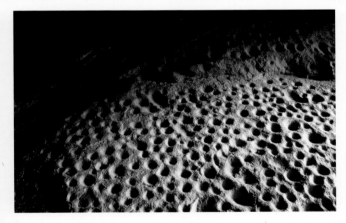

63 Western Archaic Tradition (top left). *Although crudely executed, this image nonetheless deserves our respect; to the artist the creative process may have been more important than the final result. Santa Cruz Co.*

64 Western Archaic Tradition (top right). *Rectilinear and curvilinear rock art is found throughout Arizona; the more recent waterbird is probably of Patayan origin. Maricopa Co.*

65 Western Archaic Tradition (bottom left). *Early hunter-gatherer artists may have preferred to create abstract depictions rather than concrete visual images because the latter were considered taboo. Yavapai Co.*

66 Western Archaic Tradition (bottom right). *Cupules, small hemispherical pits, are found world-wide and are thought to represent the earliest rock art. Gila Co.*

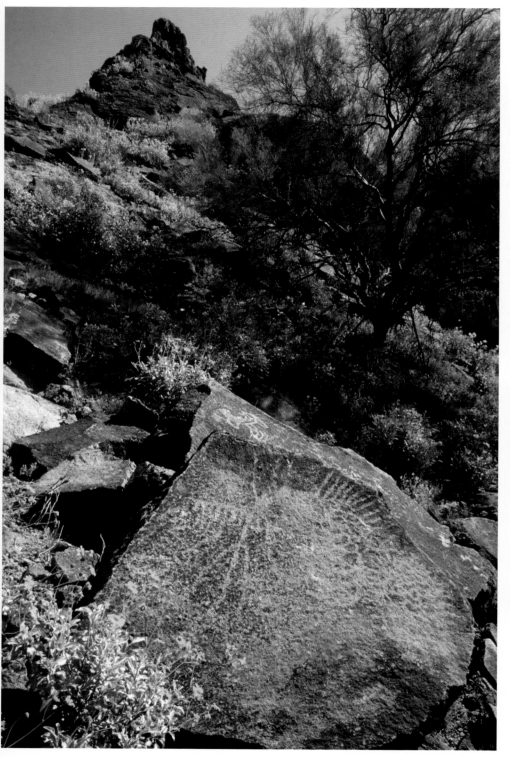

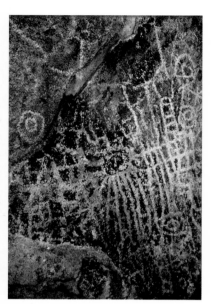

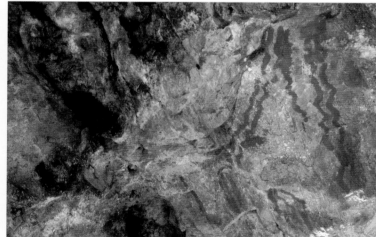

67 Western Archaic Tradition (left). *Many believe that all motifs created prior to iconic depictions come from phosphenic elements produced in the human brain. Pima Co.*

68 Western Archaic Tradition (top right). *These ancient elements were likely repecked by historic Piman groups; whether to ritually obliterate the art or renew its potency will never be known. Pinal Co.*

69 Western Archaic Tradition (bottom right). *These painted abstracts may reflect their makers' attempt to connect with the spirit world behind the rock face. Graham Co.*

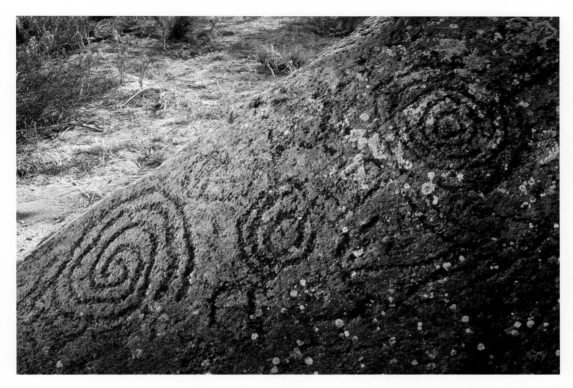

70 Western Archaic Tradition (left). *The expression of abstract-geometric art through time and space may have been a psychobiological necessity. Yavapai Co.*

71 Western Archaic Tradition (below). *The production of abstract-geometric forms may have been emotionally satisfying, providing feelings of mastery and security. Coconino Co.*

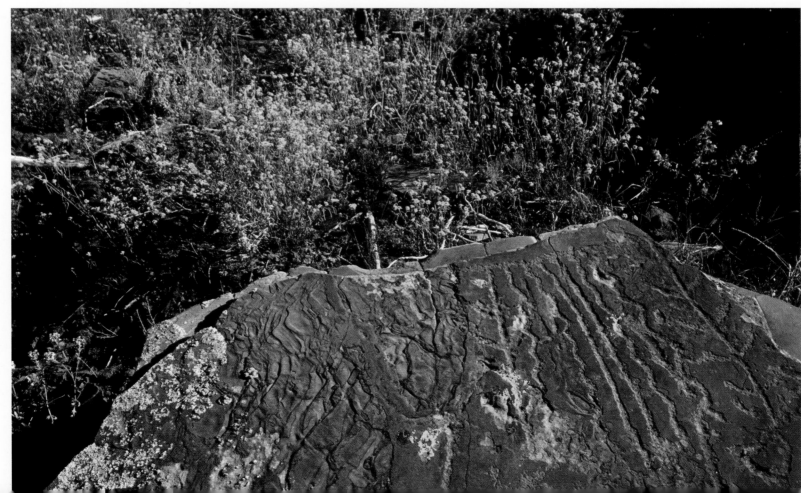

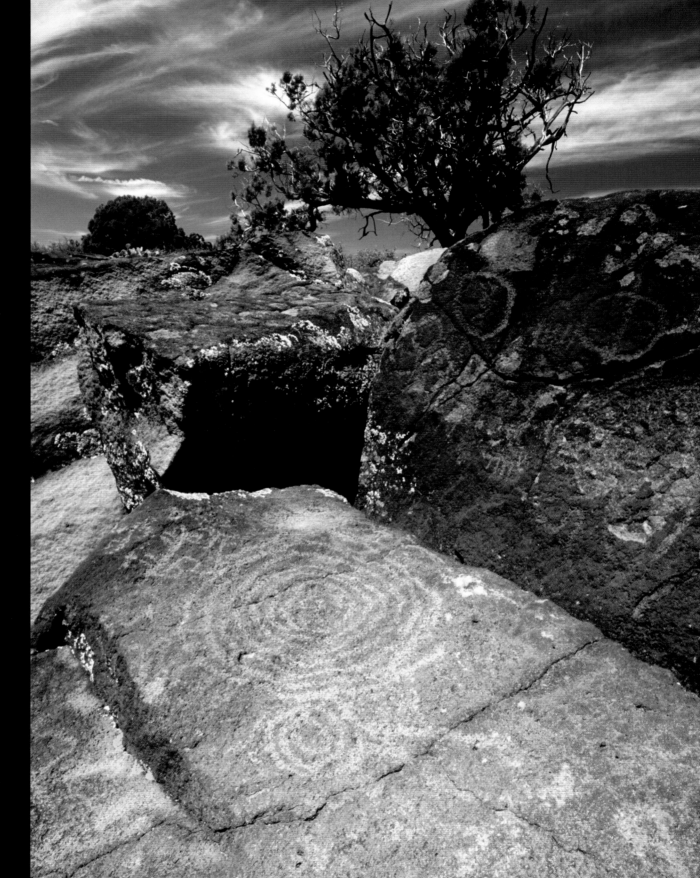

**72 Western Archaic
Tradition.** *The com-
mon idea that images
attract images is
demonstrated at this
site, where Archaic
hunter-gatherer art
(circles and parallel
lines at top) inspired
later agriculturalists
from the Central
Arizona Tradition to
add their own cre-
ations (concentric cir-
cles and animal fig-
ures). Gila Co.*

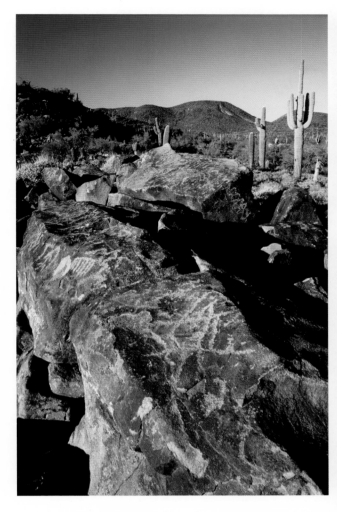

73 Western Archaic Tradition (above). *Some abstract geometrics appear as wild scrawls but may have served to humanize the landscape. Maricopa Co.*

74 Western Archaic Tradition (top right). *The human characteristic to communicate through symbols is shown here in the original Archaic abstract and the superimposed "lizard-man" by an O'odham artist. Pima Co.*

75 Western Archaic Tradition (bottom right). *Although extremely rare, representational face- or masklike designs do occur in Archaic rock art. Yavapai Co.*

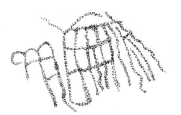

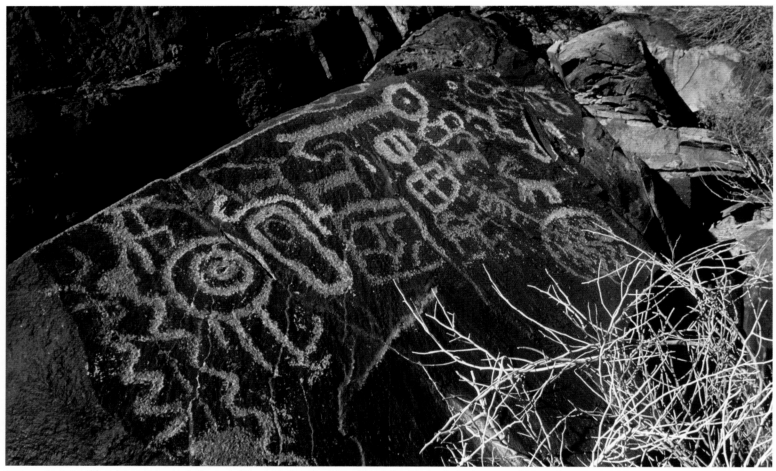

76 **Grapevine Style.** *Although in many ways similar to the Western Archaic Tradition, this style has its own distinctive aspects. Mohave Co.*

THE GRAPEVINE STYLE

Originally designated the Colorado River Style and only recently renamed (Christensen and Dickey 2001), the predominantly geocentric Grapevine Style has been identified along both sides of the Colorado River between Hoover Dam and Blythe, California. While its core area is said to center between the Mohave River Sink near Baker, California, and the Spring Mountains in southern Nevada, it also covers a substantial part of west-central Arizona. Here it ranges from its southernmost border along the Plomosa and Eagletail Mountains to its westernmost tip in the vicinity of Seligman, Ash Fork, and Picacho Butte, where a whole new suite of Grapevine sites has been discovered (Figure 3).

Based mainly on data collected by Don Christensen et al. in California and Nevada, the style is 95% nonrepresentational with designs predominantly symmetrical and geometric. Hallmarks of the style, which is dominated by petroglyphs, include rectilinear, oval, or oblong geomorphs reminiscent of ancient Egyptian cartouches. These bounded forms contain simple to elaborate internal patterns. Other abstract elements observed include wavy, zigzag or straight lines and

such figures as outlined crosses, rakes, ladders and spirals, as well as an array of circle motifs such as rayed and concentric circles. Also found are items shaped like capital letters I and T, double crenelations reminiscent of Hohokam "pipette" designs, and complex geometrics with ticks or fringes on the interior and/or exterior edges. Among the less frequent but distinctive icons are an "hourglass" figure, negative rectangular designs, and masklike motifs (Christensen and Dickey 2001:188-190).

The representational motif index of this style contains a few human stick figures and rare digitated anthropomorphs, that is, humanoids with exaggerated hands, fingers, feet, and toes. Zoomorphs, also often in stick-figure form, are predominantly ungulates, especially bighorn sheep. Ambiguous life-forms known as "lizard-men" may be interpreted as long-tailed lacertilian creatures or phallic anthropomorphs. Hand- and footprints are the other notable elements. The majority of Grapevine panels consist of randomly placed depictions; however, at some locations, such as the type site for this style, Grapevine Canyon in southern Nevada, hundreds of superimposed and juxtaposed elements are crowded onto a few conspicuous panels. Dense assemblages are also found at several of the newly discovered Grapevine sites in the Seligman area and may ultimately warrant a separate style designation. Pictographic images are rare and usually occur in red, black, white, and only occasionally polychrome.

Based on limited observations, the iconographic repertoire of the Grapevine Style in Arizona exhibits a number of differences from that

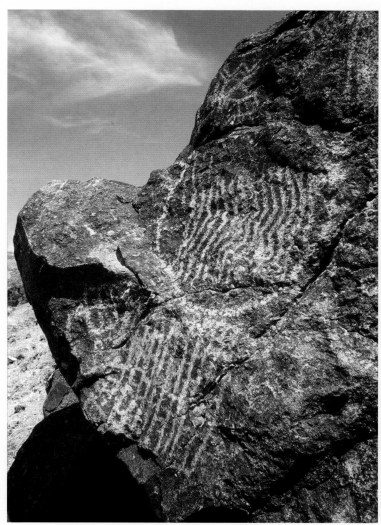

77 Grapevine Style. *Open and enclosed parallel-line motifs typical of this style. Mohave Co.*

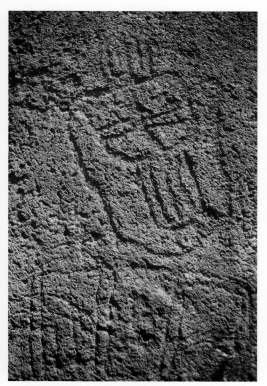

78 Grapevine Style. *A stylized masklike motif with apparent facial features. Yavapai Co.*

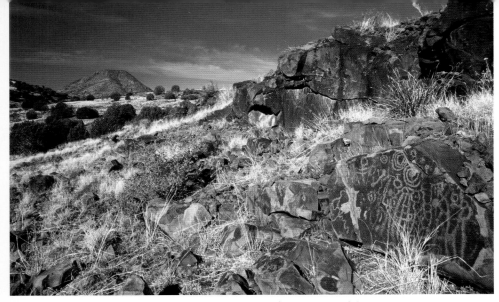

79 **Grapevine Style.** *Intricate engravings near Picacho Butte. Yavapai Co.*

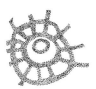

This consistent correlation between primarily abstract-geometric, phosphene-derived rock art and the hunter-gatherer lifeway suggests that this type of geocentric art was developed in response to a hunter-gatherer adaptation, and that it is universal in some respects for this adaptation. An obvious corollary to this observation can be seen in the fact that rock art styles are not universal for agricultural adaptations and therefore must be products of the diverse cultural and ritual institutions developed by agricultural societies (Wallace, personal communication 2005).

of California and Nevada. For example, no "hourglass" figures have been found in this state, and stylized "masklike" motifs are rare and portrayed in less realistic fashion. Overall, Arizona Grapevine sites also show a stronger affinity to the abstract art of the Western Archaic Geocentric Tradition. Differences of this nature should be expected, of course, in any designated style that is attested over such a large area.

As with other styles, the dating of Grapevine Style rock art is problematical. Based on diagnostic artifacts reportedly found at Grapevine Style sites in California and Nevada (and assuming these archaeological associations are valid age indicators), the Grapevine Style had its beginnings in the terminal stage of the Archeoiconic period (ca. 2000 B.C.) and continued into the ceramic periods (post-A.D. 700) until at least late prehistoric times (ca. A.D. 1500). Some of these diagnostic artifacts are Gypsum and Elk dart points (Late Archeoiconic period), Lower Colorado Buff Ware and Tizon Brown Ware ceramics (A.D. 700-1500), and Cottonwood Triangular arrow points in the late prehistoric period (Christensen and Dickey 2001:194). One must assume, therefore, that the Grapevine Style postdates in large part the end point for the Archeoiconic period in most of Arizona. It should be noted that in large areas of western Arizona, due to the absence of agriculture, the Archaic lifeway of hunting and gathering lasted far beyond the generally accepted cut-off point for the Archeoiconic period. This means that so-called "Archaic rock art" based on lifeway criteria was probably produced there as recently as the Proto- and Historioiconic periods.

As to the interpretation of the Grapevine Style, most of the hypotheses advanced to shed light on the Western Archaic Geocentric Tradition also apply here. As explained previously, the early geocentric pattern was replaced or intensively modified by the creators of later biocentric styles centered predominantly on humans and animals. This modified imagery is best exemplified by the lifeform oriented Glen Canyon Linear, Grand Canyon Polychrome, and Palavayu Anthropomorphic Styles, all temporally allocated to the middle and/or terminal Archeoiconic period.

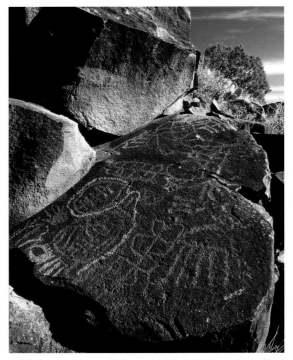

80 **Grapevine Style.** *An orderly array of abstract-geometrics and a possible handprint or bear paw. Yavapai Co.*

48
▼

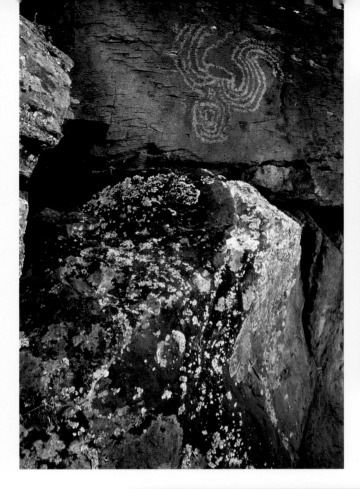

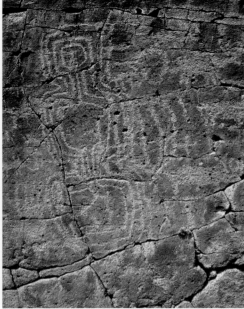

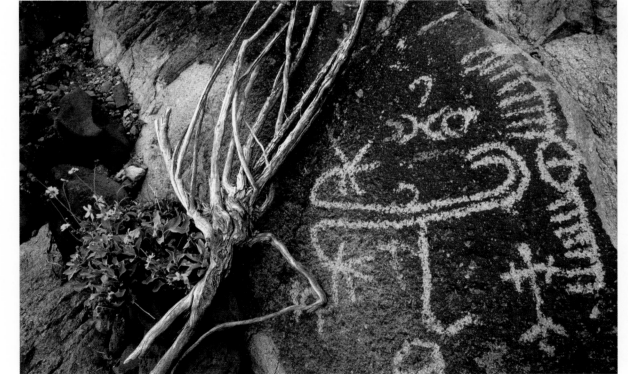

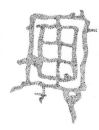

81 Grapevine Style (top left). *Multiple parallel lines are a prominent feature of the style. Yavapai Co.*

82 Grapevine Style (top middle). *A symmetrical crenelated arrangement with adjacent quadrupeds. Yavapai Co.*

83 Grapevine Style (top right). *Curvilinear and rectilinear configurations complementing each other. Yavapai Co.*

84 Grapevine Style (left). *Iconic and noniconic images reflecting a late expression of the style. Mohave Co.*

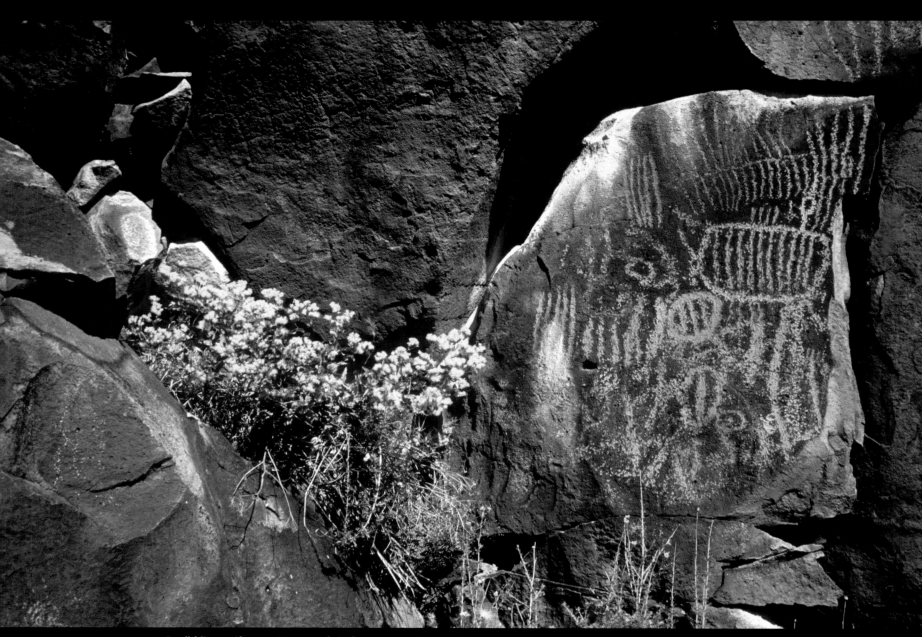

85 Grapevine Style. *Parallel-line motifs next to Western Archaic abstract-geometrics. Yavapai Co.*

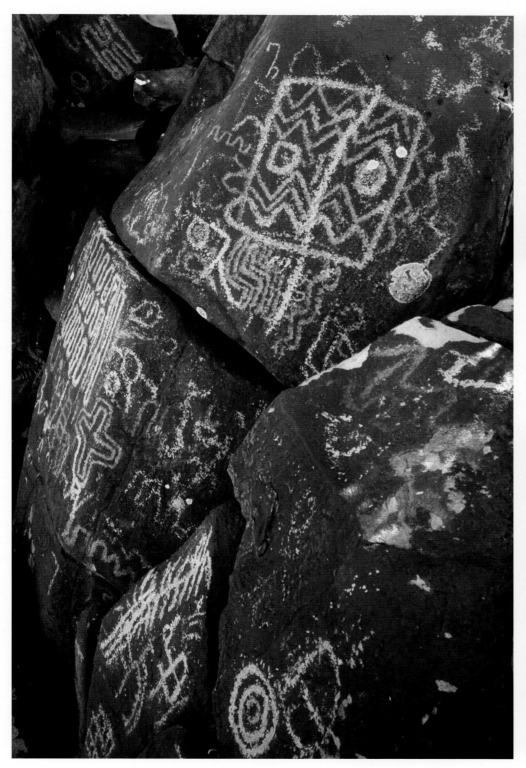

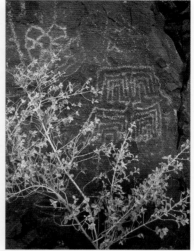

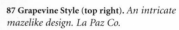

86 Grapevine Style (left). *A complex panel featuring a large masklike design and an outlined cross. Mohave Co.*

87 Grapevine Style (top right). *An intricate mazelike design. La Paz Co.*

51

88 Grapevine Style (bottom right). *An anthropomorph and other figurative elements characteristic of the late phase of this style. Mohave Co.*

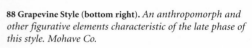

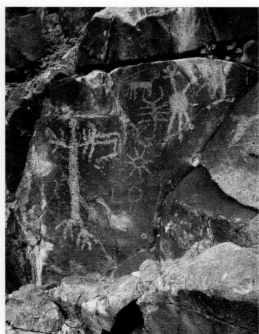

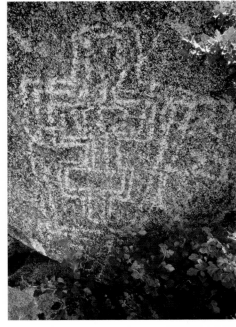

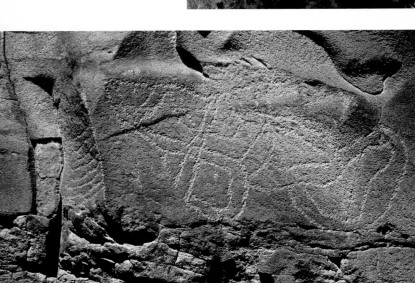

89 Grapevine Style (top left). *A motif suggesting a possible fusion of outlined crosses. Mohave Co.*

90 Grapevine Style (bottom left). *A complex curvilinear design next to a simple rake motif. Yavapai Co.*

91 Grapevine Style (right). *A classic cartouchelike design typical of this style. Mohave Co.*

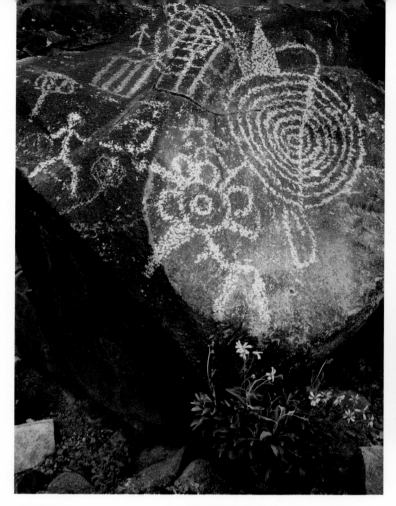

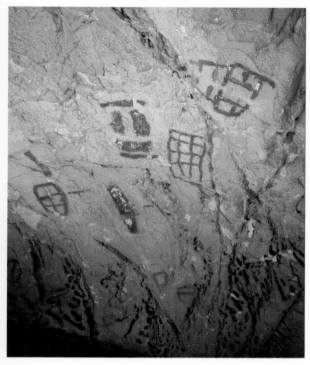

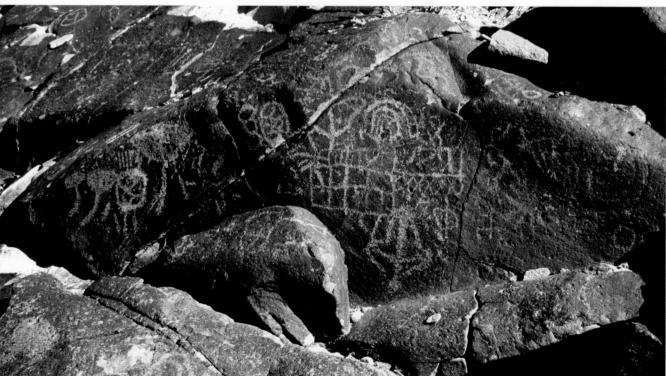

92 Grapevine Style (top left).
*Varying degrees of repatination
point to different periods of this
long-lasting style. Mohave Co.*

93 Grapevine Style (top right).
*Painted versions of this style are
extremely rare in Arizona.
Mohave Co.*

94 Grapevine Style (left). *A crowded
panel with multiple geometric
components. Mohave Co.*

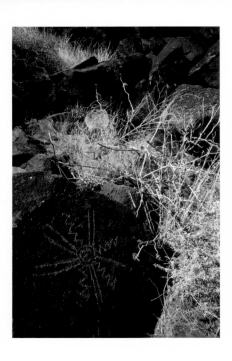

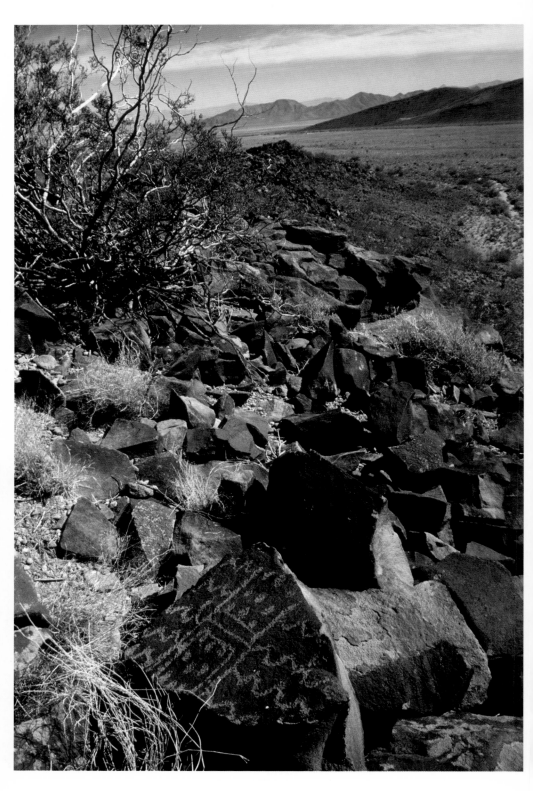

95 Grapevine Style (top left). *An unusual starlike design of atypical complexity. Mohave Co.*

54

96 Grapevine Style (bottom left). *A masklike motif possibly resembling an owl. Mohave Co.*

97 Grapevine Style (right). *A volcanic boulder covered with dot patterns and meanders north of Kingman. Mohave Co.*

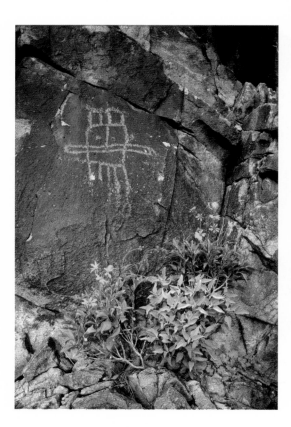

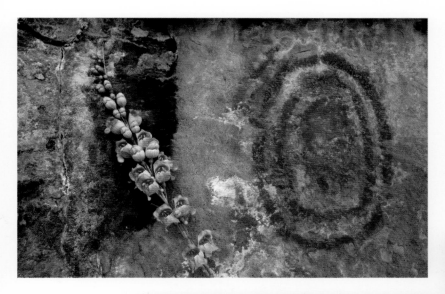

98 Grapevine Style (left). *A rare painted oval of concentric lines. Mohave Co.*

99 Grapevine Style (bottom left). *Sprawling elements showing superimposition and various degrees of modification. La Paz Co.*

100 Grapevine Style (bottom right). *An assemblage of densely packed cartouchelike elements and horned quadrupeds. Yavapai Co.*

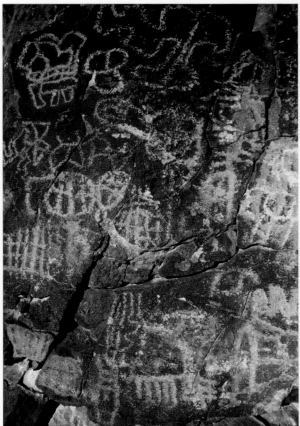

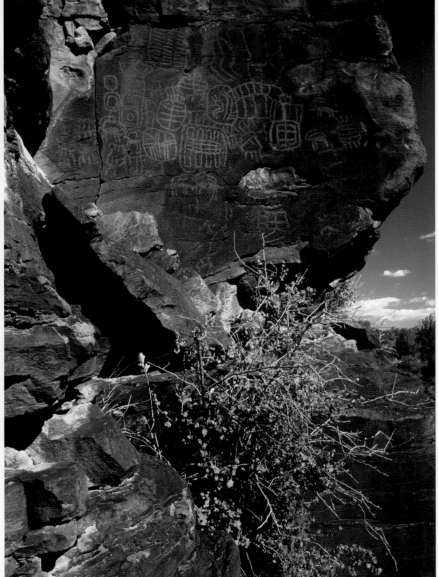

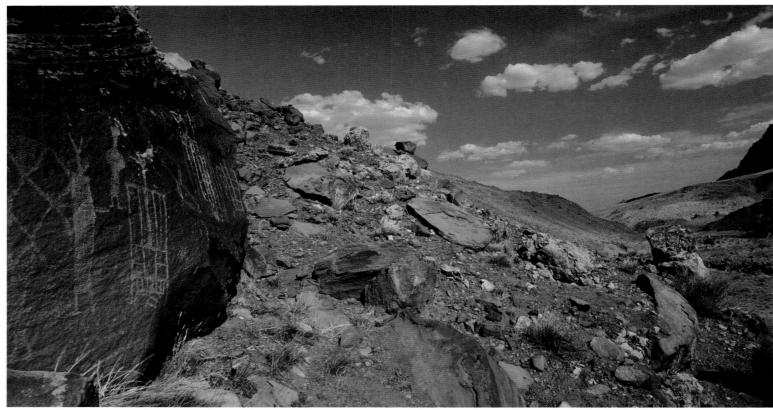

101 Glen Canyon Linear Style. *Archaic rock art with a clear preference for the depiction of human and animal life-forms is best characterized as "biocentric." Coconino Co.*

THE WESTERN ARCHAIC BIOCENTRIC STYLES

While it will never be known who produced the plethora of geometric designs that distinguishes Arizona's most ancient rock art stratum or what their function may have been, three sharply defined regional styles attributable to the later Archeoiconic period show a clear shift from noniconic elements to an emphasis on representational images. The styles which demonstrate this dramatic change, from the earliest geocentric iconography to a biocentric one dominated by figurative emblems of humans and animals, are the Glen Canyon Linear, Grand Canyon Polychrome, and Palavayu Anthropomorphic Styles (Figure 3).

It is probably safe to assume that this break with the established and long-lived noniconic imagery was the result of an equally far-reaching innovation in the lifeway and worldview of the cultural groups responsible for creating the art. While Turner's (1963:41) concept of "anthropomorphic deification" may summarize the functional essence of many of the humanoid images, they may also have been intended to portray shamans, supernatural spirit beings, deceased ancestors, or mythological personages. This marked cognitive shift from noniconic to iconic imagery may, in part, reflect the growing emergence of an anthropocentric thought world and cosmology anchored in a heightened emphasis on shamanism. While for thousands of years people generally may have been on their own and content to humanize the landscape with phosphene-inspired creations, new social circumstances and ideological conditions likely produced religious specialists with a novel view of themselves, their human

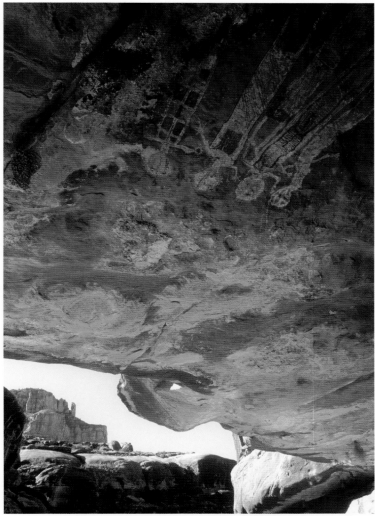

102 Grand Canyon Polychrome Style. *These spirit beings seemingly flying out from the ceiling of this rock shelter may represent an out-of-body experience of the shaman artist who painted them. Mohave Co.*

charges, values, environment, economic resources, and spiritual responsibilities. Noteworthy among the various explanatory scenarios for the rise of representational rock art styles in the Greater Southwest some 4,000 years ago is a rather plausible one advanced by Alan Schroedl. Based on research findings that climatic conditions of the region changed dramatically around that time, he suggests that this environmental shift affected the populations of large game animals and brought about a dwindling of food resources. This may

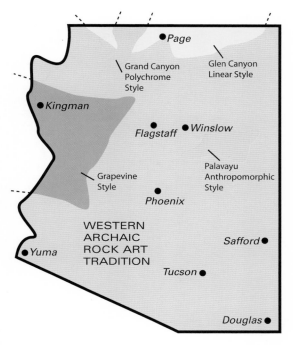

Figure 3. *Approximate areal distribution of Arizona's earliest rock art styles and traditions.*

thus have been the reason that during times of stress Archaic people "turned to religion and shamanistic activities to try to magically increase the number of plants and animals" (Schroedl 1989:14).

When trying to interpret the anthropocentric iconographies of the Glen Canyon Linear, Grand Canyon Polychrome, and Palavayu Anthropomorphic Styles, it is tempting for the modern viewer to succumb to literal explanations. As Sven Ouzman (1998a:30) has pointed out, it is necessary to go beyond the merely descriptive and observable and move towards an exploration that tries to fathom the nonmaterial, cognitive landscape of the art's creators. Because hunter-gatherer cognition is thought to have been strongly, but not exclusively, lodged in shamanic practices distinguished by ecstatic trance experiences, soul loss, and extracorporeal flight, it is assumed that ancient bands responsible for much of the imagery encountered in the three styles mentioned above were inspired by institu-

58
▼

103 Palavayu Anthropomorphic Style.
Two anthropomorphic figures—the upper hailing from the Archaic era, the other of more recent Puebloan origin—showing vastly different conceptualization. Navajo Co.

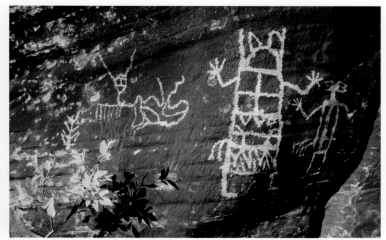

tionalized altered states of consciousness and/or vision quests. In this context, their iconography can be seen not as wall ornaments but as the product of shamanistically oriented ideologues who enculturated their environment according to their forager world-understanding.

When applied as an unconditional, monolithic explanation, however, the shamanistic origin hypothesis with its rigid three-tiered trance paradigm initially advocated by Lewis-Williams and Dowson (1988) does not fully account for the genesis of these three eminently iconic rock art styles from Arizona's Archaic past. Still, when applied as a heuristic strategy, this neuropsychological model, at least in its focus on the visionary aspects of rupestrian origin, provides for deeper and more meaningful insights than alternative theories into the otherwise enigmatic ingredients of these styles. Their shamanistically derived imagery thus represents an ancient pictorial record of the mindscapes of Arizona's ancient hunter-gatherer creators and their religious communication with the supernatural spirit world. Here too, the arts, as defined by Dissanayake for traditional societies, are in the service of ritual. "The arts, because they are different from the ordinary, attract attention to the substance and the importance of the event. Additionally, the arts create, shape, and sustain interest and emotion, making the ceremony memorable and meaningful" (Dissanayake 2006). Thus, *Homo aestheticus* is inextricably entwined with *Homo religiosus*, a concept introduced by Mircea Eliade (1959). Evidentiary clues for this proposition abound in the graphic symbolism and conventions of the styles.

Chief among these clues are the highly ornate anthropomorphic renditions and

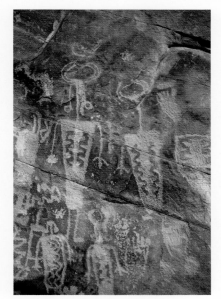

104 Grand Canyon Polychrome Style (top left). *The fact that this antlered deer is painted and not engraved places it into this polychrome category rather than into the Glen Canyon Linear Style. Mohave Co.*

105 Palavayu Anthropomorphic Style (top right). *The partially repecked figure on the left, when compared to the two Puebloan anthropomorphs to its right, is indicative of the great antiquity of this style. Navajo Co.*

106 Palavayu Anthropomorphic Style (left). *Snakelike motifs in negative technique decorate the torsos of these figures of the late "Majestic" expression of this biocentric style. Navajo Co.*

motifs reflecting skeletonization, distortion and elongation, solarization, micropsia, and piloerection, all of which may indicate visual, somatic, and tactile hallucinations portraying the trance-experienced pseudo-death of the religious specialist. Depictions of apparent out-of-body flight, transformation scenes, ancillary spirits, attendant figures, liminal animals, all attested in the imagery, combine to metaphorically convey the pivotal role of the shaman who, as guardian of his people, ultimately procures and ensures all life-sustaining necessities on behalf of his group. To this extent, the body of art of the three styles is a testimonial to one of the oldest religious ideologies in Arizona.

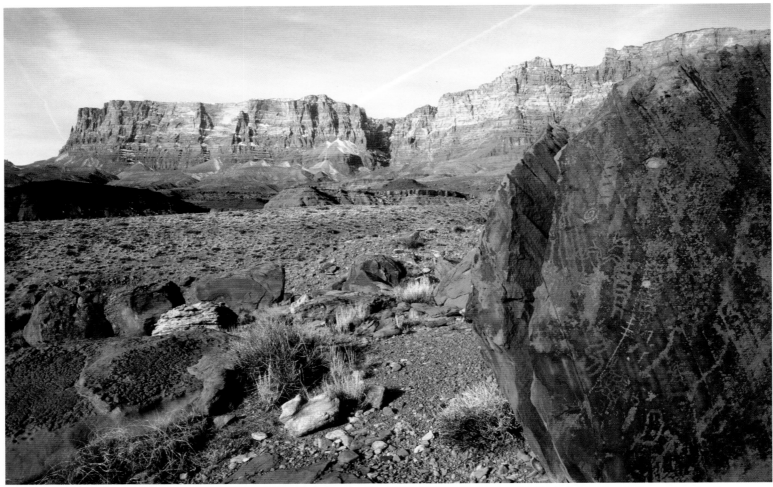

107 Glen Canyon Linear Style. *Heavily weathered and crudely pecked, these anthropomorphs and simple geometrics decorate a boulder in the Vermilion Cliffs area. Coconino Co.*

THE GLEN CANYON LINEAR STYLE

This style, whose type-sites are centered in the Glen Canyon region of southern Utah, consists exclusively of petroglyphs dispersed along the corridors of the Colorado, San Juan, Green, and Escalante Rivers in southeastern and eastern Utah. River drainages were prime areas where Archaic populations engaged in hunting and foraging, trade and ritual, and the exchange of ideas over time, which help explain certain stylistic similarities between this style and the Barrier Canyon Style of Utah and the Coso Style of eastern California (Cole 1990:63).

The Glen Canyon Linear Style also shows some affinities with the "Linear" phase of the Palavayu Anthropomorphic Style, in particular to grid-bodied anthropomorphs and ungulates, despite the epicenter of the latter style being 175 km (110 miles) to the southeast, in Arizona. Some characteristic glyphs also occur in the northwestern corner of New Mexico, and along the Dolores River in west-central Colorado. In Arizona, only about thirty Glen Canyon Linear sites are known along the extreme northern edge of the state, in an area of

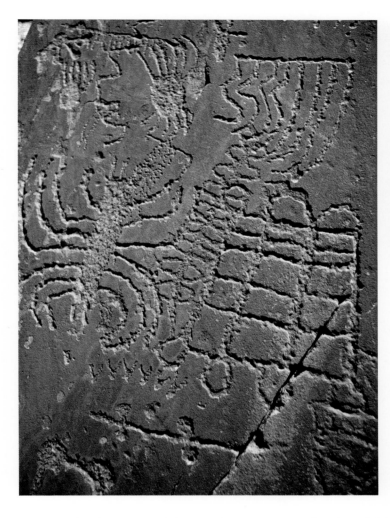

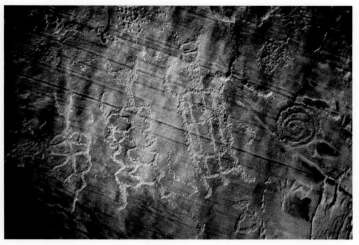

108 **Glen Canyon Linear Style (left).** *Fanciful spider- and scorpionlike designs are part of this intriguing boulder surface in Paria Canyon. Coconino Co.*

109 **Glen Canyon Linear Style (right).** *While the rectangular-bodied anthropomorph is clearly marked as male, it is unknown whether the curvilinear contours of the two figures to its right symbolize female gender. Coconino Co.*

15,000 sq. km (5,800 sq. mi) (Figure 3). Systematic exploration of the region, if ever undertaken, will undoubtedly reveal additional sites.

The style is essentially biocentric, that is, life-form oriented with human and animal elements. Static anthropomorphic figures are a hallmark of the style, with rectangular and ovoid torsos in outline form, decorated with crossbars, hachures, grids and other interior markings, though solid and stippled bodies also occur. These figures range from small (20 to 30 cm or about 8-12 in.) to nearly life size (155 cm or up to 60 in.), and are typically endowed with disproportionately tiny heads, sporting horns or other fanciful projections. Facial features are rare, except for dot eyes. More often than not, extremities are nonexistent or appended in stick fashion.

Disembodied heads, which may be illustrations of trophies, are known from at least five locations in Utah, but thus far are unattested in the Arizona segment of the style. Overall, the humanlike portrayals, with their often masklike faces, stiff, ornate bodies, and occasional nondescript accessories, exude an otherworldly and supernatural aura.

Quadrupeds, such as bighorn sheep, deer, or elk, have oval and rectangular bodies with tiny heads and stick legs similar to the humanlike figures. While sometimes undecorated or solidly pecked, the majority are stippled, filled with horizontal or vertical hatching, or gridded. Additional iconic depictions include snakes with bulbous heads, insects resembling scorpions, spiders and centipedes, and at least one birdlike creature reminiscent of an owl. Animal tracks and plantlike elements are also found.

In addition to these human and animal elements, nonfigurative motifs evoking the abstract vocabulary of the Western Archaic Geocentric Tradition occur. These include grids and dot patterns; connected, wavy, and ticked lines; rakes and rayed circles; and ladders, spirals, and sunbursts. Also characteristic is the so-called squiggle maze,

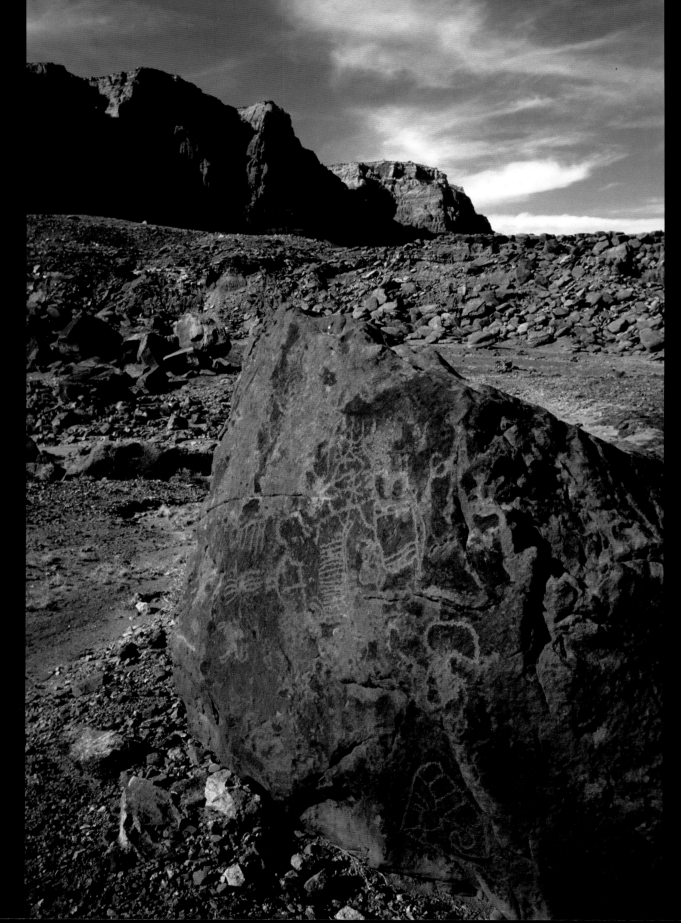

62
▼

110 Glen Canyon Linear Style. *An owl-like creature with eyes executed in negative technique dominates this panel with abstract geometrics. Coconino Co.*

an interlocking network of curved and straight lines wandering over the cliff face (Turner 1963:7).

Dating of the Glen Canyon Linear Style is controversial, with assigned dates ranging from as early as 6000 B.C. (Turner 1971) to as late as A.D. 500 (Cole 1990:62). Although almost total repatination of many motifs and the resemblance of quadruped motifs to split-twig figurines radiocarbon-dated to 2150 B.C. (Schroedl 1977:255) indicate images possibly several thousand years old, survival of the style into Basketmaker II times of the late Mesoiconic era cannot be entirely ruled out.

Of the three styles, Glen Canyon Linear, as seen in Arizona, offers the least diverse repertoire of motifs, and the anthropomorphic and zoomorphic depictions convey a much less pronounced impression of "otherworldliness" than Palavayu Anthropomorphic and Grand Canyon Polychrome. Nevertheless, most of the anthropomorphs sport hornlike excrescences from their heads, thought nearly universally to be symbols of regeneration and insignias of shamanic power as well as of spiritual and sexual potency. In addition, the frequently gridded torsos of the figures, reminiscent of skeletonization, may allude to the shaman's death and resurrection. More than in the Palavayu Anthropomorphic and Grand Canyon Polychrome Styles, Glen Canyon Linear life-forms are accompanied by noniconic, abstract-geometric elements whose functions, while unknowable, may have been manifold.

Interestingly, Christy Turner (1963:29) who investigated, both in Utah and Arizona, many Glen Canyon Linear sites before they were inundated by the rising Colorado River waters behind Glen Canyon Dam, expressed the opinion that "many of the Glen Canyon region petroglyphs which defy interpretation of subject matter may represent a form of 'art for art's sake.'" In this vein, he likened "the meaningless jumble of lines wandering over a rock, or up and down a cliff," to modern abstract art. As he put it, "one knows that a painting is good and meaningful in itself and need not represent anything other than itself." Polly Schaafsma (1980:74), too, compared the style's elements to modern fine art when she stated that "many of the representational forms appear to the modern viewer to be fanciful in their interpretation, rendered with a light, imaginative touch reminiscent of Paul Klee." Understandably, views such as these reflected thinking about rock art at the time, but may need to be reevaluated in light of the assessment of traditional arts by Dissanayake and other evolutionary psychologists.

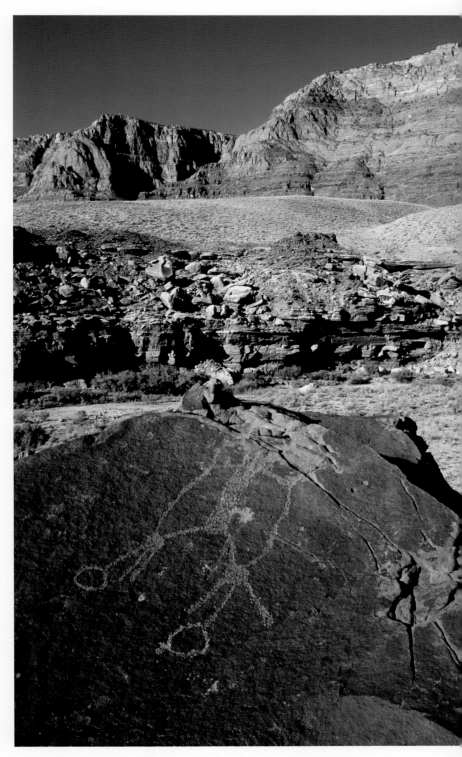

111 Glen Canyon Linear Style. *While the configuration of this image is obviously deliberate, the intention behind it will forever elude us. Coconino Co.*

112 Glen Canyon Linear Style (top left). *The blue-black varnish of these two anthropic glyphs completely matches that of the host rock. Coconino Co.*

113 Glen Canyon Linear Style (top middle). *Grid-bodied anthropomorphs flanked by a row of solidly pecked mountain sheep and indeterminate abstracts. Coconino Co.*

114 Glen Canyon Linear Style (top right). *A solidly pecked zoomorph and an anthropomorph with headgear ending in bulbous knobs. Coconino Co.*

115 Glen Canyon Linear Style (below). *Rectangular-bodied anthropomorphs with interior gridding or hatching are typical of this style. Coconino Co.*

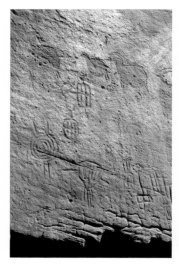
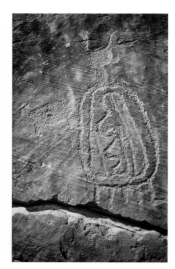

64

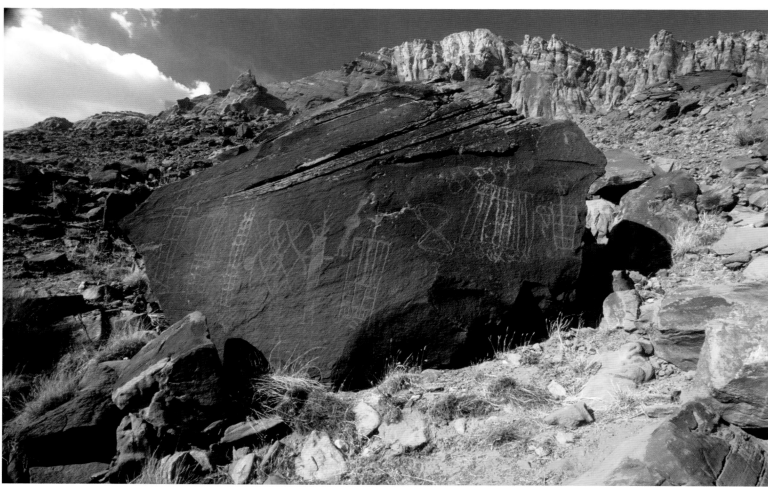

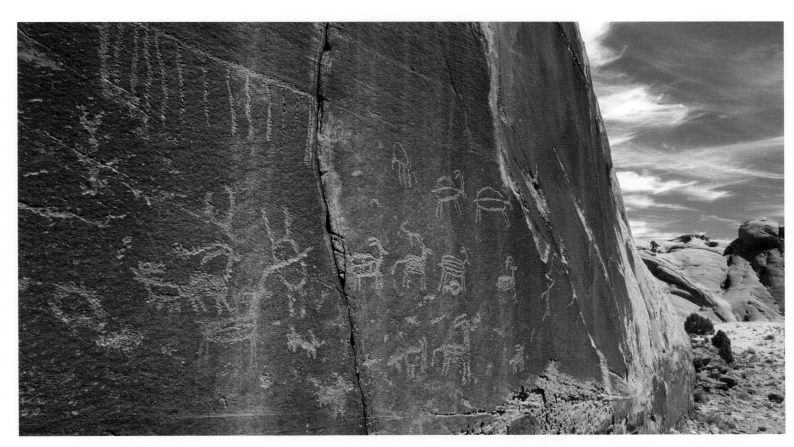

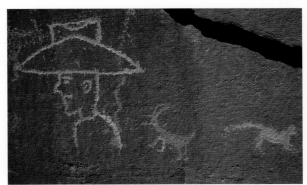

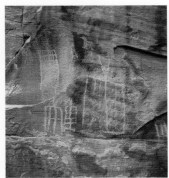

116 Glen Canyon Linear Style (top). *The frequent depiction of zoomorphs, primarily bighorn sheep and deer, is one reason for classifying this style as biocentric. Coconino Co.*

117 Glen Canyon Linear Style (middle left). *Three rock art styles are evident in this panel: Glen Canyon Linear (stippled mountain sheep), Ancestral Puebloan (pronghorn), and Navajo (cowboy and catlike creature). Coconino Co.*

118 Glen Canyon Linear Style (middle right). *These horned, limbless figures in rectangular outline clearly exude an otherworldly reality. Coconino Co.*

119 Glen Canyon Linear Style (bottom). *Lifeforms featuring representational as well as phantasmagorical aspects decorate this cliff wall. Coconino Co.*

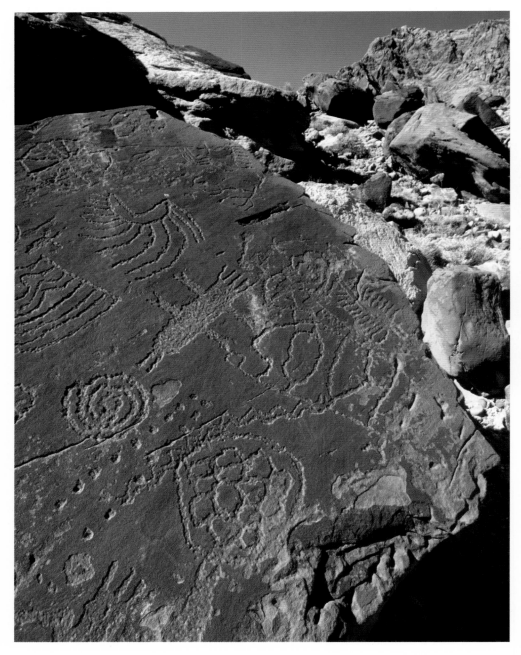

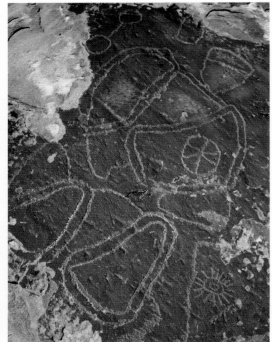

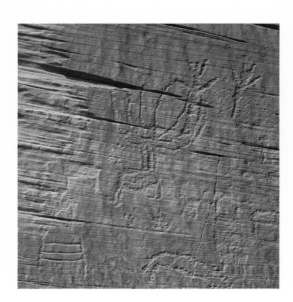

120 Glen Canyon Linear Style (above). *This unique assortment of variegated abstracts and insectile biomorphs may be the work of a single artist. Coconino Co.*

121 Glen Canyon Linear Style (top right). *Large curvilinear images next to more figurative motifs such as a sunburst, a spoked circle, and a "dumbbell." Coconino Co.*

122 Glen Canyon Linear Style (bottom right). *Two tiny figures with upraised arms hover to the right of this deer's exaggerated antler rack. Coconino Co.*

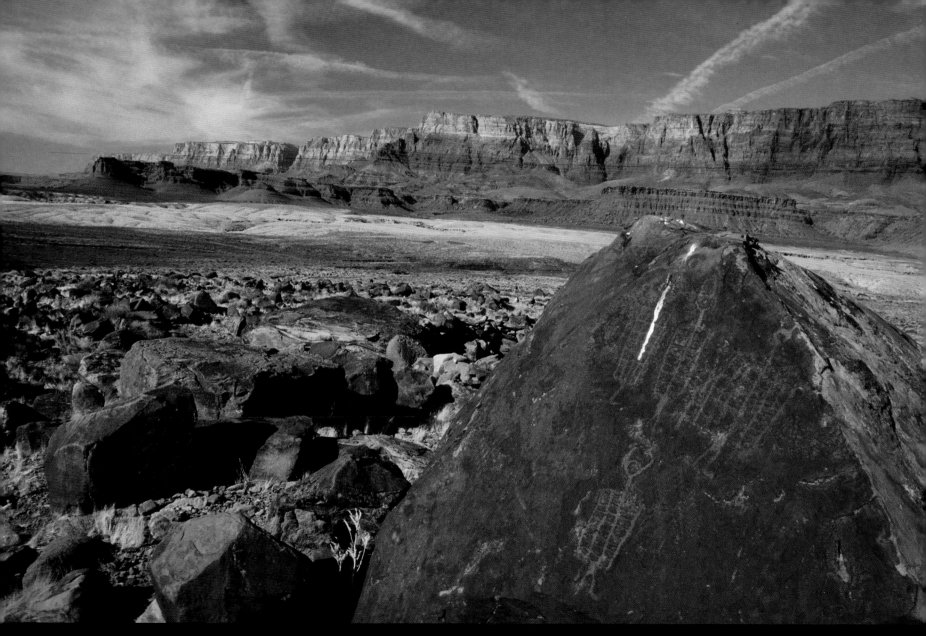

123 Glen Canyon Linear Style. *The unusually small heads of these anthropomorphs are topped by hornlike extremities producing a "rabbit-ear" effect. Coconino Co.,*

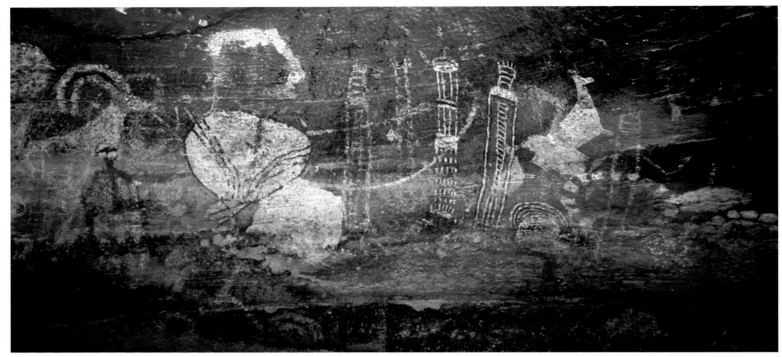

124 Grand Canyon Polychrome Style. *The biocentric nature of this Archaic style is overwhelmingly focused on shamanic themes, as indicated by these elongated anthropomorphic figures. Coconino Co.*

THE GRAND CANYON POLYCHROME STYLE

The Grand Canyon Polychrome Style is the only painted biocentric art complex in Arizona hailing from the Archeoiconic period. First discovered by Mary Allen in the early 1980s (Allen 1991), its main concentration is confined to an extremely small region on and immediately adjacent to the Esplanade below the North Rim of the Grand Canyon. The use of the term "polychrome" in the style name does not imply that all elements are multicolored; rather it suggests that polychromatic motifs are its most intriguing aspect and that sites as a whole typically exhibit more than one color. Overall, however, approximately 80% of the style's individual elements are monochromatic, with the rest being polychrome. For this reason, Christensen and Dickey (2004) are advocating replacing the established style name with "Esplanade Style." It remains to be seen whether this name change is appropriate considering that motifs reminiscent of the style have been found north of the Grand Canyon

on both sides of the Arizona-Utah border (Figure 3).

Consisting exclusively of painted images, the iconography of the style is easily recognized by a mixture of stylized, immobile anthropomorphs, comparatively realistic zoomorphs, and linear geometric designs. While the style exhibits a marked emphasis on complex, highly detailed motifs, its signature elements are over-elongated, finely decorated anthropoid figures, such as those contained in the well-known "Shamans' Gallery" of the Grand Canyon, generally recognized as the style's declared type-site (Schaafsma 1990).

Anthropomorphic figures, often arranged in rows or groups of three or more, make up about a quarter of the total element inventory and vary in size from approximately 12 cm to 1.8 m (5 in. to 6 ft.). Usually depicted in upright frontal view and rarely prone or upside down, their elongated torsos are embellished with internal markings consisting of parallel lines, wavy lines, dots or discs, solid squares or rectangles, or

combinations of forms. Many figures are extremely attenuated with large round heads, giving an overall lollipop appearance (Christensen and Dickey 2004:73). Facial features are quite rare and fingers, feet and toes are infrequently depicted. Attached or held accouterments, such as weapons or tools, are seldom seen and are limited to a few possible atlatls, plants, and cords. In addition to the exquisitely painted anthropomorphs, there are several other recurring motifs: humanlike stick figures, bighorn sheep and deer, a few doglike zoomorphs, and geometric configurations such as lines, circles, rakes, rayed disks, and abstract white dot patterns, often painted deliberately in or around cavities.

The colors seen are usually white for monochrome images and red and white or cream for polychrome figures, though other colors, such as black, maroon, tan, orange and shades of green and yellow are sometimes employed. Obvious compositions reminiscent of narratives or suggestive of unified themes are infrequent in this style; nevertheless, some amazingly complex examples can be found. By and large, sites were placed in secluded, out-of-the-way rock shelters, usually protected by low overhangs, suggesting that their creators did not intend the imagery to be generally accessible.

Sites of the Grand Canyon Polychrome Style, like many others, have never been dated by reliable scientific techniques. However, the art can be placed in the late Archeoiconic period (3000–1000 B.C.) on the basis of stylistic similarities to other probable and/or provisionally dated early styles and traditions, such as the Barrier Canyon Style in Utah and the Pecos River Rock Art Tradition in Texas (Allen 1994:102-104).

The bizarre figures and shapes of the Grand Canyon Polychrome Style, often marked by dense crowding and/or multiple superimpositions, transmit a sense of hallucinatory dream or vision imagery unparalleled by any other rupestrian manifestation in Arizona. Close resemblances, however, have been noted with the equally surrealistic and polychromatic Lower Pecos River art in Texas (Allen 1994:99), which may be indicative of a pan-Archaic painted tradition encountered throughout the Greater Southwest.

125 **Grand Canyon Polychrome Style (left).** *Highly stylized, surreal anthropomorphs and realistically portrayed zoomorphs characterize this style. Mohave Co.*

126 **Grand Canyon Polychrome Style (right).** *Visionary, dreamlike iconography is the hallmark of this exclusively painted style. Coconino Co.*

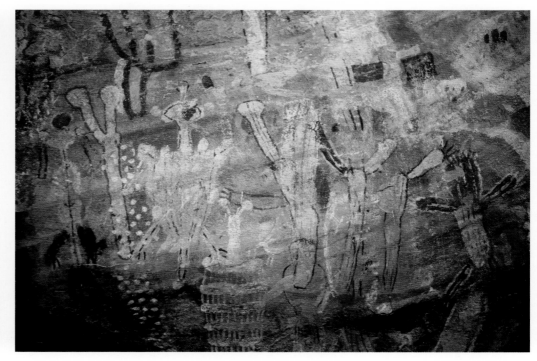

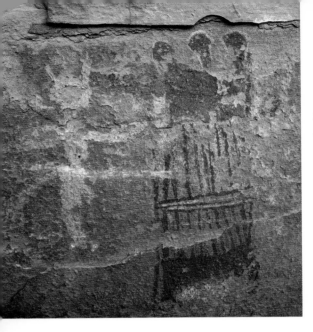

There is general agreement among the investigators of Grand Canyon Polychrome sites that much of the esoteric imagery bears all the hallmarks of shamanistic visions generated by the human nervous system in altered states of consciousness (ASC). The premier technician of such altered states is the shaman who, in his role as "broker" or "boundary player" (Bean and Vane 1978:127) between the domains of the sacred and profane, transports himself intentionally into the realm of the spirit world by means of extracorporeal flight. To achieve this end, he may resort to a wide range of techniques: exposure to the elements; sensory deprivation brought on by physical exhaustion, sleeplessness, prolonged solitude, or thirsting and fasting; rhythmic and sonic driving such as drumming or dancing; hyperventilation, intense concentration, sexual abstinence, and pain; and self-mutilation and self-torture such as bloodletting. In addition to these nonchemical means of achieving ASC, the shaman, equipped with extensive psychopharmacological knowledge, can induce powerful botanical hallucinations through the use of psychoactive plants.

Schaafsma (1990:230), in her analysis of the paintings at the "Shamans' Gallery," sees pictorial evidence for their shamanic origins in "birds, snakes, skeletal and X-ray motifs, horned and other elaborate headgear." Additionally, there is an array of other diagnostic features suggesting trance genesis, such as humanoid shapes of

Lilliputian dimensions, figures with extremely elongated torsos often lacking necks or shoulders, embellished by interior designs and occasionally equipped with multiple heads. Inverted figures also occur, as do therianthropic composites of human and animal parts. The round or bulbous heads of the predominantly static anthropomorphs are sometimes surrounded by dotted halos, and from their feet may emanate radiating lines "as though to illustrate power or sound" (Allen 1994:100). Several motifs seem to allude to the shaman's shape-shifting abilities. One of them, characterized by Allen (1994:102) as "the ultimate shamanic transformation," has, according to her, "not only panther-like traits but also two sets of wings, and an exposed set of skeleton-like rib bones, thus illustrating several shamanic transformation qualities in one body." This style's anthropomorphic assemblage is rounded out by a much smaller percentage of zoomorphs, the majority of which are hoofed animals such as deer (Christensen and Dickey 2004:76). Since none of them are depicted in hunting contexts, one can assume that they represent ancillary spirits or shamanic companion animals. The same probably holds for the numerous birds, possible snakes, and the few canines, felines, and insects that are part of the bestiary.

The combined effect on the modern viewer of this graphic melange of anthropomorphic and zoomorphic motifs, intermingled with a variety of abstract line and dot configurations, is that of a psychologically "alienating" meta-reality populated by spirit-, ghoul-, or demonlike beings. This impression is reinforced by the fact that many

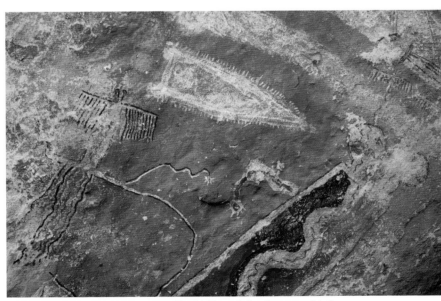

127 Grand Canyon Polychrome Style (top). *Two highly eroded anthropomorphic figures reflecting the otherworldly nature of the style. Mohave Co.*

128 Grand Canyon Polychrome Style (bottom). *A birdlike motif, suggestive of shamanic transformation, and other psychologically alienating images. Mohave Co.*

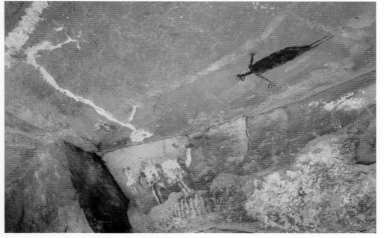

129 Grand Canyon Polychrome Style (left). *Repeated overpainting distinguishes this surrealistic melange of anthropomorphs and zoomorphs. Mohave Co.*

130 Grand Canyon Polychrome Style (right). *Possibly the depiction of a trancing shaman voyaging to the spirit realm. Mohave Co.*

1994:282). Hence, shaman-artists, endowed with extraordinary power, were believed to be capable not only of coaxing the creatures and spirits of this otherworld through the rock (Clottes and Lewis-Williams 1998:33), but also of themselves crossing the liminal space of this permeable divide and interacting with supernaturals in the sacred realm.

In their functional analysis of the Grand Canyon Polychrome Style, Dickey and Christensen (2004:95) confirm the interpretive consensus that this iconography was essentially "associated with attempts to evoke supernatural power through altered states of consciousness," with several of the panels portraying "figures interacting with each other as if to suggest ritual, mythic, or ceremonial scenes." Postulating that the style was created over a relatively short time span, they hypothesize that the art was "connected to ceremonial rituals performed during the period of spring aggregation keyed by agave harvests." While they concede that it will never be known whether the paintings "were related specifically to agave or were merely associated with the gathering of kin groups initiated by the agave harvest" (2004:93), they have no doubt that this paleoart complex was shamanistically inspired and anchored in a concern with mythology and the spirit world.

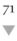

of the anthropomorphs seem to be rising up from holes, cracks, and other imperfections in the shelter walls or flying out from inside the cave ceilings on which they occur. Observations of this kind, subjective though they may be, confirm the idea that to shamans the rock surface may have been not just a neutral, meaningless canvas functioning solely as support for the art, but rather a kind of "veil" or membranous interface behind which lay the supernatural world (Lewis-Williams

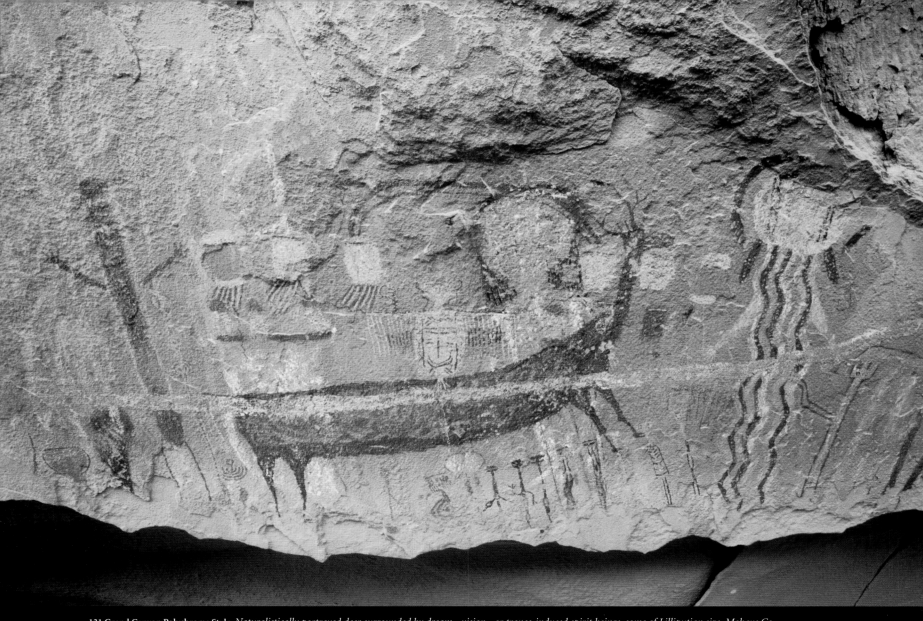

131 Grand Canyon Polychrome Style. *Naturalistically portrayed deer surrounded by dream-, vision-, or trance-induced spirit beings, some of Lilliputian size. Mohave Co.*

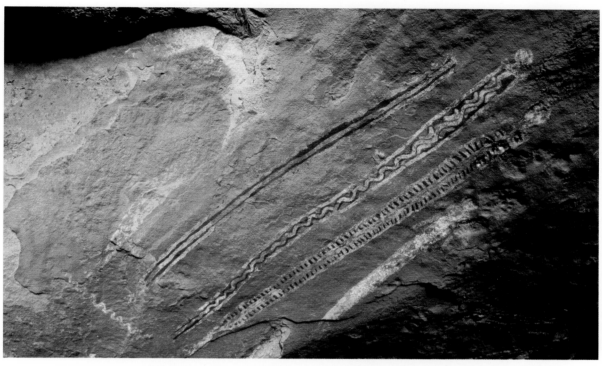

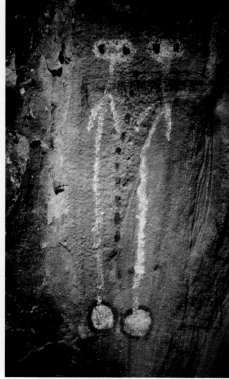

132 Grand Canyon Polychrome Style (top). *The sensation of physical attenuation, a common somatic hallucination, is captured in the overlong torsos of these multicolored figures. Mohave Co.*

133 Grand Canyon Polychrome Style (bottom left). *Bizarre phantasmomorphs conveying nonordinary reality. Coconino Co.*

134 Grand Canyon Polychrome Style (bottom right). *Twinned spirit figures in red and white, two of the dominant colors of this polychromatic style. Coconino Co.*

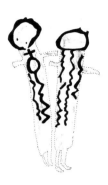

135 Grand Canyon Polychrome Style (top left). *Animal familiars in the role of spirit helpers or psychopomps are a universal motif in shamanistic art. Mohave Co.*

136 Grand Canyon Polychrome Style (top right). *A shamanistic interpretation is the most useful approach to illuminating this fantastical imagery. Mohave Co.*

137 Grand Canyon Polychrome Style (bottom). *An exceptional scene suggesting an everyday activity. Mohave Co.*

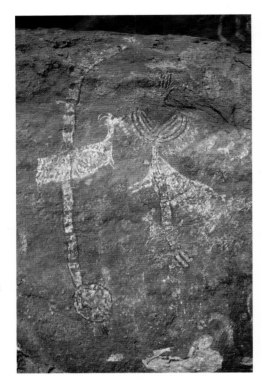

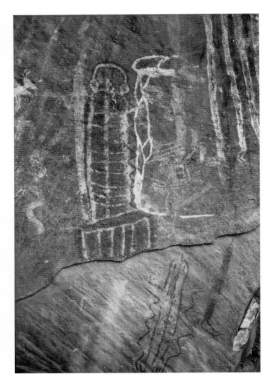

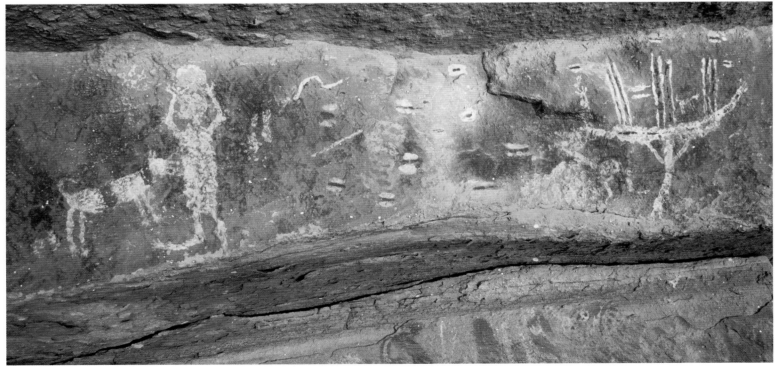

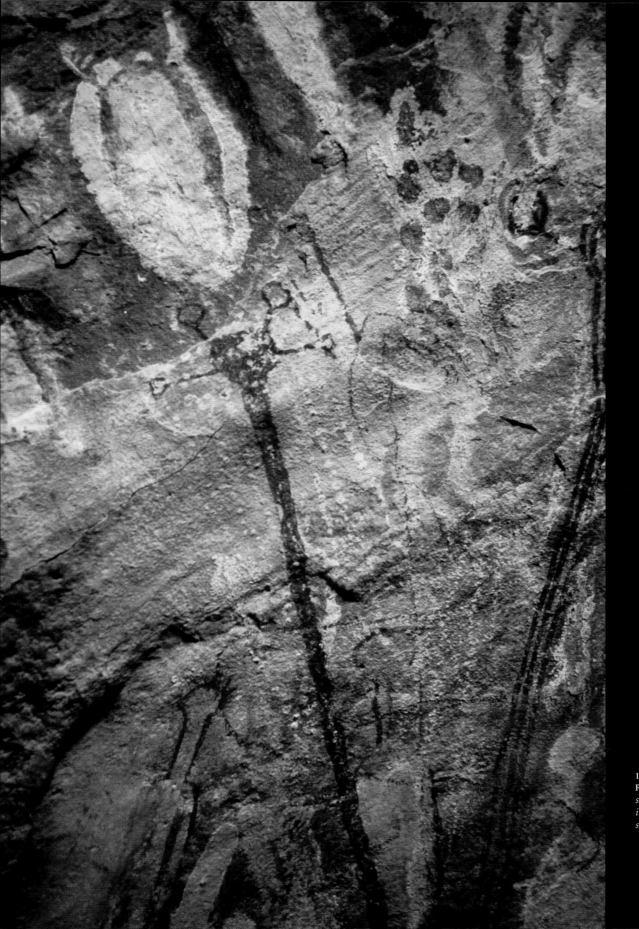

138 Grand Canyon
Polychrome Style. *Multiple
superimposition manifest-
ing the mental imagery of
shamanic art. Coconino Co.*

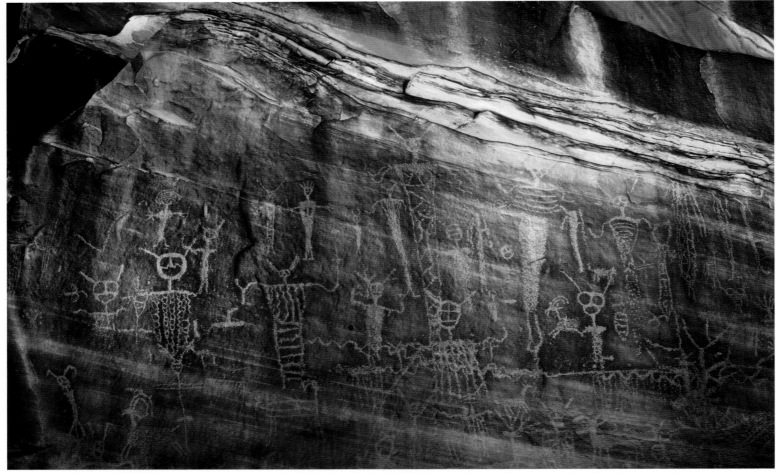

139 Palavayu Anthropomorphic Style. *The preference for biocentric motifs is impressively illustrated by the surreal, vision-related iconography at the style's type site. Navajo Co.*

THE PALAVAYU ANTHROPOMORPHIC STYLE

The Palavayu Anthropomorphic Style has been analyzed and interpreted in more detail than any other biocentric style of the Archeoiconic period in the American Southwest. The word *Palavayu* refers to the traditional Hopi term for the Little Colorado River, and literally means "Red River." The central drainage of this river, with its tributaries and canyons, forms the core of this unique rock art area.

The style is called "anthropomorphic" because some 2,200 such images have been identified at over 250 sites located within the 4,000 sq. km (1500 sq. mi) geographic boundaries of the style (Figure 3), a greater anthropic headcount than for any of the other representational styles of the Western Archaic Rock Art Tradition. Although the style is named for its concentration of anthropomorphic motifs, nonanthropomorphic elements also occur, including zoomorphs, phytomorphs, and phantasmomorphs, as well as geomorphs and reomorphs.

The style is unique in its area, as none of the immediate culture areas surrounding the Palavayu in prehistoric times have any rock art elements resembling its imagery. Its closest stylistic affinity is found approximately 175 km (110 miles) to the northwest, in the form of the Glen Canyon Linear Style, which also features simple grid-bodied anthropomorphs and ungulates.

Various forms of evidence, both circumstantial and associative in nature, indicate that the main creators of this paleoart were hunter-

gatherers of the Archeoiconic era, though some researchers previously placed the style in Basketmaker (Pilles 1975:5-6) or Puebloan time periods (Ferg 1974:14). Direct evidence for an early occupation of the Palavayu area comes in the form of distinctive projectile points found throughout the region, such as the Jay, Bajada, San Jose, Pinto, and Elko types (Burton 1993:139). Atlatl dart points resembling Elko Corner-Notched or Elko Eared points are actually depicted in several panels. Additionally, some of the style's quadrupeds resemble split-twig figurines, which have been radio-carbon dated at 2150 B.C. Thus I divide the Palavayu Anthropomorphic Style into a major "Linear" phase estimated to have begun around 4500 B.C., while its terminal, graphically more ornate, "Majestic" phase, is believed to have lasted well into the Preformative Period (ca. 1000 B.C. to A.D. 250).

Palavayu Anthropomorphic Style art is exclusively petroglyphic and is distinguished by idiosyncratic motifs and diagnostic elements not found in adjacent rock art territories and styles. Most of the motifs are anthropomorphic, primarily in static and front-facing postures. Running the gamut from solidly pecked to patterned-body figures, these humanoid designs display an incredible variety of torso decora-

tions consisting of geometric (bars, dots, grids) as well as occasional iconic elements (snakes) in both positive and negative techniques. Interestingly, some thirty lateral images also occur, three of which resemble ordinary human beings ("citizen" figures), while the rest form a peculiar sub-class of staff-carrying individuals. Many are also shown holding an assortment of other items such as fending sticks, spears, projectile-point tipped cords, hoops, crooks, and other eccentric, odd-shaped objects of unknown function. In addition, plants and, in one case, a pair of snakes are shown hand-held. As a rule, the anthropomorphs appear randomly scattered on the panels, but arrangements in cohesive groups or rows also exist. Torsos, frequently elongated and/or trapezoidal, may be bounded, with internal segments being blank, solid, or patterned; unbounded, for example when consisting of rakes or horizontally nested bars; or configured in a fashion that combines bounded and unbounded traits. Heads, varying in size from small circular blobs to large outlined ovals, are generally attached to torsos via necks of differing lengths; however, neckless examples and totally disembodied heads are also found. Although head interiors can be totally blank or displaying only lines, most are iconic, that is, with facial features. Many heads, with bug- or pop-eyes and circular mouths, convey the impression of skulls. Head exteriors include elaborate emanations such as headdresses, horns, streamers, antlers, antennae, rays, and feathers. A few heads are surrounded by halos or auras and topped by detached arcs or crowns.

77

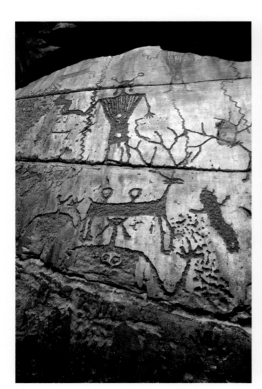

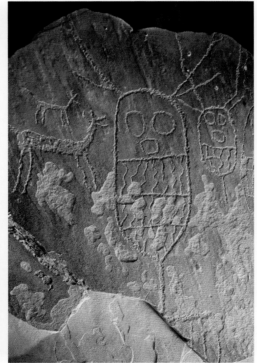

140 Palavayu Anthropomorphic Style (left). *The superimposition of the quadruped over the headgear of the human figure may illustrate the intimate relationship of a shaman with his tutelary animal. Navajo Co.*

141 Palavayu Anthropomorphic Style (right). *Natural erosion has left little of the rake-bodied torso supporting this fantastical head. Navajo Co.*

Extremities such as arms (with or without hands) and legs (with or without feet) may be either present or absent, as are fingers and toes. As to gender, most anthropomorphs are unsexed or indeterminate. While not a single figure possesses female genitalia or breasts, males, when sexually marked, are shown in simple phallic fashion. Ithyphallic depictions are quite rare and generally seen only on profile figures.

Zoomorphs make up the second largest category of the style's images, dominated by mammals but also including birds, insects, and reptiles. Most of the mammals portrayed are hoofed animals such as elk, deer, pronghorn, and bighorn sheep. Of the birds, owls are encountered with a higher frequency than in any other rock art style in the American West. The most frequently depicted insect is the dragonfly. The only reptiles portrayed are snakes and a single image of a turtle. The motif index is rounded out with some therianthropic composites, such as humanized rattlesnakes and anthropomorphized owls; some rare phytomorphs, including the naturalistic rendition of a datura plant; and geomorphs, consisting mainly of numerous basic form constants or phosphenes such as dots, grids, spirals and other abstract-geometric

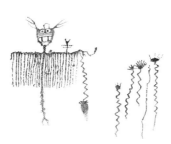

78 ▼

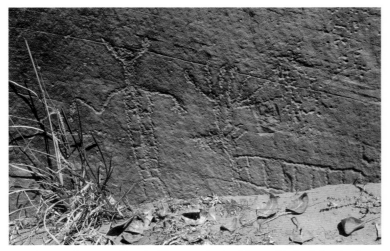

142 Palavayu Anthropomorphic Style. *Human and animal forms with simple interior decorations are typical of the style's long-lasting "Linear" period. Navajo Co.*

forms. Prominent among the non-figurative images are fringe-like elements generally termed "rakes," usually attached to the heads of human- or owl-like figures. "Rakebods" of this type are a hallmark of Palavayu Anthropomorphic art and, with the few exceptions in Utah's Barrier Canyon Style, are unknown in other iconographies of the Western Archaic Rock Art Tradition.

The rupestrian archives of the Palavayu Anthropomorphic Style constitute one of the richest storehouses of biocentric art within the Western Archaic Rock Art Tradition. Distinguished by a high degree of iconographic consistency, the style nevertheless shows some internal variation that led to the postulating of an incipient "Linear" and a terminal "Majestic" phase (McCreery and Malotki 1994:16-17). Created by people relying on hunter-gatherer subsistence strategies, Palavayu Anthropomorphic imagery can summarily be characterized as depicting nonordinary reality dominated by a wide range of specific elements attributable to shamanistic ideology.

In addition to the iconography itself, which provides much of the "circumstantial" evidence for the claim that the majority of this art was shamanistically inspired, especially when tested against certain aspects of the neuropsychological paradigm, I draw on observations derived from ethnographic analogy and human universals. As mentioned earlier, probably the most exhaustive study to date on human universals comes from Donald Brown (1991:130-141) and his heuristic notion of a "Universal People." In his opinion, the Universal People share a whole catalog of traits for which human biology is the principal key. Of paramount significance, in this context, is his con-

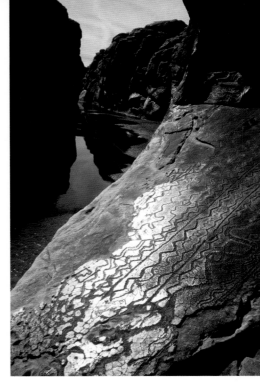

143 Palavayu Anthropomorphic Style. *Most sites of this style are located close to available water sources. Navajo Co.*

clusion that aspects of religion and ritual also appear, in part, to be explainable in evolutionary and biological terms. The Universal People "have religious or supernatural beliefs in that they believe in something beyond the visible and palpable. They anthropomorphize and (some if not all of them) believe things that are demonstrably false. They also practice magic, and their magic is designed to do such things as to sustain and increase life and to win the attention of the opposite sex. They have theories of fortune and misfortune. They have ideas about how to explain disease and death. They see a connection between sickness and death. They try to heal the sick and have medicines for this purpose." The Universal People "practice divination. And they try to control the weather." They also "dream and attempt to interpret their dreams and, "to alter their moods and feelings" they will resort to psychotropic substances such as stimulants, narcotics, or intoxicants.

These universal traits certainly hold, in my view, for the hunter-gatherer artists who produced the highly idiosyncratic imagery of the Palavayu Anthropomorphic Style. Due to lack of space, only a selected few of the style's motifs with their most salient features can be commented on here. Paradigmatically, aspects of their interpretations are

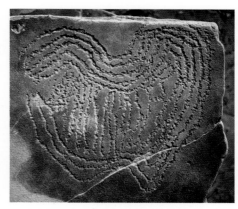

also applicable to other shamanistically conceived rock art of Arizona.

As the style name implies, the anthropomorphs are the most prominent life-form of this corpus. Conceptualized primarily as patterned-body humanoids, they demonstrate, in their idiosyncratic portrayals, that much of the style's iconography was likely derived from hallucinations, visions, or dreams. According to the neuropsychological model of interpretation, the incorporation of phosphenic geometrics into representational designs is a reliable indicator of origin in deep trance. Functionally, the multitude of interior torso markings may signify the shaman's outward sign of supernatural power. Specifically, they may reflect esoteric paraphernalia, adornments in the form of ritual body painting, cicatrization, and tattooing, or totemic identifiers, ceremonial garments, or status insignia. Frequently executed in X-ray, riblike, or skeletonized fashion, many of the anthropomorphs are evocative of transparency, immateriality, and otherworldliness; others, in their ethereal appearance, seem to be symbolic of death imagery emphasizing the shaman's ordeal of dismemberment and resurrection.

Other features reflecting the visionary phenomena of trance or other forms of altered states of consciousness are the figures' disproportionately elongated and/or distorted bodies, believed to be suggestive of the somatic sensations of floating or levitating. In addition to many other torso configurations (solidly pecked, outlined, dotted or dinted), Palavayu Anthropomorphic figures feature the unique phenomenon of bodies reduced to a rakelike design with the bar of the rake taking the place of the shoulders. The rake motif by itself figures prominently as one of the leitmotifs in the nonfigurative vocabulary of the Western Archaic Rock Art

79

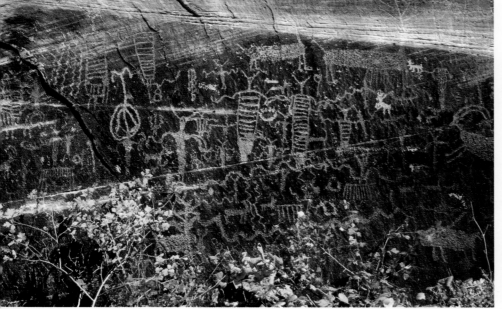

144 Palavayu Anthropomorphic Style (left). *Exclusively petroglyphic, highly stylized patterned-body anthropomorphs are the style's leitmotif. Coconino Co.*

145 Palavayu Anthropomorphic Style (above). *Isolated abstract designs such as this are rare in this style. Navajo Co.*

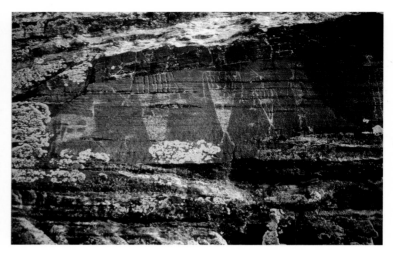

146 **Palavayu Anthropomorphic Style.** *Simple, phosphene-inspired geometrics are almost always integrated into existing life-forms. Navajo Co.*

147 **Palavayu Anthropomorphic Style.** *Whether these trapezoidal figures represent trancing shamans, mythological deities, or supernatural spirits will never be known. Navajo Co.*

Tradition. This schematized icon, with its pendant parallel tines consisting of straight, dotted, zigzagging, or wavy lines, is generally thought to simulate rain in the form of drops, showers or rivulets descending from the clouds (Hedges 1985). When alternately interpreted as a stylized wing, the rake may relate to the shaman's ability for magic flight, as his soul embarks on an extracorporeal voyage to the spirit world. If the water-related explanation is correct, however, Palavayu Anthropomorphic rakes topped by humanlike heads may be assumed to symbolize the shaman in his cardinal role as rain-maker (Malotki 2000). Another, related interpretation for anthropomorphized rakes may be as rain deities, that is, supernatural beings with rain-generating powers. As such they could be compared to the kachinas of the Pueblo world. Although kachina gods and Palavayu Anthropomorphic rake-rain deities are, chronologically, probably separated by several thousand years, there exist a number of conceptual parallels between the two. Hopi kachinas, for example, are believed to visit the land of their protégés in the shape of clouds and to bestow on it life-assuring moisture. The same desire for the life force of water may have motivated the Palavayu Anthropomorphic shaman-artists to engrave their visions of supernatural rain-providers on the sandstone faces at selected power spots in the Palavayu area.

Although no ethnographic information exists as to what techniques the ancient shaman-artists of the Palavayu employed to communicate via trance with the spirit realm, a number of clues in the anthropic depictions suggest the ingestion of psychotropic substances. Unlike Eliade (1964:401), who deems the use of narcotics "a vulgar substitution for pure trance," La Barre (in Furst 1976:2) actually argues that the early Native Americans were "culturally programmed" for conscious exploitation of hallucinogenic plants. In an Archaic subsistence economy that emphasized the gathering of plants over the hunting of animals, an intimate knowledge of plants was a survival necessity. There can thus be no doubt that the Archaic inhabitants of the Palavayu were thoroughly familiar with the flora of the various regions they inhabited and that their pharmacopoeia would, in all likelihood, also have contained an assortment of botanical hallucinogens. Among those believed to have been available within the confines of their territory are datura, Indian tobacco, four o'clock, and the mushroom species psilocybe and fly-agaric. Of these, datura seems to be the most qualified to have acted as a hallucinogenic catalyst for altered states of consciousness (Malotki 1999).

Palavayu Anthropomorphic imagery contains, in addition to a fairly realistic portrayal of the datura plant (Malotki and Weaver 2002:5), multiple allusions to its spinescent seed capsules, not only in conjunction with hand-

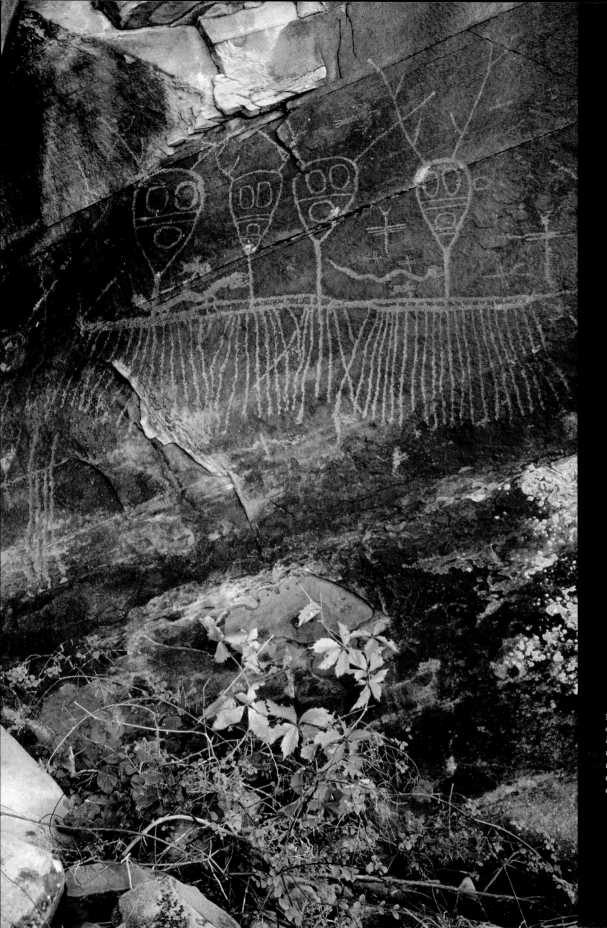

**148 Palavayu
Anthropomorphic Style.**
*Rake-bodied phantasmo-
morphs reflect hallucinatory
iconography probably gen-
erated in altered states of
consciousness. Navajo Co.*

149 Palavayu Anthropomorphic Style. *These bug-eyed heads are reminiscent of skulls and highlight the otherworldly flavor of the style. Navajo Co.*

held staffs but also as echoed in the rayed heads and bodies distinguishing some of the human figures. Alternately, the cephalic projections, which are thought to portray common somatic hallucinations during altered states of consciousness, could be viewed as the shaman's vital energy field, radiating from the head. Another piece of evidence may be the so-called dint-splotches found interspersed on several of the style's panels that conceivably represent the seeds of the plant.

Indirect evidence of the physiological effects of datura intoxication appear in several motifs. Thus, examples of apparent bodily levitation, very pervasive in the art, may pertain to the somatic sensation of flying and may portray the shaman's ability to enter the world of the supernatural. Furthermore, there are occasional images of ithyphallic males thought to represent the plant's aphrodisiac effect. Finally, a sign of intoxication frequently captured in the art is apparent pupil dilation. Extreme pupil enlargement causes photophobia to the point that a person may have the ability to see clearly at night but be abnormally intolerant of daylight. This effect may also ultimately explain why so many of the style's anthropomorphs are bug-eyed, that is, rendered with widely open and staring eyes.

Geomorphs, when portrayed, are rarely seen in isolation in Palavayu Anthropomorphic imagery. In the majority of cases, they are fully integrated into the abundantly occurring life-forms. This also holds for quadrupeds such as bighorn sheep, elk, pronghorn, and deer. Although certainly desirable as food items and their depiction thus amenable to the theory of sympathetic hunting magic, they never appear in an obvious hunting context. More likely, their main function was that of spirit helpers or guardian spirits that were manipulated by the shaman in carrying out ritual obligations.

An even stronger case for the role of spirit tutelaries can be made for most of the remaining animals in the style's zoomorphic inventory, specifically owls, dragonflies, and serpents. While their actual meaning to ancient creators eludes us, it is safe to assume that few, if any, of them were the products of idle artisans or lessons in ornithology, entomology, or herpetology. Nor could they have had any significance as dependable menu items, that is, as objects *bons à manger,* "good to eat," to refer to Lévi Strauss' famous observation. Rather, they must have been selected because they were *bons à penser,* "good to think," denoting that ancient people identified with their perceived natural and supernatural characteristics.

Many of the owl's behavioral traits have immediate relevance for the shaman (Malotki 1998). Owls are nocturnal. Shamans, likewise, apparently prefer the dark of night for their work sessions. Because of the bird's legendary visual acuity, the owl might have come to represent, in the minds of Archaic hunters and gatherers, a sort of shamanic ability to "see into" the other, hidden world of spirits or to "see beyond" the ordinary, visible world. A liminal creature that is at home in the realms of both light and dark, like the shaman who commutes between the secular and supernatural worlds, the owl was

150 Palavayu Anthropomorphic Style. *This levitating limbless anthropomorph may be symbolic of the shamanic-flight motif. Navajo Co.*

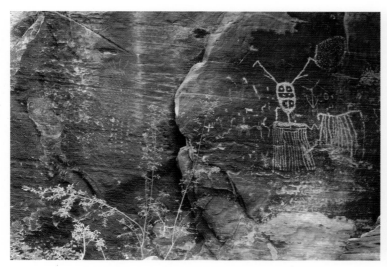

151 Palavayu Anthropomorphic Style. *While the dot-bodied anthropomorph on the left is almost completely revarnished, that on the right shows repecking. Navajo Co.*

152 Palavayu Anthropomorphic Style. *Therianthropic depictions, combining snakelike torsos with antler-topped human faces. Navajo Co.*

thus singularly predestined to become the metaphor par excellence for the shaman, indeed, be regarded as his *alter ego*. It is, therefore, not surprising that nearly ninety images reminiscent of owls have been counted in Palavayu Anthropomorphic art.

Equally interesting are the over fifty dragonfly depictions that populate this iconography (Malotki 1997), an unusual occurrence when compared to the general sparsity of the insectile motif in all other Archaic and post-Archaic rock art styles of the American Southwest. Foremost an aquatic or pluvial icon, the insect may have been petitioned in rain-making rituals or revered as some guarantor of life-sustaining moisture. Frequently depicted with V-shaped excrescences that may stand for horns, and eminently qualified to serve as a metaphor for shamanic flight, the dragonfly was probably also revered as an important shamanic spirit helper. Additionally, it must have been recognized as a symbol for liminal status and miraculous transmogrification. Like the religious specialist, who experiences the "betwixt and between" when he moves between two radically different realities or transforms himself into one of his many animal familiars, dragonflies, after leaving behind their nymphal stage in the water, assume an adult aerial life. Mimicking the shaman's position as a liminar or boundary person, the insect thus elegantly fits the shamanistic origin hypothesis that I postulate for much of Palavayu Anthropomorphic art.

The same conclusion can be drawn for Palavayu Anthropomorphic serpent images (Malotki 2001). With the reptile's undulations perfectly symbolizing the sinuousness of flowing water or a path of lightning, hunter-gatherer artists of the Palavayu Anthropomorphic Style most likely linked snakes and serpentine elements to the realms of water and rain. In addition to their conception as "rain-makers," the reptiles may have been interpreted as metaphors of the shaman. Roving back and forth between the under-ground and above-ground worlds, snakes may also have been regarded as liminal creatures emulating the shaman's journey from the profane to the sacred realm. When actually incorporated into the torsos of Palavayu Anthropomorphic figures or portrayed as humanized snakes with facial features and hands, serpents may have been seen as the shaman's tutelary spirits that aided him in his quest for supernatural power and empowered him to heal, control the weather, and carry out his spiritual journeys.

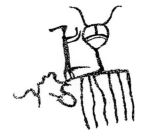

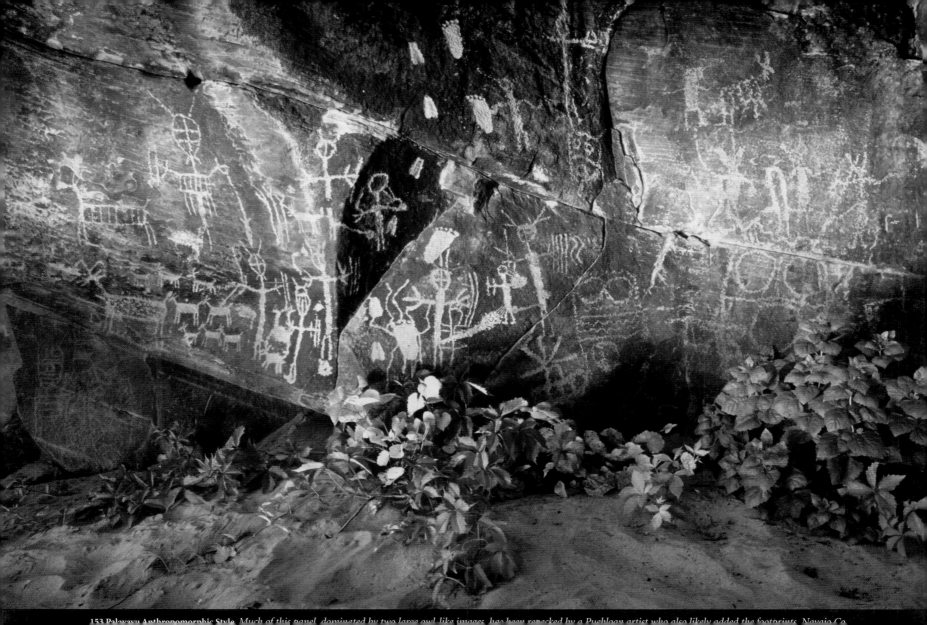

153 Palavayu Anthropomorphic Style. *Much of this panel, dominated by two large owl-like images, has been repecked by a Puebloan artist who also likely added the footprints. Navajo Co.*

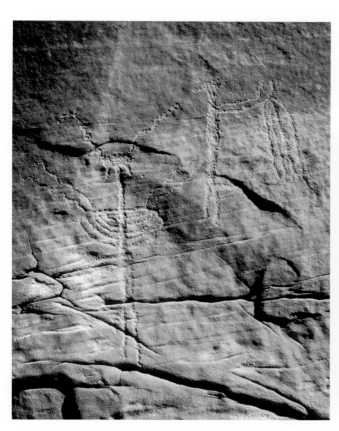

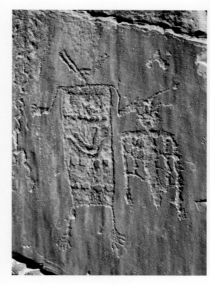

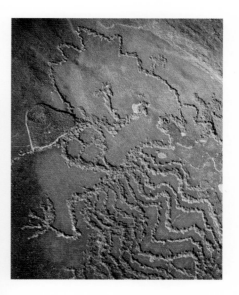

85

154 Palavayu Anthropomorphic Style (top left). *Most anthropomorphs occur in frontal postures; lateral depictions such as of this ithyphallic figure are exceptional. Navaho Co.*

155 Palavayu Anthropomorphic Style (top middle). *Humanoid designs displaying a wide variety of torso decorations occur in both positive and negative techniques. Navajo Co.*

156 Palavayu Anthropomorphic Style (top right). *Depicting an apparent "otherworld" reality, much of the imagery may be due to shamanistic ideology. Navajo Co.*

157 Palavayu Anthropomorphic Style (right). *Superimposition of an Ancestral Puebloan quadruped points to the great antiquity of the underlying stick figures. Navajo Co.*

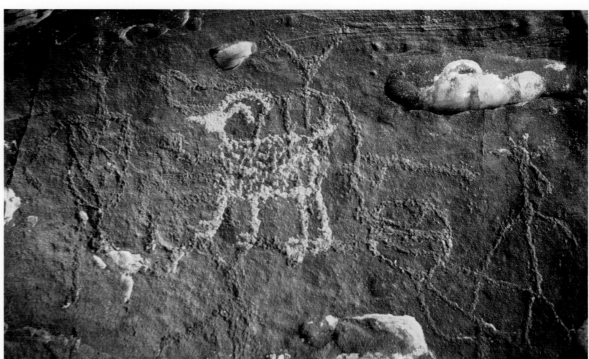

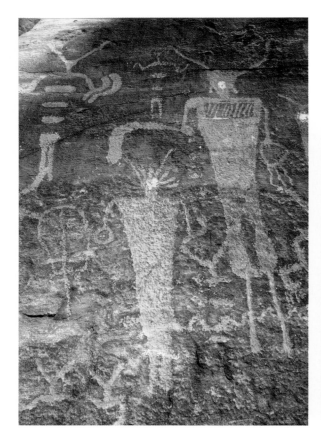

158 Palavayu Anthropomorphic Style (top left). *Anthropomorphs holding various implements such as possible throwing and fending sticks; note deliberate modification of the heads. Coconino Co.*

159 Palavayu Anthropomorphic Style (top right). *Three of the over eighty owl-like images that are part of the zoomorphic inventory of this style. Navajo Co.*

160 Palavayu Anthropomorphic Style (right). *Although anthropomorphs are at times holding spears, none are shown in obvious hunting contexts. Navajo Co.*

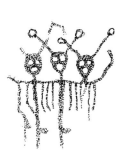

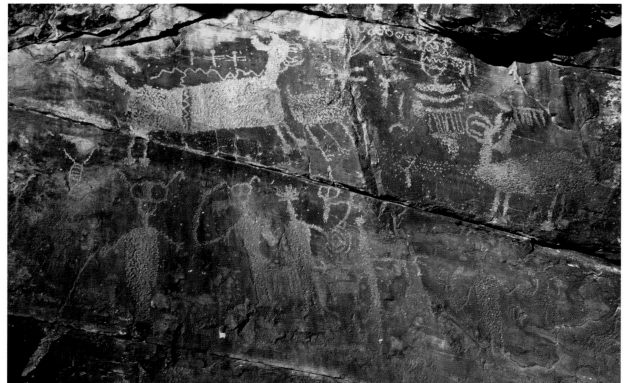

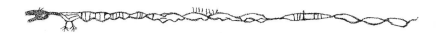

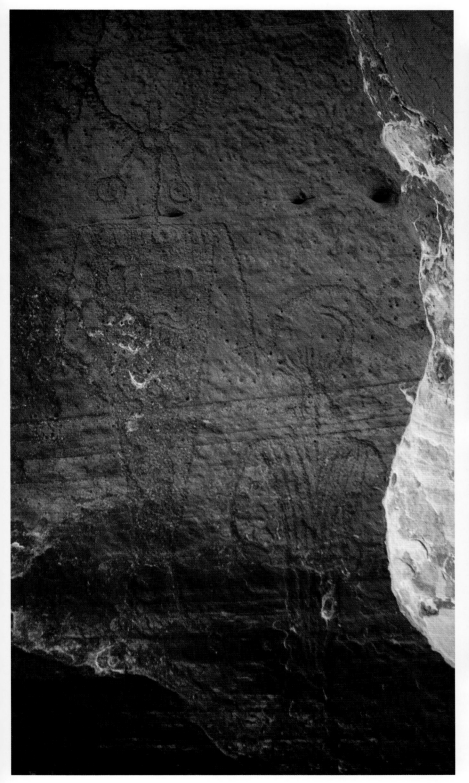

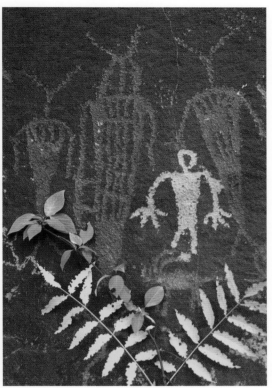

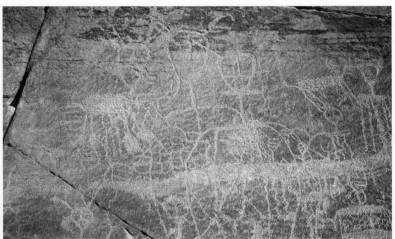

161 Palavayu Anthropomorphic Style (left). *Two highly ornate figures representative of the style's late "Majestic" period. Navajo Co.*

162 Palavayu Anthropomorphic Style (top right). *The addition of a more recent anthropomorph suggests that people belonging to different cultures could be attracted to the same site. Navajo Co.*

163 Palavayu Anthropomorphic Style (bottom right). *An almost indecipherable melange of elements, this multilayered superimposition is exceptional. Navajo Co.*

THE POST-ARCHAIC ROCK ART OF ARIZONA

In the preceding pages, Arizona's Archaic rock art of the Paleoiconic and Archeoiconic periods was discussed by treating the entire state as a single unit. This approach, however, is not suitable for presenting the enormous wealth of Arizona's post-Archaic art, which comprises a multitude of regional variations that developed quite rapidly and with noticeable stylistic differences after 1000 B.C. For reasons of practicality, in the following pages the state has been divided into seven smaller, more manageable segments: the Northeast, Northwest, Central, Mountain, Riverine, Southwest, and Southeast provinces (Figure 4). Each province will provide a succinct summary of the principal rock art traditions and styles that are known or can be posited at this time within the region. It should be emphasized, however, that style and tradition designations cannot always be stated with a high degree of confidence. This is due, in addition to the fact that stylistic analysis is quite subjective, to the paucity of archaeological and rupestrian research in certain parts of the state. For this reason, these designations should be considered provisional rather than definitive and thus subject to change. Decisive progress in this respect cannot be expected until reliable direct dating methods become available, especially for petroglyhs, which constitute the vast majority of Arizona's paleoart.

A similar cautionary note pertains to the provinces. Much like the areas specified by archaeologists for prehistoric cultures, provincial boundaries are not static; borders may require future adjustments as the data base of Arizona rock art sites increases and as our knowledge of the significance of newly discovered, documented, and reported sites evolves.

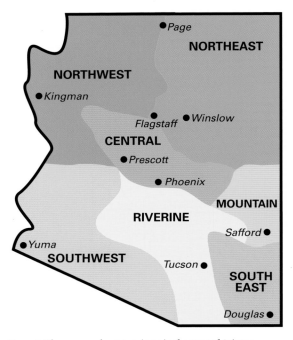

Figure 4. *The seven rock art provinces in the state of Arizona.*

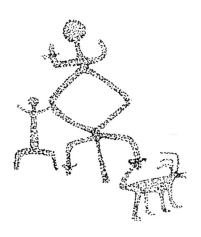

89
▼

164 Central Arizona Petroglyph Tradition. *The prevailing Western elitist concept of "fine" art that associates "art objects" with the primary purpose of providing opportunities for an aesthetic experience does not seem applicable to prehistoric engravings such as these. Yavapai Co.*

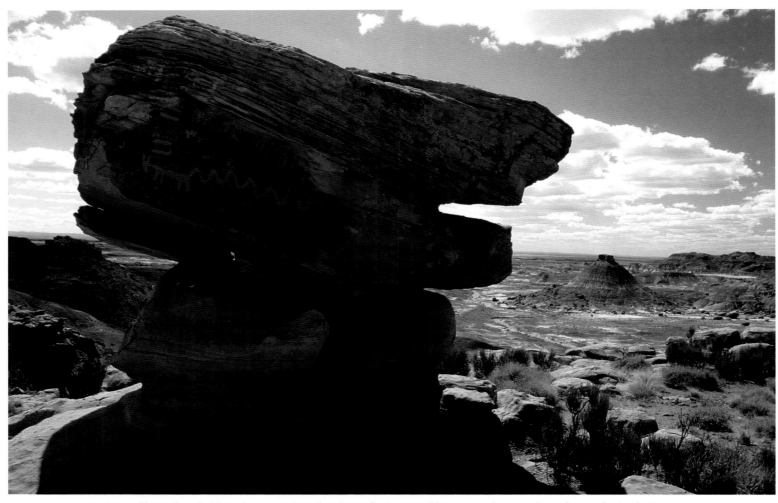

165 Puebloan Tradition. *A coyotelike quadruped with overlong serpentine tail, perhaps reflecting a motif from a story plot; note adjacent bear tracks. Apache Co.*

THE NORTHEAST ROCK ART PROVINCE

The Northeast Rock Art Province, the most studied and documented of the provinces, lies within the southeast segment of the Colorado Plateau, a zone of high elevation (above 1,660 m or 5,000 feet) but generally also of level plateaus and plains. Sharp escarpments and canyons cut through the area, interrupted by the huge volcanic fields of the Chuska Mountains, the Hopi Buttes, and the San Francisco Mountains, with Humphrey's Peak the highest point at 4,210 m (12,633 ft.). Two of the most famous landscapes in the Southwest, the Painted Desert and Canyon de Chelly, are the result of erosional forces affecting the area. Drained by the Little Colorado and the Puerco rivers, the Clear, Chevelon, and Silver creeks, and the

Moencopi and Chinle washes, the province houses most of the present-day counties of Apache and Navajo and a large portion of eastern Coconino County (Figure 5).

The predominant rock art in the Northeast Province was originally referred to as the Anasazi Rock Art Tradition (Schaafsma 1980:105-108), named after the archaeologically defined cultural group that inhabited the area from at least 1000 B.C. to the beginning of the Protoiconic period, ca. A.D. 1540. However, the name Anasazi, derived from the Navajo *anaasázi*, denoting "enemy ancestors," is no longer in general use. While the Hopi have suggested *hisatsinom*, "ancient people," as a replacement, among archaeologists the term

"Ancestral Puebloans" has become the accepted norm and will be followed here, although the label Anasazi is retained when referring to specific cultures such as the Virgin or Kayenta Anasazi.

Originating in the Four Corners region from a hunting and gathering base, the Ancestral Puebloan cultural tradition reached its maximum geographic expanse by about A.D. 1000. In just over a millennium of development, this tradition achieved its architectural apex in the remarkable cliff dwellings so well known to the general public. The tradition eventually spread over the plateau country of the American Southwest to include nearly all of northern Arizona above the Mogollon Rim, most of southern Utah, virtually all of southwestern Colorado, northwestern New Mexico, and parts of southern Nevada. The Ancestral Puebloans are traceable into historic times, with the Hopi in Arizona, and the people of the Zuni, Acoma, Laguna, and Rio Grande pueblos in New Mexico considered their biological and cultural descendants (Lister and Lister 1993).

Rock art produced by the Ancestral Pueblo people is widespread and extremely abundant throughout northeastern Arizona, with hundreds of large and complex sites on record. Just as considerable regional variation existed in the Ancestral Puebloan culture, so too are marked differences found in the associated rock art tradition

within the province. Several localized styles, and many more widely spread but unnamed and poorly described styles, form the core of the Ancestral Puebloan Rock Art Tradition. This situation makes it difficult to accurately present the overall content and distribution of rupestrian art within the area. Throughout much of its range, especially in the Lower Colorado River and Painted Desert region, the tradition is overwhelmingly represented by petroglyphs, with pictographs prevalent in only a few locations. The Kayenta/Tsegi Canyon and Chinle Wash/Canyon de Chelly territories, on the other hand, are distinguished by painted imagery, although pecked, incised, and scratched petroglyphs also occur.

Figure 5. *Northeast Rock Art Province.*

Despite the long history of rock art research in the region, no consistent style sequences have been established for the paleoart of the Northeast Province except for the Glen Canyon area (mostly in

91

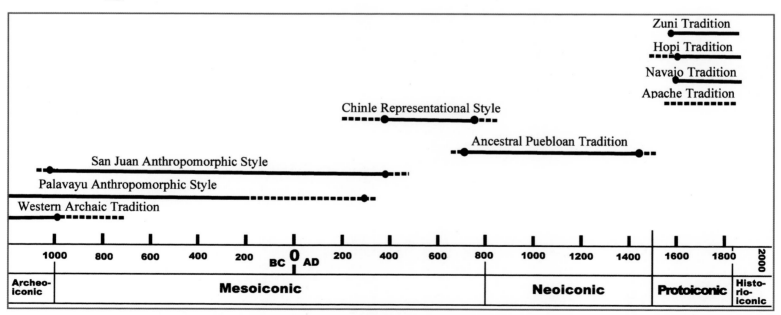

Figure 6. *Northeast Rock Art Province: Approximate time spans of currently known styles and traditions.*

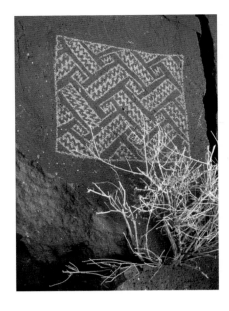

Utah) and the Palavayu centered in the Little Colorado River Valley around Petrified Forest National Park (McCreery and Malotki 1994; Malotki 1999:104). In other areas, the existence of multiple style names for the same rupestrian phenomenon has led to confusion. Because only the development of acceptable, absolute dating processes is likely to bring greater clarity to the problem, at present the province's post-Archeoiconic rock art corpus is best divided into three major archaeological periods: Preformative, Formative, and Protohistoric/Historic.

The Preformative (1000 B.C. to A.D. 400) is the earliest archaeological horizon on the Colorado Plateau in the post-Archeoiconic era. Generally equated with the Basketmaker II period, it is characterized as a time of transition from a primarily hunting-foraging subsistence economy to one of reduced mobility and a steadily increasing reliance on cultigens, especially corn (maize), squash, and beans, all originally cultivated in the highlands of Mexico (Plog 1997:52). The paleoart attributable to this period is an extension of the rock art complex centered along the San Juan River corridor in southern Utah and along its tributaries, primarily Chinle Wash in the heart of northeastern Arizona. While the early phase of this corpus has been referred to variously as Basketmaker Style (Cole 1990:109-130; Grant 1978:164-170), San Juan Anthropomorphic Style (Schaafsma 1980:108-121), and also Basketmaker II San Juan Anthropomorphic Style (Schaafsma 1992: 6), the later phase, equivalent to the Basketmaker III period, is known, in part, as Chinle Representational Style (Schaafsma 1980:121-122) or Modified Basketmaker Style (Grant 1978:171-193). To simplify this confusing terminology, it is proposed here to retain the San Juan Anthropomorphic Style (1000 B.C. to A.D. 400) for the early phase of the Preformative and to use Chinle Representational Style for all subsequent rock art manufactured through the end of the first millennium.

Standing out from the plethora of iconic and noniconic motifs that constitute the San Juan Anthropomorphic Style are many large, broad-shouldered anthropomorphs, often elaborately decorated, with drooping hands and feet, in both painted and engraved forms. While the early phase of the subsequent Chinle Representational Style (A.D. 400 to 700) shows numerous continuities with the preceding art, it is overall less imposing and spectacular in its portrayal of human images. In its late phase (A.D. 700 to 1000), major differences appear, with paintings gradually fading away and petroglyphs becoming dominant. Diagnostic motifs now embrace bighorn sheep and relatively small anthropomorphs, including fluteplayers. Hunting scenes and complex assemblages with a multitude of elements suggesting a narrative content also become common. Late examples of the Chinle Representational Style, so abundant and extensive throughout the Kayenta/Tsegi and Chinle/Canyon de Chelly regions of the Northeast Province, are also prevalent in bordering regions of the Northwest, Central, and Mountain provinces (Schaafsma 1980:134-135).

As may be expected, Ancestral Puebloan rock art of the Formative Period (A.D.1000–1500) also exhibits a great deal of stylistic variation, as reflected by such designations as Kayenta Representational, Tsegi Painted Representational, and Rio Grande Styles, all named by Polly

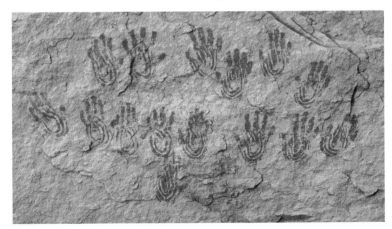

166 Chinle Representational Style (above). *Human handprints, one of the most ubiquitous rupestrian motifs worldwide. Apache Co.*

167 Puebloan Tradition (top right). *An intricate interplay of positive and negative design elements, probably inspired by a blanket pattern. Coconino Co.*

168 Puebloan Tradition.
*Highly complex
melanges of this type
are characteristic of
the late phase of this
rock art tradition.
Apache Co.*

Schaafsma (1980:19; 143-153). While these and other unnamed styles exhibit many motifs that recall the rock art of earlier periods, the Ancestral Puebloan Tradition demonstrates an explosion of new motifs in all morphologically distinguishable categories. Thus, anthropic depictions now include clearly gendered females, many figures portrayed in hunting, birthing, or ceremonial contexts, and numerous fluteplayers. Zoomorphs, while continuing the ever present line of ungulates, also comprise predators such as mountain lions and bears. A range of avian, insectile, and reptilian creatures, some identifiable as to species, become apparent, as do a legion of geometric configurations, including designs evoking those found on textiles, basketry, and pottery in the archaeological record. Among reomorphs, one sees crook staffs, sandals, ceremonial implements such as rattles, dance wands and prayer sticks, and weapons such as nodule clubs and bow and arrow. Finally, a major innovation in the post-A.D. 1300 rupestrian vocabulary is the occurrence of kachina figures and masks (Schaafsma 1981).

94

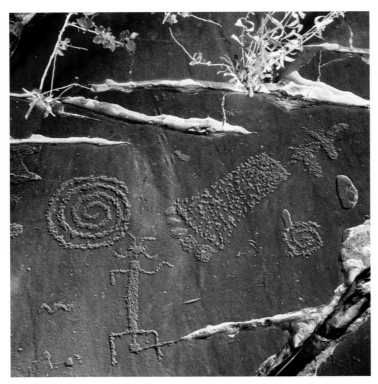

169 Chinle Representational Style. *Geometric designs, including two spirals, next to a phallic figure and a large footprint. Navajo Co.*

From about A.D. 1500 onward, Protoiconic and Historioiconic rock art in the province is broadly covered by the Hopi and Navajo Rock Art Traditions, though a few instances of art of the Zuni and Western Apache Traditions can be found in the southeastern corner. While the Hopi and Zuni Traditions are continuations, in part, of the Ancestral Puebloan Rock Art Tradition, the Navajo and Apache Traditions are not, as their descendants were latecomers to the Southwest, arriving sometime just prior to A.D. 1500 (Brugge 1983:489-491).

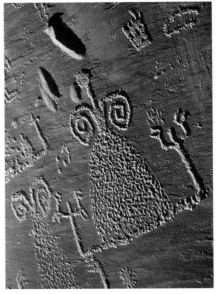

170 Puebloan Tradition. *A bizarre anthropic figure with spiral arms and trident feet in an anatomically impossible posture. Navajo Co.*

Both the Hopi and Zuni Rock Art Traditions are characterized by petroglyphs. Many of these images were apparently produced with metal tools, as indicated by the fine, deeply incised line-work. During this period, a novel rock art form became part of the Hopi Tradition, possibly under influence from Zuni or Pueblo refugees from the Rio Grande area. This involved the incising of large outlined images such as shield-bearing and patently sexed humans, whose inner matrix was then removed to bring about a bas-relief effect (Malotki and Gary 1996).

The hallmarks of Navajo Tradition rock art in the province are pecked and shallowly scratched petroglyphs, as well as painted and charcoal-drawn pictographs.

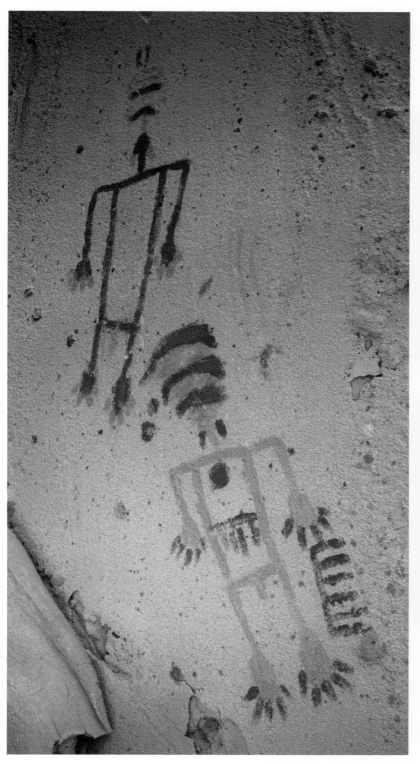

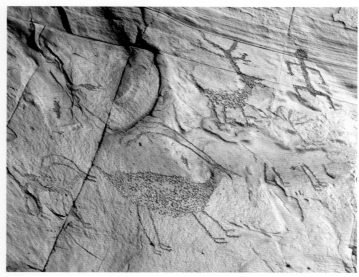

171 San Juan Anthropomorphic Style (left). *Polychrome anthropomorphs with spectacular headdresses consisting of vertically stacked arcs or crescents. Apache Co.*

172 Puebloan Tradition (top). *A human figure in praying stance accompanied by a ceremonial staff-bearer. Apache Co.*

173 Chinle Representational Style (middle). *Ungulates with cloven hooves; note incomplete figure below human image. Coconino Co.*

174 Puebloan Tradition (bottom right). *An enclosed geometric motif reminiscent of a textile design. Navajo Co.*

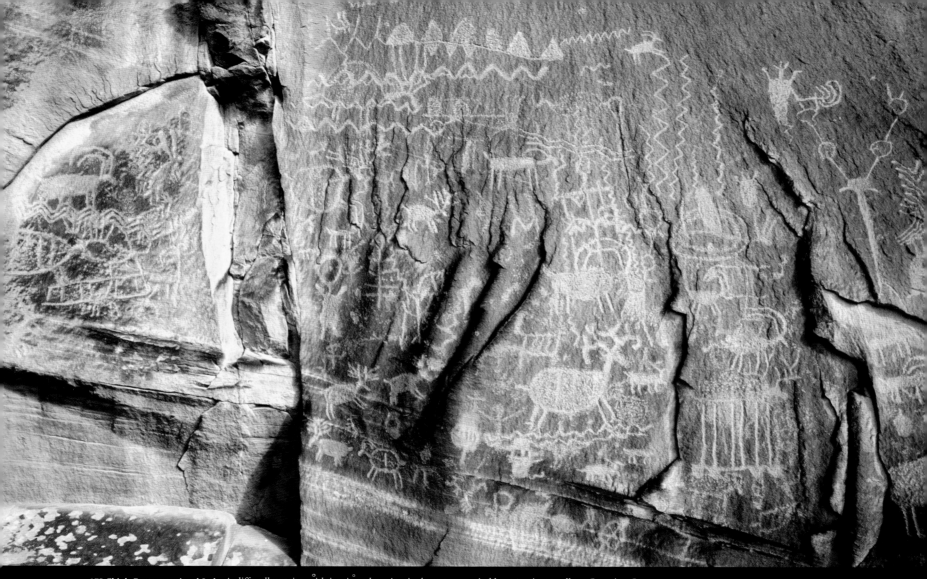

175 Chiple Representational Style. *A cliff wall teeming with iconic and noniconic elements, a veritable open-air art gallery. Coconino Co.*

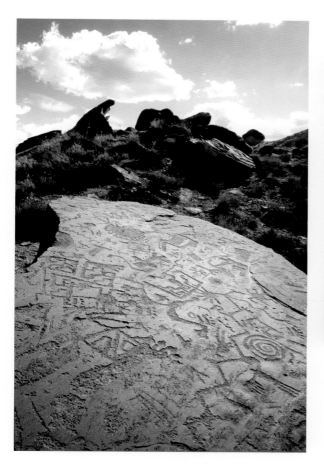

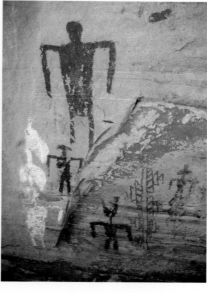

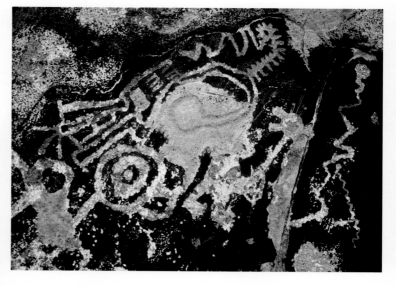

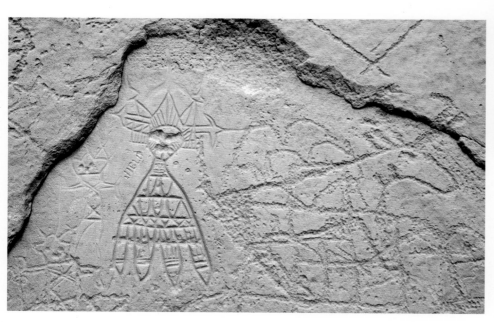

176 Puebloan Tradition (top left). *Revarnished petroglyphic designs show up best when illuminated by sidelight. Apache Co.*

177 San Juan Anthropomorphic Style (top right). *Solidly painted anthropomorphic figures in typical immobile, frontal attitudes. Apache Co.*

178 Hopi Tradition (bottom left). *A deeply incised kachina figure with elaborate tableta, identifiable as a Sa'lakwmana, next to an earlier, pecked pronghorn. Navajo Co.*

179 Puebloan Tradition (bottom right). *Various serpentine configurations suffering from lichen infestation and erosion. Apache Co.*

180 Puebloan Tradition (top left). *A male figure with decorative headgear and large ear pendants; note tiny outlined cross. Navajo Co.*

181 Puebloan Tradition (top right). *An aesthetically pleasing design that in its playfulness borders on "art for art's sake." Coconino Co.*

182 San Juan Anthropomorphic Style (bottom left). *Stick-figure anthropomorphs with drooping hands and feet on remnants of a weathered sandstone boulder north of the San Francisco Peaks. Coconino Co.*

183 Puebloan Tradition (bottom right). *A jumble of linear, curvilinear, and rectilinear elements. Apache Co.*

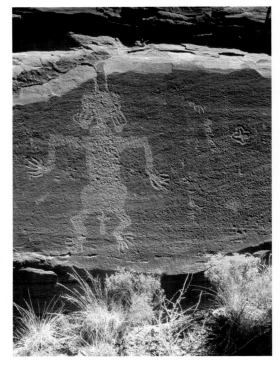

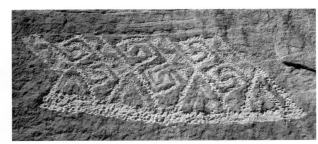

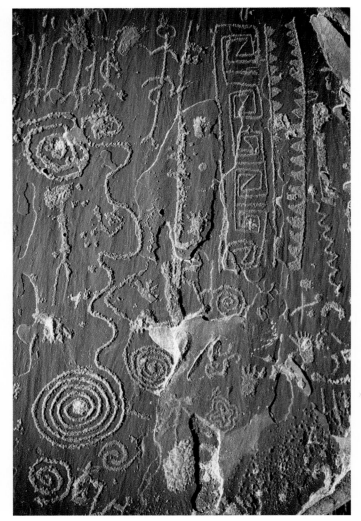

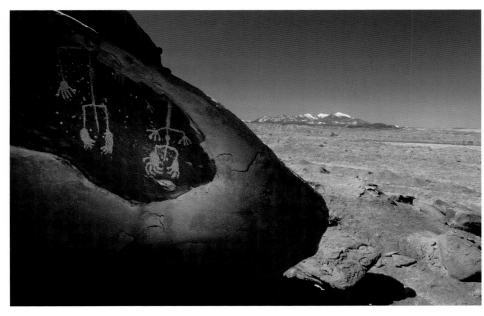

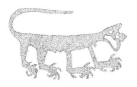

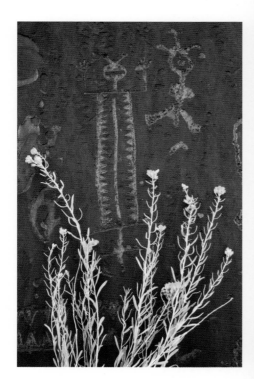

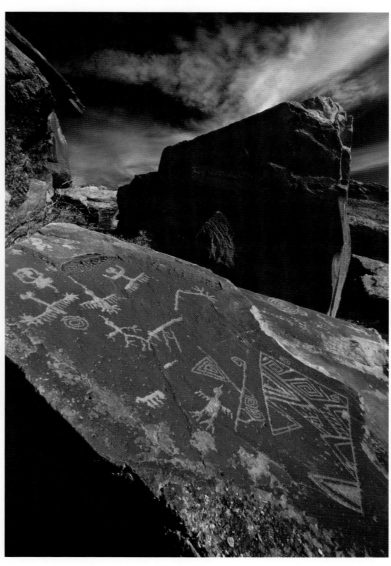

184 Puebloan Tradition (top left). *A group of human figures, likely involved in hunting activities; note arrows attached to figure on right. Navajo Co.*

185 Puebloan Tradition (top right). *A circular kachina mask with large bug-eyes seemingly rising from behind the eroding rockface. Navajo Co.*

186 Puebloan Tradition (bottom left). *The naming of objects, a human universal, resulted in this whimsical figure being called "Thermometer Man." Apache Co.*

187 Puebloan Tradition (bottom right). *A geometrized design and dynamic bird depictions complement each other. Coconino Co.*

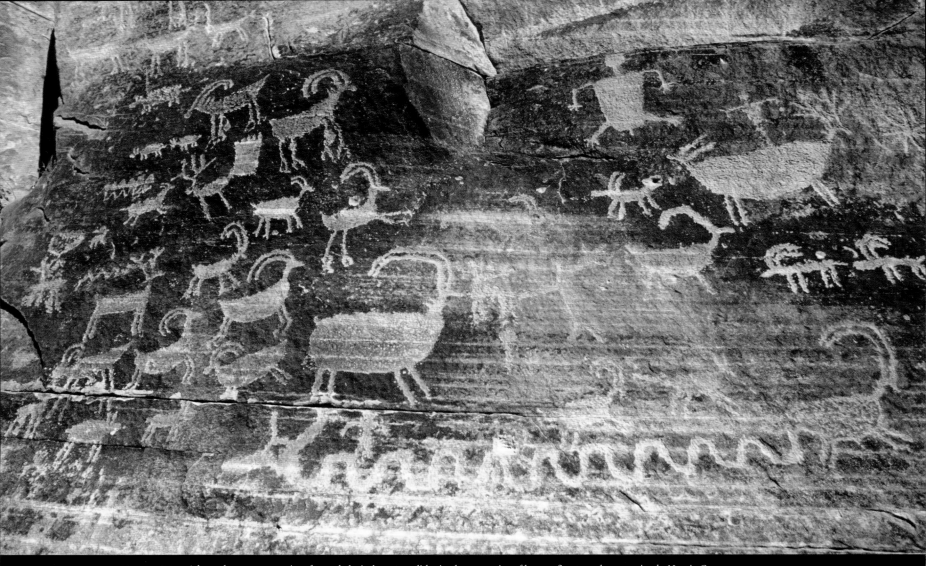

188 Puebloan Tradition. *A horned serpent suggestive of a mythological creature slithering by a grouping of human figures and game animals. Navajo Co.*

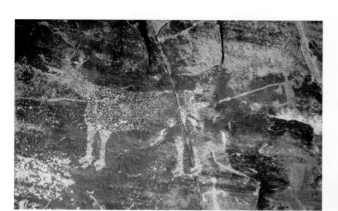

189 Puebloan Tradition (top left). *The foregrounding of a large quadruped against the smaller, spear-thrusting hunter, creates a sense of perspective. Coconino Co.*

190 San Juan Anthropomorphic Style (bottom left). *An upside-down anthropomorph typical of this style, with double-crescent head and huge extremities; note deeply engraved atlatl. Navajo Co.*

191 Hopi Tradition (top right). *Masks identifiable as Kooyemsi kachinas, popularly known as "Mudheads." Coconino Co.*

192 Puebloan Tradition (bottom right). *Several footprints, geometric configurations, and a tiny macaw come together on this boulder. Navajo Co.*

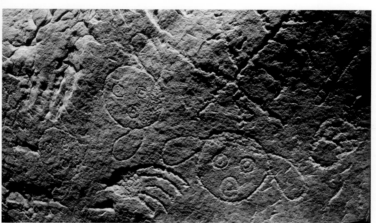

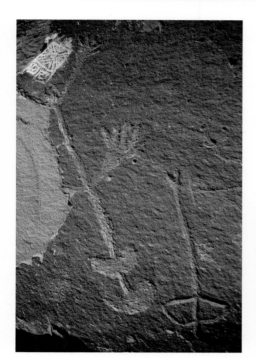

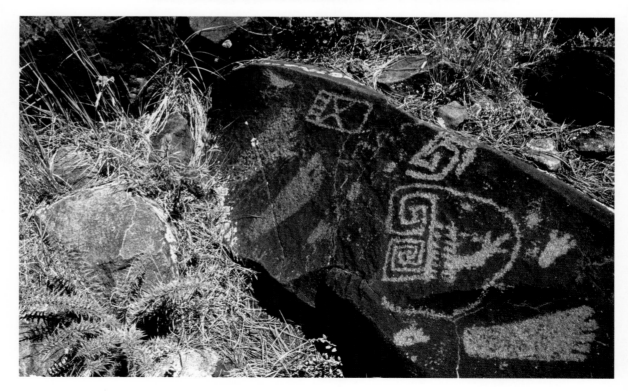

193 Zuni Tradition (top left). *The identical craftsmanship of images surrounding an insectile fluteplayer suggests a single artist. Apache Co.*

194 Navajo Tradition (top right). *A realistic warrior figure with huge shield in lateral portrayal. Apache Co.*

195 Navajo Tradition (below). *Horse-mounted riders, possibly depicting a raiding party with female captives and stolen lifestock. Apache Co.*

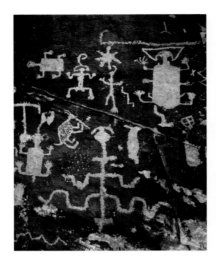

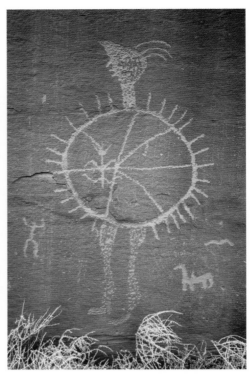

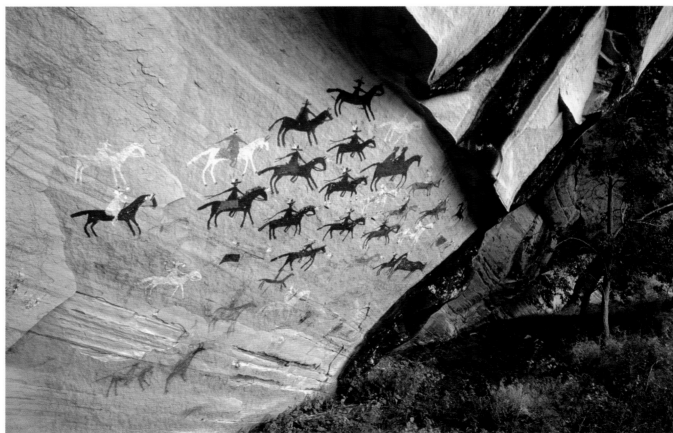

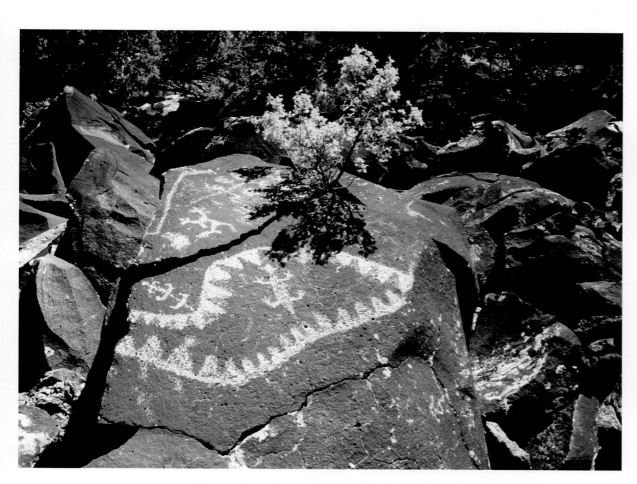

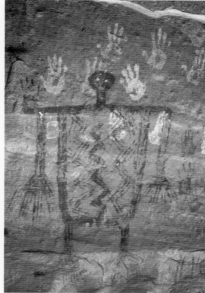

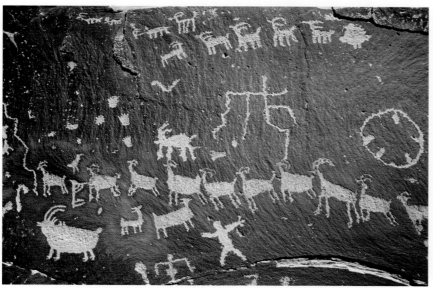

196 Puebloan Tradition (top left). *A geomorph with dentate fringe starkly contrasts with several lizardlike images. Coconino Co.*

197 San Juan Anthropomorphic Style (top right). *A ghostlike anthropomorph with huge digitate hands and feet, superimposed over positive handprints. Apache Co.*

198 Puebloan Tradition (left). *A seated fluteplayer integrated into a long line of ungulates suggests the "pied piper" motif. Coconino Co.*

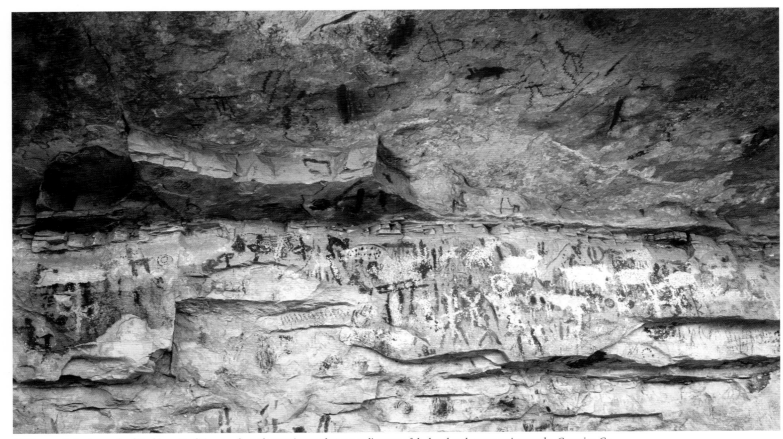

199 Tusayan Style. *A parade of Puebloan Tradition quadrupeds superimposed over a palimpsest of dark red and maroon pictographs. Coconino Co.*

THE NORTHWEST ROCK ART PROVINCE

The Northwest Rock Art Province of Arizona, bordering California and Nevada on the west and Utah on the north, is a diverse area of low deserts and grasslands interrupted by high mountain ranges and plateaus marked by steep-walled canyons. The Colorado River gorge, with its dramatic rock strata within Grand Canyon National Park, makes this one of the most visually spectacular areas in the state. Two other rivers flow through the province: the Bill Williams along the southern boundary and a small section of the Virgin River in the extreme north-west corner. The region contains virtually all of Mohave County, the entire western portion of Coconino County, a narrow segment of Yavapai County, and the southwest corner of La Paz County (Figure 7).

On the Colorado Plateau of the Northwest Province, the earliest archaeological phase of the post-Archeoiconic period is known as the Preformative. During this span, which lasted from approximately 1000 B.C. to A.D. 400, horticulture made its initial appearance and was slowly adopted in varying degrees by the Archaic hunter-gatherers (Fairley 2003:82-87). Three identifiable rupestrian expressions can be assigned to the Preformative: the Tusayan, Snake Gulch, and Cave Valley Styles.

The oldest of these is the Tusayan Style, only recently so designated by Christensen and Dickey (2006b). Located primarily along both the northern and southern rims of the Grand Canyon and south of the

canyon on the Coconino Plateau, the style consists exclusively of painted images, most of which are executed in monochromatic red and maroon. Characteristic features of the style include fine-line abstract-geometric designs with emphasis on dot patterns and a mix of anthropomorphic and zoomorphic motifs. In assigning the style to the post-1000 B.C. Preformative, I differ from Christensen and Dickey (2006b), who consider it distinctly Archaic (ca. 3000 to 1000 B.C.) and thus contemporaneous with Grand Canyon Polychrome. Only accurate dating will ultimately solve this chronometric uncertainty.

On the Arizona Strip, between the Colorado River and the Utah border, a major rock art focus is the Snake Gulch Style. Diagnostic elements include highly stylized anthropomorphic figures, often depicted with dot headdresses, bichromatic ear bobs, and necklaces (Christensen 1998:117-118). Among associated motifs are ungulates, turkeys, and atlatls. Snake Gulch images are commonly painted in a wide variety of colors, but also occur in pecked and scratched form. Based on radiocarbon dates of perishable artifacts from sites in Snake Gulch, the time span allotted to the style is 400 B.C. to A.D. 400.

The Cave Valley Style, while more prevalent in the Vermilion Cliffs area of southern Utah, is also present on the Arizona Strip. It has been tentatively assigned a time frame of A.D. 400 to 900, although there is lit-

tle in the way of corroborating evidence (Schaafsma 1980:131-132). Most characteristic are human figures with inverted triangular or trapezoidal heads and torsos. The style is frequently confused with Snake Gulch iconography, with which it shares motifs of anthropomorphs wearing dot headdresses. Both also show a preference for painted versions, including polychromes. Overall, the Cave Valley and Snake Gulch Styles

Figure 7. *Northwest Rock Art Province.*

are still poorly understood because their associated motifs have not been clearly defined or adequately surveyed, and the styles thus warrant further investigation.

The Formative Period in the Northwest Province is generally believed to have commenced around A.D. 700 to 800, that is, after a transition span of some 300 years. Characterized by an increased dependency on cultivation, the adoption of ceramic technology, and a semi-sedentary settlement pattern, it is expressed primarily in the Ancestral Puebloan

105

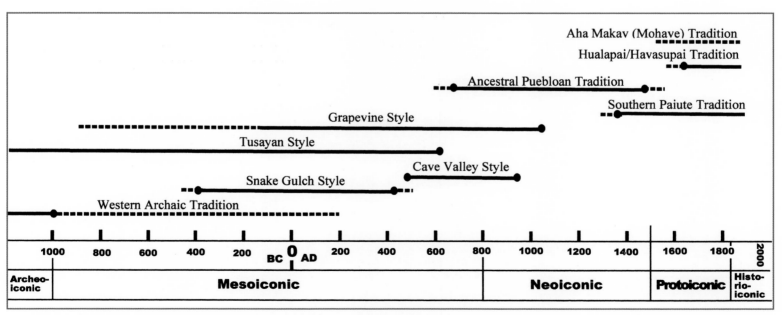

Figure 8. *Northwest Rock Art Province: Approximate time spans of currently known styles and traditions.*

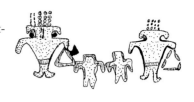

Tradition and its numerous regional manifestations (Fairley 2003:87-97): the Virgin Anasazi, who occupied the entire Arizona Strip and portions of adjacent Nevada and Utah; the Cohonina, who were dominant south of the Colorado River on the Coconino Plateau; and the Kayenta Anasazi, on the Kaibab Plateau, in the Colorado River corridor, and along the South Rim of the Grand Canyon.

In addition to the Puebloan tribes, several other cultures had developed in the region and have left evidence of their existence in rock art. One of these was the Upland Patayan, who lived along the Colorado River around present-day Kingman and the Mohave Desert and to the east along the Grand Canyon. The Yavapai, and the Hualapai and Havasupai (who were designated separate tribes by the U.S. government for administrative reasons in 1880), are considered their cultural descendants. Although the Cohonina were once thought affiliated with the Cerbat, an Upland Patayan group in the western part of the Northwest Province (Cordell 1997:210-211), more recent research has firmly established their Puebloan roots (Coder 2000:27).

Distinguishing the rock art of the three Puebloan groups is a difficult task, since all employed similar designs in both painted and engraved form. What currently differentiates them is the presence or absence of certain motifs and the degree to which the motifs are utilized. Further differentiation will require

extensive motif inventories from documented sites yet to be compiled. For this reason, the umbrella term Ancestral Puebloan Tradition will be used here for all three rupestrian styles.

Little investigation has been done on the rock art of the Protoiconic and Historioiconic periods of the province. Identifiable Hualapai and Havasupai Tradition rock art involves depictions of mounted figures and horses, although recorded Pai art on the Coconino Plateau features geometric designs sketched with black and red pigment sticks (Christensen and Dickey 2006a). Art of the Southern Paiute, who entered Arizona from the Great Basin sometime after A.D. 1100, is also usually identified by historic subject matter such as equestrian motifs, people in "western wear," and by shield figures. Some images are associated with the Ghost Dance ceremonies of the 1890s (Stoffle et al. 2000). In addition, the Paiute tended to replicate earlier Virgin Anasazi motifs on the same panel. Paiute Tradition rock art is pecked, sketched with a dry pigment stick, or painted, predominantly in white but occasionally in red. Examples of polychrome paintings are rare.

200 Puebloan Tradition (top). *A whimsical creature combining insectile and lizardlike attributes. Coconino Co.*

201 Tusayan Style (right). *Extremely delicate brushes must have been used to draw the diminutive dotted and zigzag designs on this panel; coarser motifs are probably Puebloan additions. Coconino Co.*

106

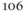

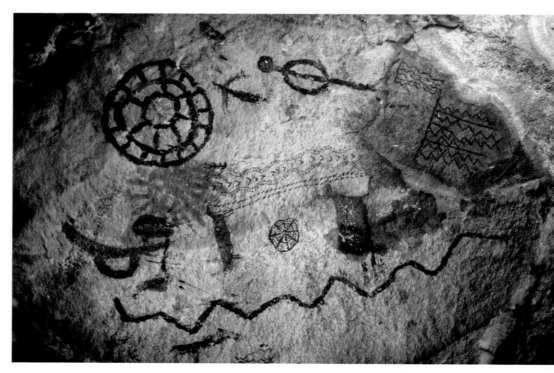

There are anecdotal accounts of the Aha Makav (formerly known as Mohave) producing rock art along the Colorado River in the Historioiconic period (Christensen and Dickey 1998:40). Based on relative repatination, it appears that more recent rock art involves the use of circular, nonrepresentational motifs and the repecking and repainting of Grapevine Style designs at earlier Patayan sites. This latter practice, along with the incorporation of Grapevine motifs into historic Aha Makav ceramic, face painting, and tattooing designs, seems to substantiate the connection of these historic people with the Patayan Tradition (Christensen and Dickey 2001:194).

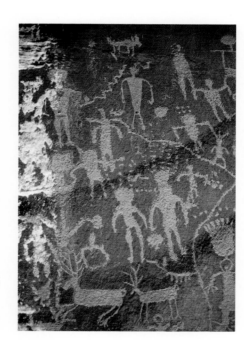

202 Puebloan Tradition (left). *An amalgam of abstract configurations featuring pecking, scratching, and engraving techniques. Mohave Co.*

203 Puebloan Tradition (right). *A footprint or paw-print with seven toes amidst a melange of human and animal figures. Mohave Co.*

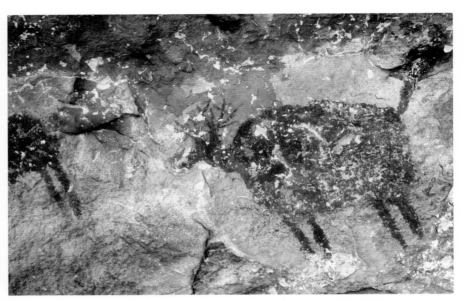

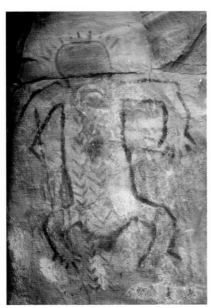

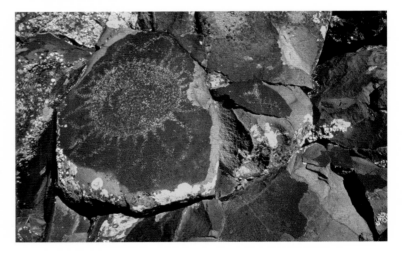

204 Puebloan Tradition (top left). *This straight-backed fluteplayer is atypical in that it occurs without associated imagery. Coconino Co.*

205 Tusayan Style (top right). *A bicolored deer showing deterioration due to spalling pigment chips. Coconino Co.*

206 Cave Valley Style (bottom left). *A painted anthropomorph featuring a bucket-shaped head topped with decorative emanations typical of this style; note superimposed chevrons and mountain sheep. Mohave Co.*

207 Puebloan Tradition (bottom right). *A flowerlike motif creating a stunning impact on the lichen-encrusted basalt cliff. Coconino Co.*

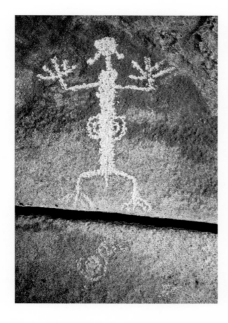

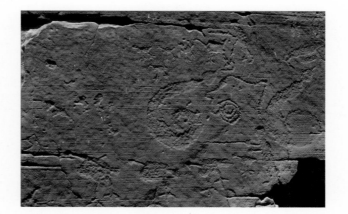

208 Puebloan Tradition (top left). *A surreal anthropic figure of ambiguous gender; or a possible birthing scene? Coconino Co.*

209 Puebloan Tradition (top right). *Pairings of birds and snake motifs are universally encountered in mythology and iconography. Coconino Co.*

210 Snake Gulch Style (bottom left). *A green anthropomorph and a serpentine element modified by scratching. Coconino Co.*

211 Puebloan Tradition (bottom right). *Two stick-figures, one resembling a "centipede-man," dominate this multi-layered composition. Coconino Co.*

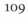

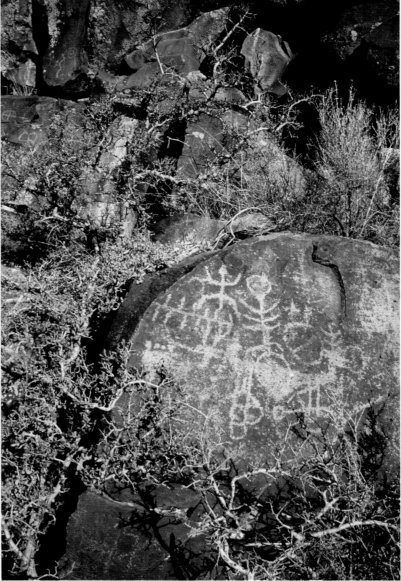

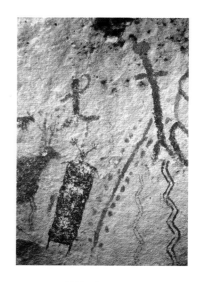

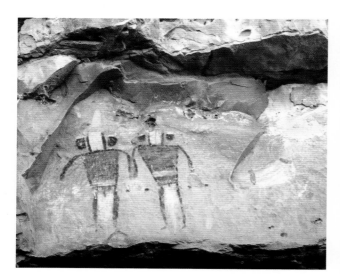

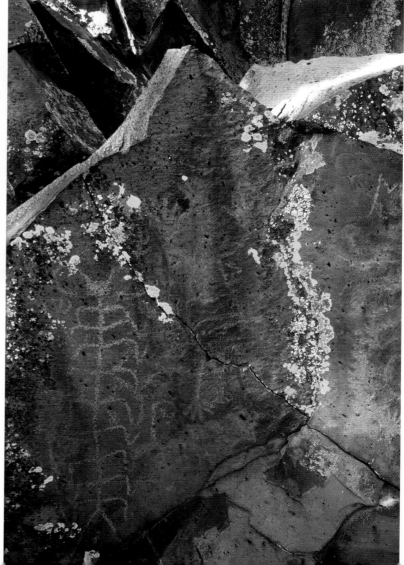

212 Southern Paiute Tradition (top left). *Red pictographs in a shelter along the Colorado River. Mohave Co.*

213 Tusayan Style (top right). *A finely drawn shaman figure with his animal spirit helper, next to coarse finger-painted stick figures. Coconino Co.*

214 Snake Gulch Style (bottom left). *Phallic anthropomorphs holding roundish objects believed to be trophy heads. Coconino Co.*

215 Puebloan Tradition (bottom right). *Centipedelike human stick figures occur throughout the distribution of this style. Coconino Co.*

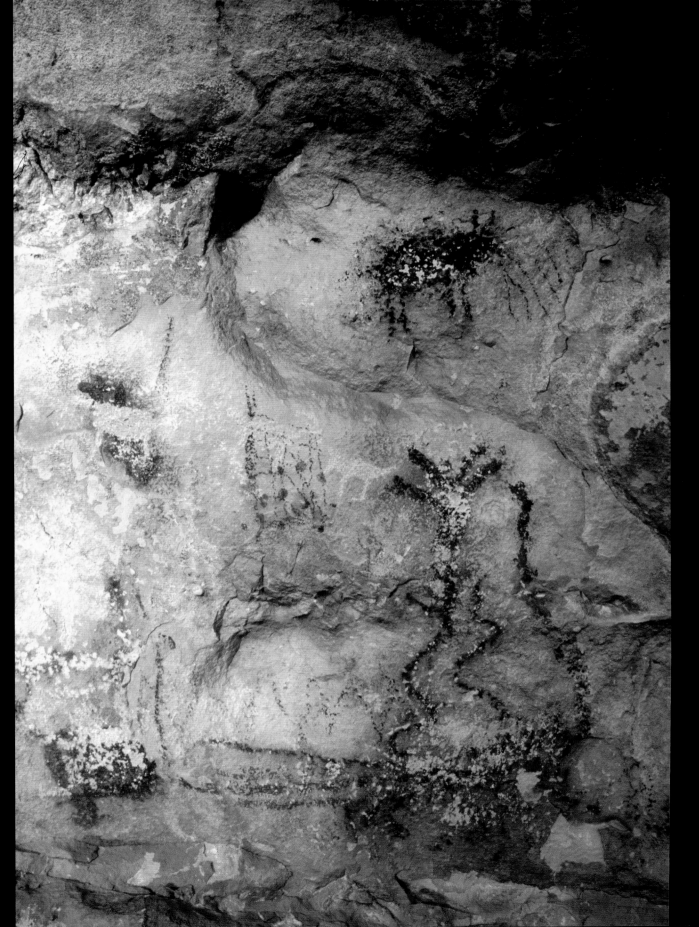

216 Tusayan Style. *A palimpsest of painted and engraved elements, later altered by random pecking. Coconino Co.*

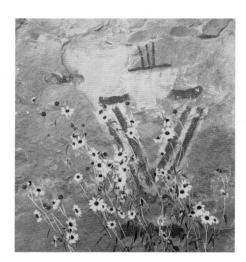

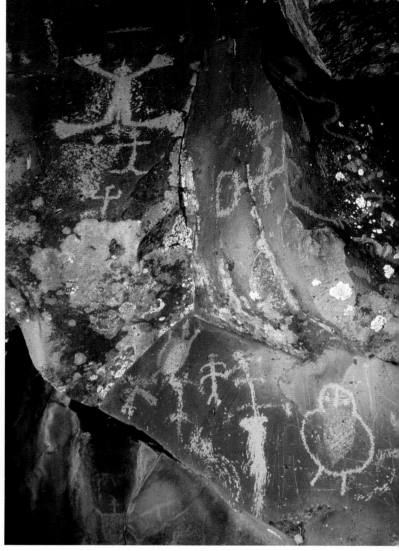

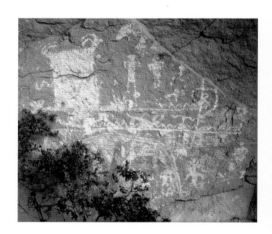

217 Snake Gulch Style (top left). *A bicolor painting of an imposing triangular-shaped anthropomorph with noniconic face and feather headdress. Coconino Co.*

218 Puebloan Tradition (top right). *A hodge-podge of glyphs dominated by a splayed fig-ure, possibly of female gender; note also owl depiction. Mohave Co.*

219 Southern Paiute Tradition (center). *Crudely painted elements, including a large rectangular-shaped human figure in upside-down position. Mohave Co.*

220 Southern Paiute Tradition (right). *Rare bison depictions drawn with charcoal. Mohave Co.*

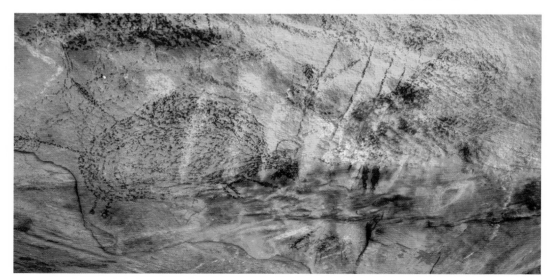

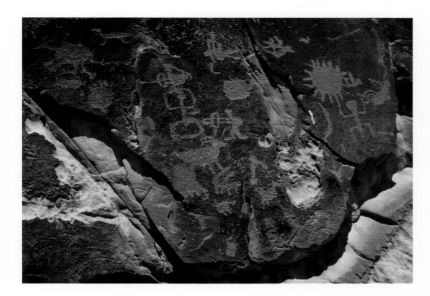

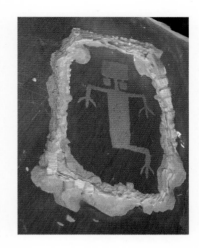

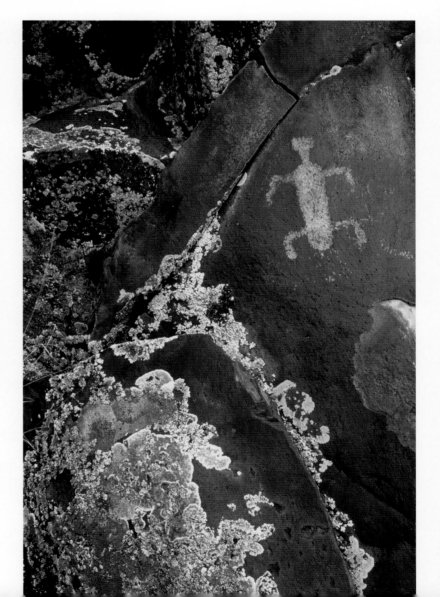

221 Puebloan Tradition (top left). *Animated archers and hump-backed fluteplayers are easily discernable in this assemblage. Coconino Co.*

222 Puebloan Tradition (top right). *Vandalism such as this is a serious threat to Arizona's rock art heritage. Mohave Co.*

223 Puebloan Tradition (bottom left). *Explicit scenes of this kind are a great rarity in the large body of Arizona rock art. Mohave Co.*

224 Puebloan Tradition (right). *A simple buglike image on lichen-covered volcanic rock. Coconino Co.*

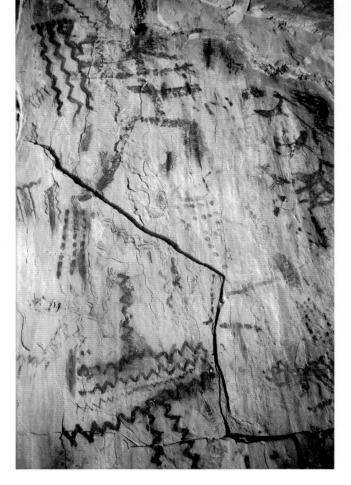

▼

225 Ground Figure Tradition (above). *Due to their fragile nature, geoglyphs such as this newly discovered one need to be protected by a fence. La Paz Co.*

226 Tusayan Style (top right). *Finely executed abstracts and quadrupeds next to crudely drawn brushmarks indicate the use of different paint applicators. Coconino Co.*

227 Snake Gulch Style (bottom left). *Red-eyed phantasmomorphs flanking a large anthropomorph with slit eyes, necklaces, and decorated torso. Coconino Co.*

228 Puebloan Tradition (bottom right). *A ritual line-dance formation with associated quadrupeds. Mohave Co.*

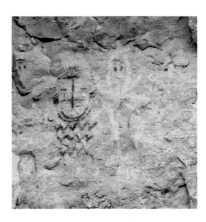

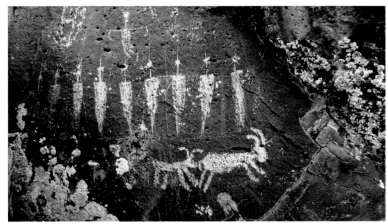

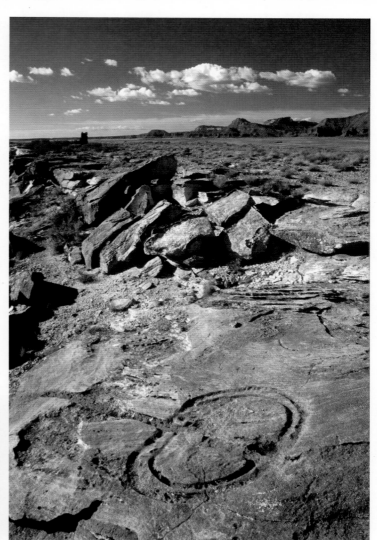

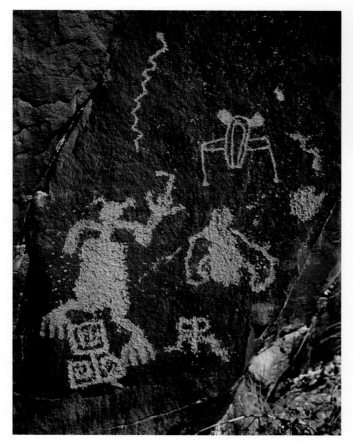

229 Pseudo-Rock Art (top left). *Always located at the edge of a flat, slanting rock surface, these so-called tar-burners do not constitute authentic Native American rock art. Mohave Co.*

230 Pseudo-Rock Art (top right). *Wild speculation as to their function surrounded these enigmatic engravings until it was determined that they served early Euro-American settlers in producing tar pitch. Mohave Co.*

231 Puebloan Tradition (bottom left). *An assortment of anthropomorphs, zoomorphs, geomorphs, and phantasmomorphs. Coconino Co.*

232 Snake Gulch Style (bottom right). *A bichrome, broad-shouldered anthropomorph, probably representing a shaman or supernatural personage. Coconino Co.*

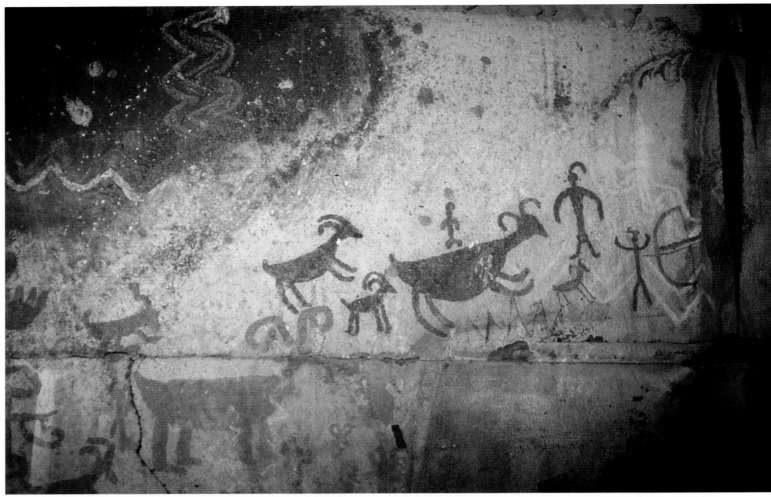

233 Sinagua Pictograph Style. *A herd of ungulates facing a group of hunters; the bowman on extreme right with elaborate headdress may represent a hunt shaman. Yavapai Co.*

THE CENTRAL ROCK ART PROVINCE

The Central Rock Art Province, comprising roughly the mid-section of the state with its many mountainous plateaus, extends from the edge of the Phoenix Basin in the south to the Mogollon Rim in the north, and in the west from Burro Creek to as far east as Pinetop-Lakeside and Fort Apache. Drained by the Big Chino Wash, the northern stretch of the Verde River, and the upper reaches of the New, the Agua Fria, and the Hassayampa rivers south of Prescott, the province lies within most of Yavapai and Gila counties, but also overlaps into the northern part of Maricopa County and includes small sections of eastern Mohave and southwestern Navajo counties (Figure 9).

Of all the provinces proposed in this book for the post-Archeo-

iconic era, the Central Province is probably the most difficult to define in terms of its archaeological affiliations. Based on ceramic evidence, by ca. A.D. 1000 the area was imprinted by at least four major overlapping cultures: Ancestral Puebloan, Hohokam, Prescott, and Mogollon (Coder 2000: 24). With Prescott and Mogollon populations positioned more or less between Ancestral Puebloans (Sinagua and Cohonina) in the north and Hohokam to the south, the province was a multicultural transition zone that is now archaeologically known, for lack of a more suitable term, as the Central Arizona Tradition (Wood 1987:6), with an approximate time span of A.D. 600 to 1425 (David Wilcox, personal communication 2006). The "betwixt-and-

between" character of the region is also reflected in the various manifestations of its petroglyphic art. Still poorly understood in many aspects due to relatively little investigative work and unpublished findings, the major concentrations of known paleoart are centered in the Prescott-Bagdad, Cave Creek-Perry Mesa, and Payson areas, and are combined here under the umbrella label of Central Arizona Petroglyph Tradition. To date, the only style specifically designated within this large collection is the Beaver Creek Pecked Style in the Sedona area, attributed to the Southern Sinagua and tentatively dated to A.D. 1150-1400 (Weaver, personal communication 2004). No doubt, additional individual styles will eventually emerge and will help fine-tune this broadly conceived tradition (Pilles 1994). Overall, however, the thematic and stylistic variations observed in the province's different rock art corpora are not any greater than those noted in other well-established traditions, such as the Ancestral Puebloan and Hohokam Traditions in the Northeast and Riverine provinces, respectively.

With pecking by far the most common manufacturing technique within the Central Arizona Petroglyph Tradition, most of the hundreds of pecked and engraved sites are small, consisting of merely a few panels with low element counts. Some exceptionally large "super-sites" are encountered, however, especially in the Perry Mesa region.

Individual glyphs vary widely in quality of execution, ranging from crude to aesthetically arresting. Among the dominant motifs are quadrupeds and anthropomorphs, including stick-figures and lizard-men that often display "ventral nodes," that is, globular mid-bodies. Notable also are poly-brachial figures possessing up to eight extra arms and/or legs.

Figure 9. *Central Rock Art Province.*

Geomorphs, in addition to the usual myriad of rectilinear and curvilinear elements, feature textile- and potterylike designs as well as huge spirals.

One exception to the predominance of petroglyphs within the tradition is encountered in the Sinagua Pictograph Style (Thiel 1995: 110). Constituting a highly localized painted manifestation with its epicenter in the Red Rock Country around Sedona, it is attributed to the Sinagua, an Ancestral Puebloan entity with a northern group in the Flagstaff region and a southern branch in the Verde Valley (Pilles

117

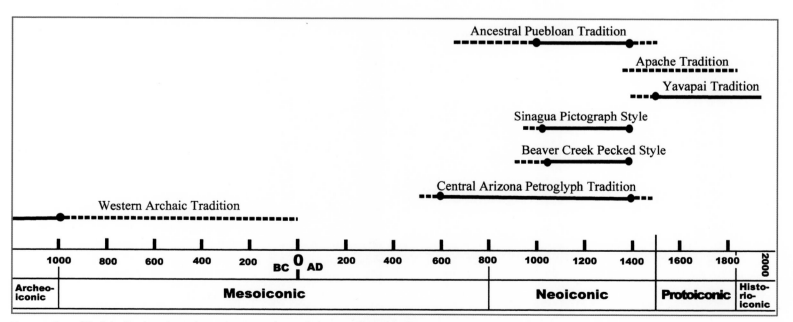

Figure 10. *Central Rock Art Province: Approximate time spans of currently known styles and traditions.*

1998). The monochrome and polychrome paintings, exclusively the work of the Southern Sinagua, are finely crafted images and intricate compositions using white, cream, red, and maroon, as well as black and green pigments. The most striking motifs are huge stylized, multicolored serpents and large circular sun or shield designs. Two of the shieldlike depictions have been dated by accelerator mass spectrometry (AMS) analysis, resulting in a calibrated date of A.D. 990 in one case and A.D. 1410 in another (Armitage et al. 2000).

From about A.D. 1500 on, the Central Province was occupied by Yavapai, Western Apache, and Hualapai/Havasupai tribal groups. However, to date, only the Yavapai Rock Art Tradition and a possible component of the Western Apache Rock Art Tradition have been studied and documented in enough detail to warrant mentioning. The best known examples of the Yavapai Tradition occur in the Sedona Red Rock area and have not been reported elsewhere in the province. Pilles (1994) has posited six different styles within the tradition, based mainly on the different manufacturing techniques involved. Thus, he distinguishes drawings done with charcoal and/or commercially obtained crayons and chalk, paintings created with thick white, orange-red, or black mud pigments, and petroglyphic renderings that were pecked, scratched, engraved, or abraded. Allocated to a time span from about A.D. 1580 to the 1890s, the most common motifs are horse-and-rider images, quadrupeds, and large game animals. Easily recognizable are supernatural beings, called *kakaka* by present-day Yavapai informants. Typical, also, are large expanses of crosshatching and multiple scratched parallel zigzags and meanders, which are often mixed in with Sinagua rock art elements at Sinagua habitation sites, especially

118

cliff-dwellings. In 1873, the Yavapai, along with their Western Apache allies, were confined to reservations (Khera and Mariella 1983: 40-41), a disrupting event which apparently also brought about the end of their traditional practice of making rock images.

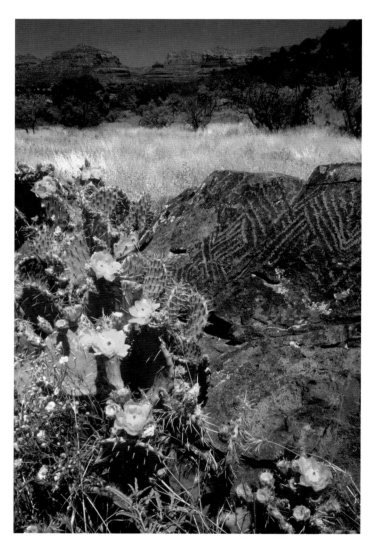

234 **Central Arizona Petroglyph Tradition (top).** *Of the manifold meanings attributed to the spiral, one explanation is that of a tunnel or vortex experienced by the hallucinating mind. Gila Co.*

235 **Central Arizona Petroglyph Tradition (bottom).** *Complex striated patterns fill a boulder face in the Red Rocks country of Sedona. Yavapai Co.*

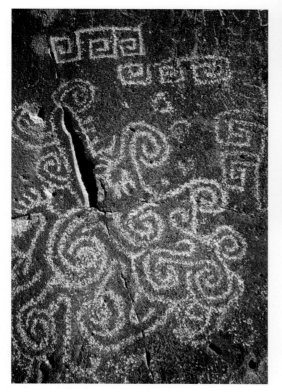

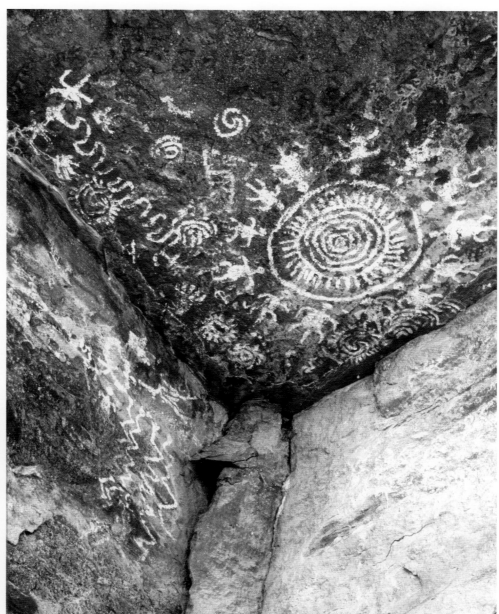

236 Central Arizona Petroglyph Tradition (top left). *A deeply incised anthropomorph with rayed headdress. Yavapai Co.*

237 Central Arizona Petroglyph Tradition (above). *A unique enclosed "sun" design ringed by thirteen "lizard-men" of equal size; note associated pinwheels and serpentine elements. Gila Co.*

238 Central Arizona Petroglyph Tradition (left). *An assortment of scrolls and frets arranged around a crack in the rock form an aesthetically attractive whole. Yavapai Co.*

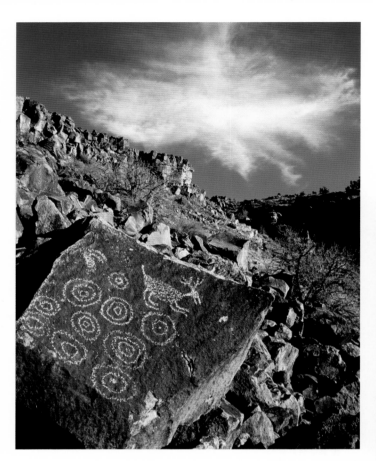

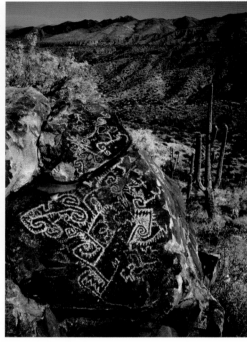

120
▼

239 Central Arizona Petroglyph Tradition (above). *An antlered quadruped with open mouth vividly contrasts with a set of concentric circles. Yavapai Co.*

240 Central Arizona Petroglyph Tradition (top right). *An elaborate concatenation of spiral forms and sawtoothed lines creates a stunning foreground for this desertscape near Humboldt Mountain. Maricopa Co.*

241 Central Arizona Petroglyph Tradition (bottom left). *A highly complex geomorph on a black basalt boulder amidst a sea of wildflowers. Yavapai Co.*

242 Sinagua Pictograph Style (bottom right). *A shield design and large serpentine elements, one with a stylized head, painted over earlier pictographs in red and black; note recent outlining with chalk. Yavapai Co.*

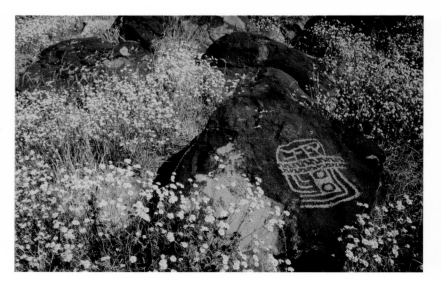

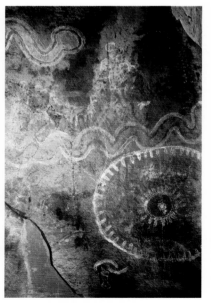

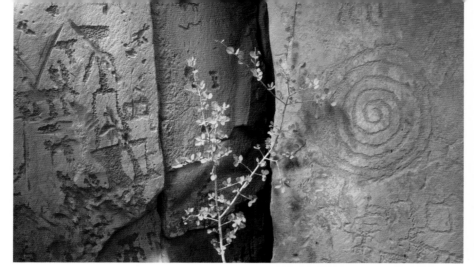

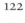

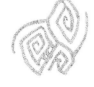

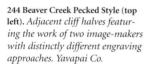

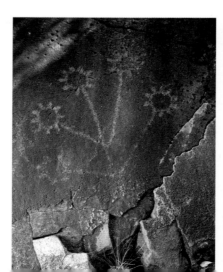

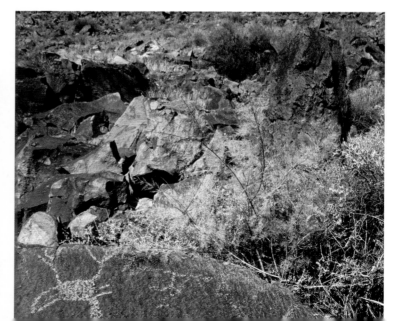

244 Beaver Creek Pecked Style (top left). *Adjacent cliff halves featuring the work of two image-makers with distinctly different engraving approaches. Yavapai Co.*

245 Central Arizona Petroglyph Tradition (top right). *This ensemble of finely incised star images and a pair of bear tracks creates a powerful "aesthetic arrest." Yavapai Co.*

246 Puebloan Tradition (bottom left). *A flowerlike design possibly depicting the spiny seed pods of a datura plant. Navajo Co.*

247 Central Arizona Petroglyph Tradition (bottom right). *A large ungulate with angular stick-*

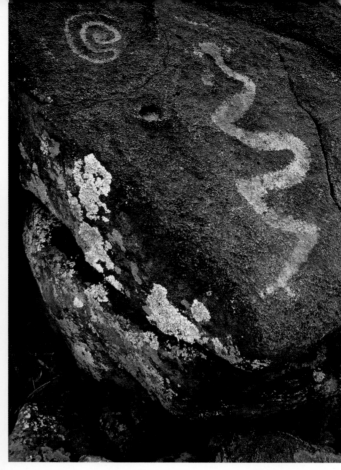

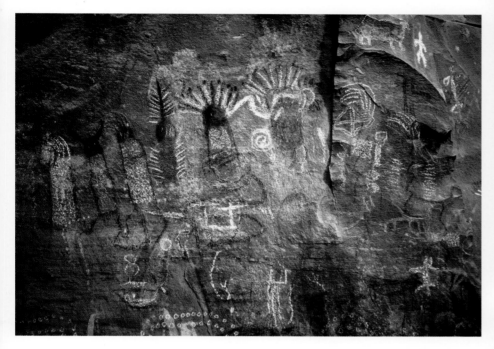

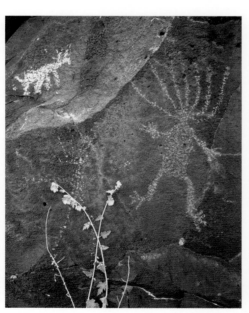

248 Yavapai Tradition (above). *An array of anthropomorphs with horned and feathered headdresses, thought to portray supernatural Kakaka spirits; note recent embellishments with chalk. Yavapai Co.*

249 Central Arizona Petroglyph Tradition (top right). *Two petroglyphic snakes; note bifurcated tail on uncoiled specimen. Yavapai Co.*

250 Central Arizona Petroglyph Tradition (bottom left). *The reasons for painting petroglyphs are not known; however, the added pigment may have enhanced the power of this shamanic figure. Yavapai Co.*

251 Central Arizona Petroglyph Tradition (bottom right). *One interpretation for lines edged with toothlike projections is that they represent drive fences for game animals. Yavapai Co.*

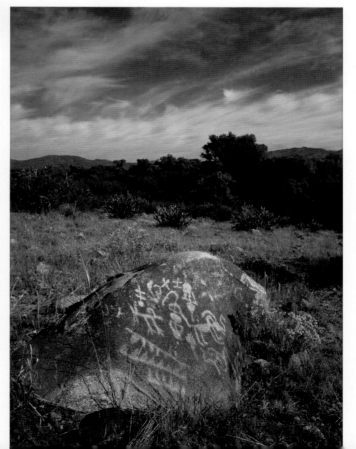

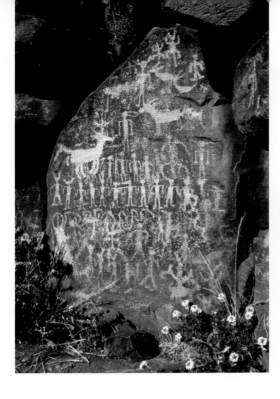

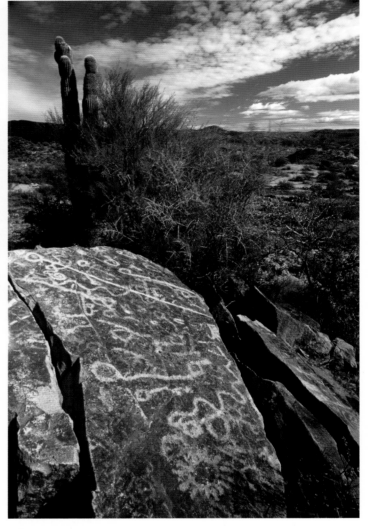

124

252 **Central Arizona Petroglyph Tradition (top left).** *Orderly rows of human figures contrast with haphazardly superimposed quadrupeds. Maricopa Co.*

253 **Central Arizona Petroglyph Tradition (right).** *While these original glyphs conform stylistically with the Western Archaic Tradition, they were repecked by more recent people. Yavapai Co.*

254 **Central Arizona Petroglyph Tradition (bottom left).** *Lifeforms embedded in an amalgam of curvilinear elements, including a cogged wheel and a gridiron. Yavapai Co.*

255 **Central Arizona Petroglyph Tradition (bottom right).** *A pair of solidly pecked birds, one of them colored red. Yavapai Co.*

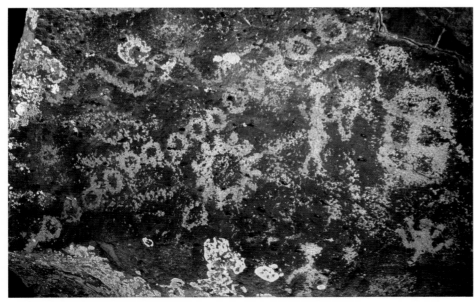

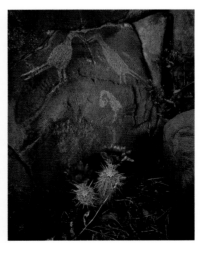

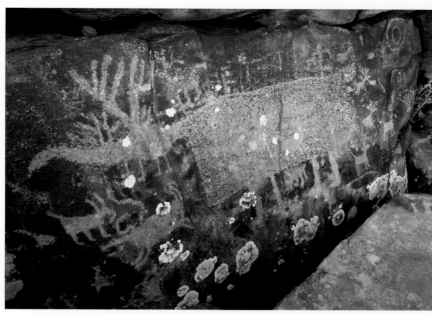

125

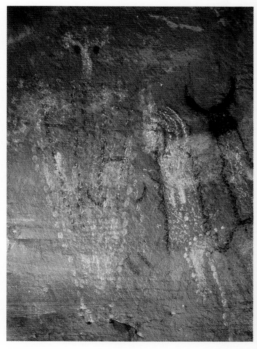

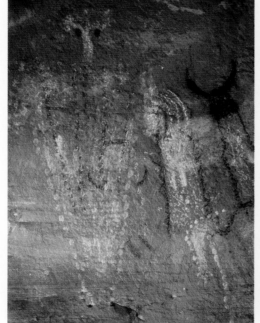

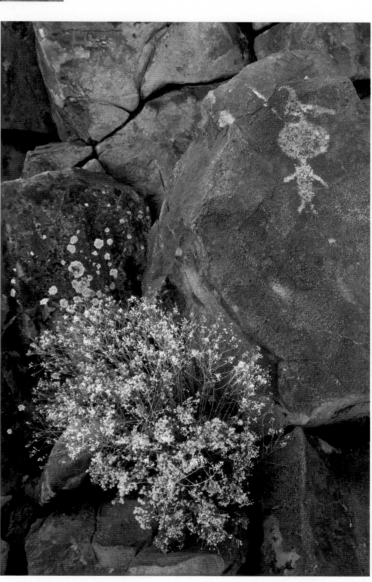

256 Central Arizona Petroglyph Tradition (top left). *A fantastical-looking zoomorph, 160 cm in length (over 5 ft.), with antlers and trunklike attachment to head, surrounded by smaller quadrupeds. Yavapai Co.*

257 Puebloan Tradition (top right). *A kachina mask with circular eyes and star-shaped mouth. Navajo Co.*

258 Puebloan Tradition (bottom left). *A large ghostlike figure with red bug eyes and dot-patterned torso ornaments adjacent to more recently drawn Kakaka spirits; note modern chalking in white. Yavapai Co.*

259 Central Arizona Petroglyph Tradition (bottom right). *An anthropomorph with a bird-topped head, perhaps symbolic of shamanic transformation. Yavapai Co.*

▼

**260 Central Arizona
Petroglyph Tradition.**
*Curvilinear geomorphs
decorating a boulder
cluster along Dugas
Road. Yavapai Co.*

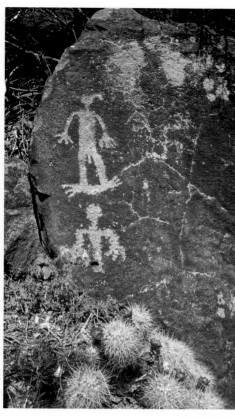

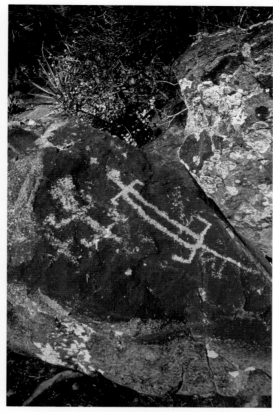

261 Central Arizona Petroglyph Tradition (top left). *A rare depiction, possibly of a couple; note natural hole in rock as part of female anatomy. Yavapai Co.*

262 Central Arizona Petroglyph Tradition (top right). *Two lizardlike creatures, one stylized with a rectangular torso. Gila Co.*

263 Sinagua Pictograph Style (below). *A large stylized rattlesnake in red, white, and black; note denticulate body ornamentation, triangles flanking head, and dot-patterned rattle. Yavapai Co.*

▼

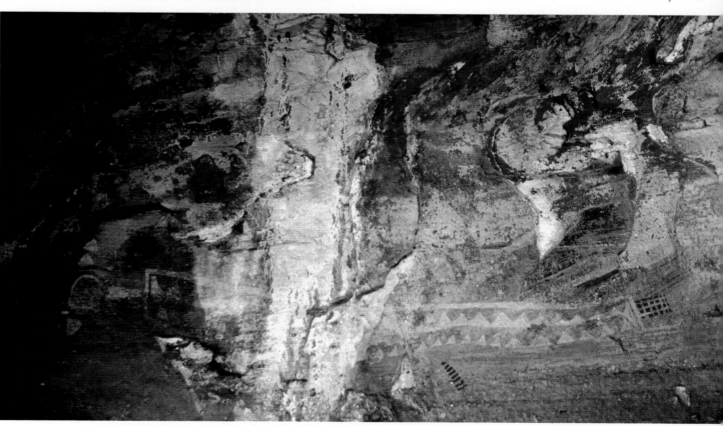

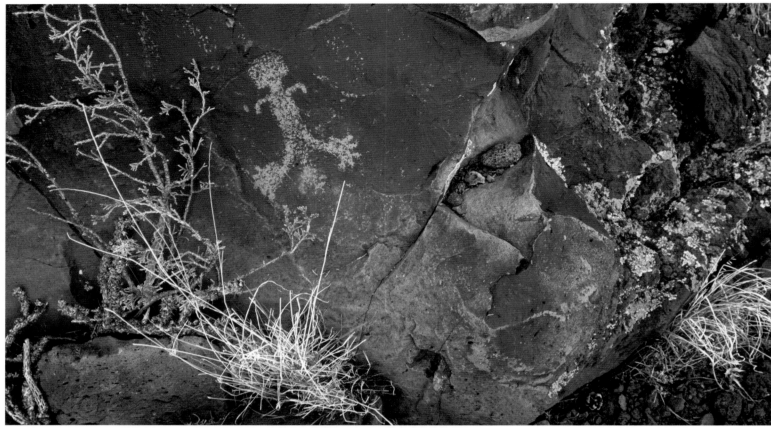

264 Springerville Miniature Style. *A solitary anthropic figure with tiny arms and oversized phallus and feet. Apache Co.*

THE MOUNTAIN ROCK ART PROVINCE

One of the best-watered areas of Arizona, the Mountain Rock Art Province is dominated by rugged mountain terrain with deeply incised drainages ranging in altitude from 1,160 m (3,500 feet) to more than 3,660 m (11,000 ft.). Several permanent streams flow through portions of the province, including the Gila, Salt, Little Colorado, Black, White, and Blue rivers. Covering the eastern corner of Gila County, most of Graham and Greenlee counties, and the southernmost parts of Navajo and Apache counties, the province encompasses a part of the intricately eroded southern edge of the Colorado Plateau and the mountainous area along the upper Gila River (Figure 11).

The umbrella term for the area's predominant rock art in the post-Archeoiconic period is the Mountain Mogollon Rock Art Tradition, named for the Mountain Mogollon people, the archaeologically defined culture that occupied the area and regions around it in Arizona and New Mexico from about A.D. 200 to roughly 1350 (Cordell 1997:203-207). Although the Mountain Mogollon were gardeners and farmers, they depended heavily on gathering and hunting.

This rock art tradition includes both pictographic and petroglyphic styles. Thus far, five styles have been named: the Mogollon Red Pictograph, Chevelon Polychrome and Canyon Creek Polychrome, Springerville Miniature Petroglyph, and Reserve

Petroglyph. All of these show significant variety as well as similarity throughout the province; the areas they occupy, however, do not share common borders. Only examples of the Mogollon Red Style are found throughout the Mountain Province, as well as in nearby areas of Arizona (the Central and Southeast Rock Art Provinces) and New Mexico.

One can assume that the earliest examples of post-Archeoiconic Mountain Mogollon Tradition are probably abstract-geometric designs similar to the motifs of the even earlier Western Archaic Geocentric Tradition. The rock art, largely petroglyphic, which appears as part of the later Mogollon Tradition, consists mainly of extremely variable anthropomorphic images (Stephenson 1997:130-134). It is believed that Mogollon rock art in the northern part of the province was heavily influenced by the adjacent Ancestral Puebloan Rock Art Tradition. The large number of similar motifs in the two traditions throughout the prehistoric era indicates a substantial degree of motif transfer. Good evidence exists that the border between the Ancestral Puebloan and Mountain Mogollon Traditions virtually disappeared after A.D. 1000 (Schaafsma 1980:195-196).

Petroglyphic styles of the Mountain Mogollon Tradition distinguished to date are the Springerville Miniature Petroglyph Style and the Reserve Petroglyph Style, both found in somewhat restricted areas. The Springerville style is named, appropriately, for the large number of unusually tiny petroglyphic images scattered throughout the vicinity of Springerville (Malotki and Weaver 2002:161). Easily recognized due to diminutive size, the style's repertoire of diagnostic motifs contains mountain lions with long back-curved tails, water birds, fluteplayers, masks, and surreal-looking quadrupeds with exaggerated teeth and unnatural appendages. Executed in an aesthetically appealing mode, the motif range suggests that they may have been produced between about A.D. 1000 and 1350.

The Reserve Petroglyph Style (Schaafsma 1980), so named for its occurrence in several river drainages near the town of Reserve in the Mogollon Mountains of western New Mexico, is also encountered in

Figure 11. *Mountain Rock Art Province.*

129

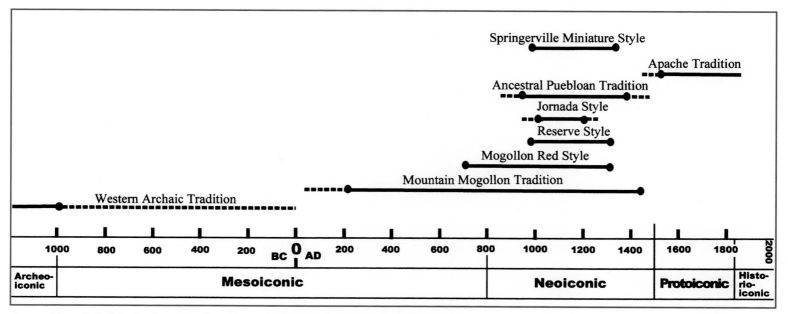

Figure 12. *Mountain Rock Art Province: Approximate time spans of currently known styles and traditions.*

the Mountain Province. Reserve sites exist along the Blue River in the east, and as far west as Show Low, Arizona. Featuring many motifs typical of the adjacent Ancestral Puebloan region, Reserve Style rock art is thought to have been made between A.D. 1000 and 1350.

Sites attributable to the Mogollon Red Style are generally small, with motifs painted in various shades of red, although white, black and orange were at times used. On the basis of associated dated Mogollon habitation sites, the style is thought to range from early in the Mogollon cultural sequence, about A.D. 700, to at least A.D. 1270, a span of almost 600 years.

Two other pictograph styles, the Chevelon Polychrome and the Canyon Creek Polychrome, appeared after about A.D. 1000 (Weaver 1993:86). The Chevelon is the more far-reaching, with sites in the upper end of Jacks Canyon, in both the Show Low and Springerville areas, as far east as the Blue River, and as far south as the Gila River. Despite the name, individual elements generally are monochrome, although bichrome and polychrome motifs are sometimes found. They are usually painted in red, but also occur in black, yellow, white, tan, and blue-green.

The Canyon Creek Polychrome Style is quite different from the Chevelon Polychrome, with typical motifs of the former rendered in white, red, green, yellow, brown and black. The few Canyon Creek

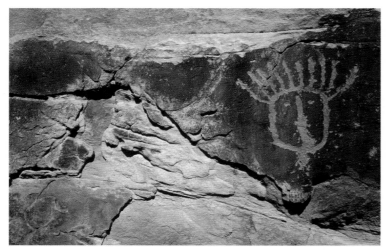

265 Reserve Style. *The depiction of this disembodied head with feather headdress probably represents a supernatural personage. Apache Co.*

sites identified thus far have been noted only in the Sierra Ancha Mountains and the extreme western portion of the Fort Apache Indian Reservation. Haury (1934) believed that these pictographs were produced in the 14th century (i.e., post-A.D. 1300).

Finally, along several of the tributaries of the Upper Gila River northeast of Safford, a number of extremely rare polychrome sites exist that show classic hallmarks of late Mogollon iconography attributable to the Jornada Style. Among the outstanding motifs, painted in red, turquoise, green, and yellow, are a horned serpent, a mountain lion, a fish, a highly ornate anthropomorph, and terraced-cloud designs.

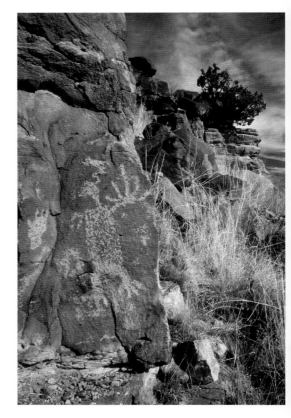

266 Puebloan Tradition. *A poorly pecked anthropomorph with huge extremities and a strange projection from the head. Apache Co.*

From post-A.D. 1600 until the early historic period, essentially the entire Mountain Province was occupied and controlled by Western Apache groups, especially the White Mountain, San Carlos, and Cibecue band-groups (Basso 1983:464-465). A limited number of Apache rock art sites have been reported (Thiel 1995:112), and based on these few known examples, the images appear to consist primarily of pictographs, created with chunks of charcoal used as crayons or painted by using thick black, white, or red pigments applied with fingers or brushes. This Apache rock art is similar, but not identical, to the Apache motifs found in the adjacent Southeast Province to the south (Burton 1988:261-268).

130

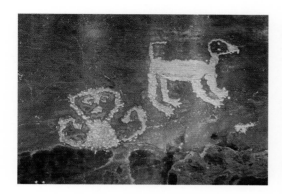

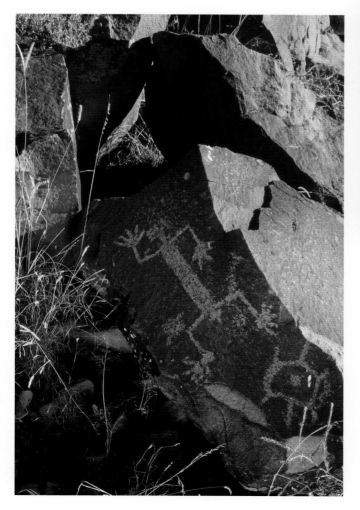

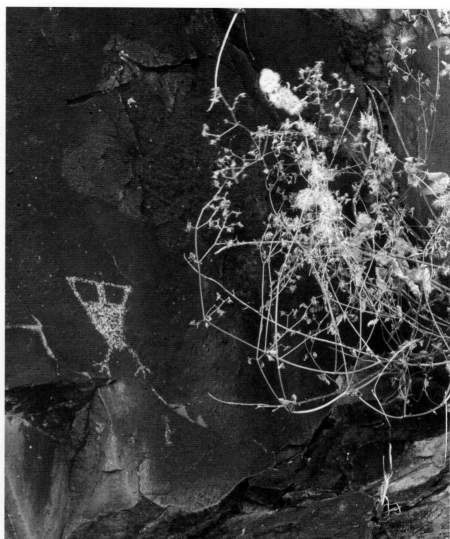

267 **Reserve Style (top left).** *A mountain lion in twisted perspective and a surreal anthropomorphic being. Apache Co.*

268 **Springerville Miniature Style (top right).** *A tiny birdlike image resembling a stylized owl. Apache Co.*

269 **Springerville Miniature Style (left).** *A phallic anthropomorph with extra-large hands and feet. Apache Co.*

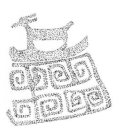

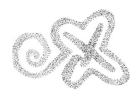

270 Springerville Miniature Style (top left). *Both stylistic execution and uniform degree of repatination point to a single artist of this dreamlike melange of images. Apache Co.*

271 Springerville Miniature Style (top right). *Dissimilar aesthetic standards and skill levels evident in these images indicate that at least three different artists were at work here. Apache Co.*

272 Jornada Style (below). *Ethnographic information from contemporary Puebloan cultures may help shed light on the symbolic meaning of this mountain lion image and the two terraced-cloud motifs. Greenlee Co.*

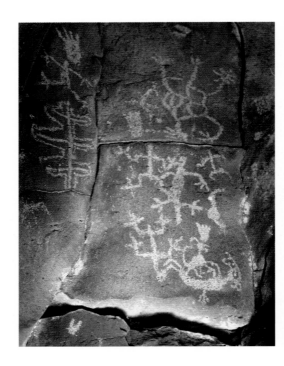

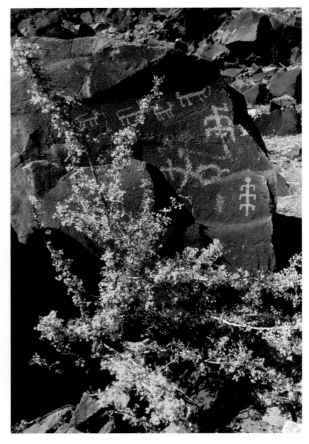

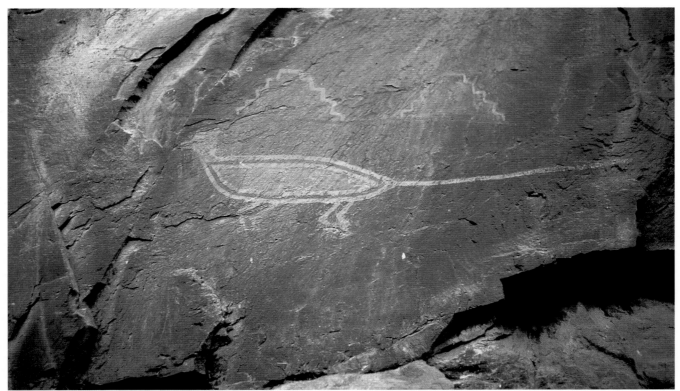

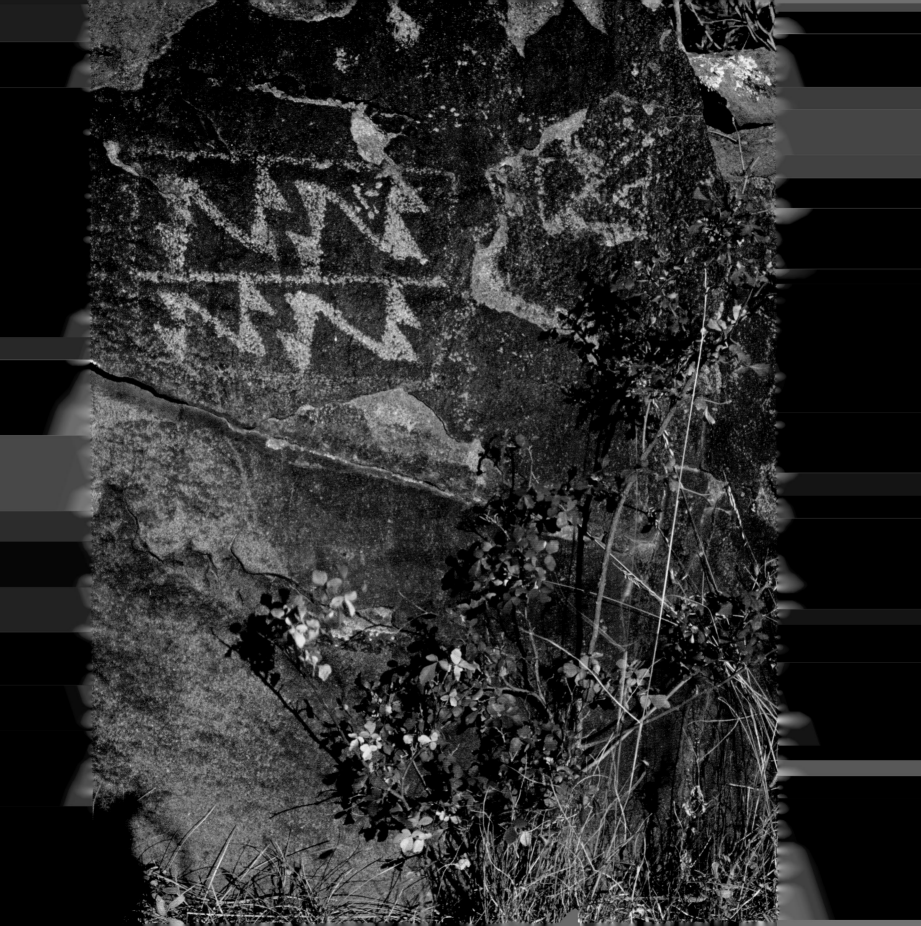

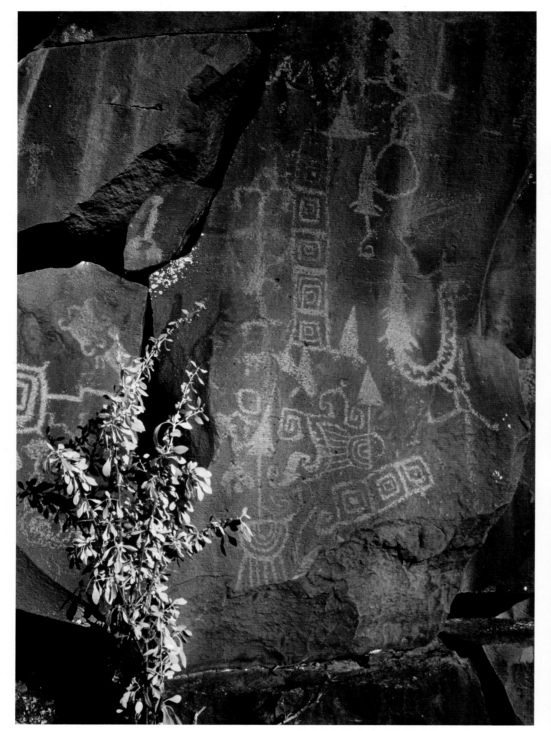

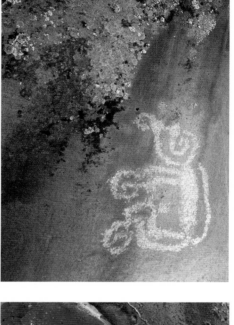

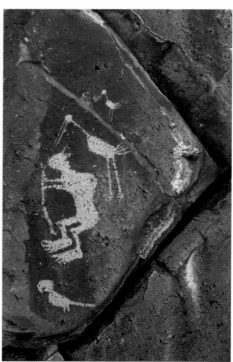

274 Springerville Miniature Style (above). *The realistic depiction of these projectile points may provide clues to the approximate age of these engravings. Apache Co.*

275 Springerville Miniature Style (top right). *A petroglyphic motif stylized beyond the point of identification. Apache Co.*

276 Springerville Miniature Style (bottom right). *Solidly pecked biomorphs, including a staff-carrying, humpbacked human; two herons; and a macaw. Apache Co.*

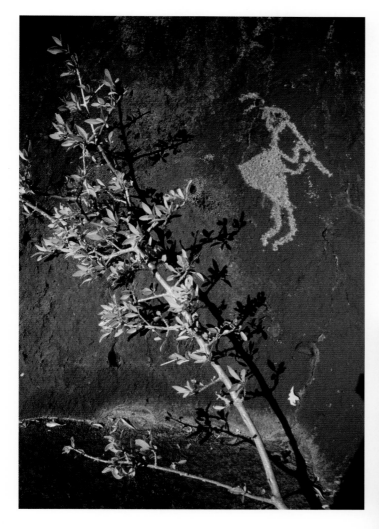

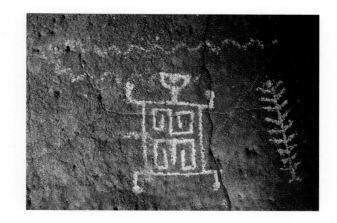

277 Puebloan Tradition (above). *The humpbacked fluteplayer, erroneously called "Kokopelli," and probably the most commodified rock art emblem, has become a symbol of good luck. Apache Co.*

278 Reserve Style (top right). *Human or turtle, plant or centipede, snake or river? Only the original artist could identify these images and inform us as to their symbolic purport. Apache Co.*

279 Jornada Style (bottom right). *A phallic anthropomorph with up-angled, digitated limbs; note rayed head, sawtoothed body contours, and lozenge-chain spine. Greenlee Co.*

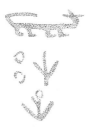

280 Jornada Style. *A unique fish image, a stamped handprint, and a human figure placed over an array of abstract elements of the Western Archaic Tradition. Greenlee Co.*

281 Reserve Style (top left). *The portrayal of upside-down humans is usually thought to symbolize death or a state of trance. Greenlee Co.*

282 Springerville Miniature Style (right). *A playful therianthropic blending of a snake with a humanized head. Apache Co.*

283 Springerville Miniature Style (bottom left). *A bear with oversized pawprints serving as legs. Apache Co.*

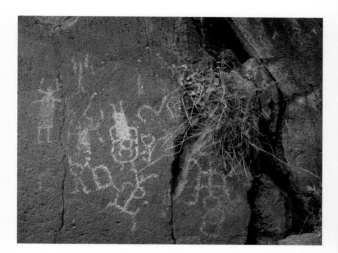

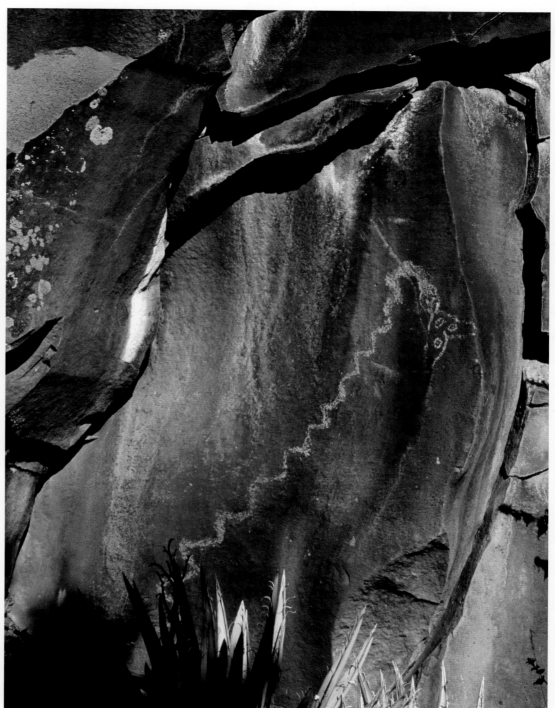

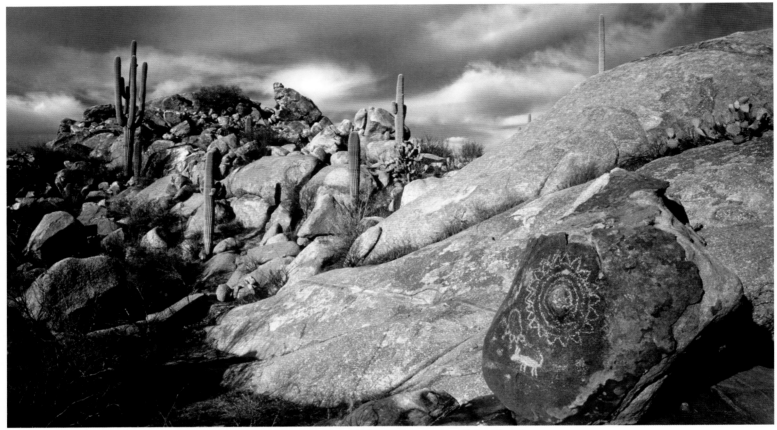

284 Hohokam Tradition. *A circumferential sun design centered around a natural nipplelike protrusion on the rock face. Pima Co.*

THE RIVERINE ROCK ART PROVINCE

Prior to modern dam construction, the desertlike Riverine Province in south-central Arizona was crossed by several major permanent and semi-permanent streams, including the Lower Verde and Salt rivers, the Agua Fria River, the Middle Gila River, and most of the San Pedro and Santa Cruz rivers from the Mexican border to their confluences with the Gila River (Figure 13). The province encompasses a large portion of western Maricopa County, most of Pinal and Santa Cruz counties, as well as eastern Pima, and small sections of Cochise, Gila, and Graham counties.

The post-Archeoiconic rock art predominant in this province belongs to the Hohokam Rock Art Tradition, named after the Hohokam, the archaeologically defined cultural group which occupied the region for nearly a millennium, beginning sometime between A.D. 400 and 600 (Wallace et al. 1995). Initially dependent on small-scale irrigation agriculture, as well as hunting and gathering, the Hohokam evolved essentially uninterrupted, eventually constructing large-scale irrigation systems and large-walled compounds with platform mounds and multi-storied adobe structures. Throughout their cultural development, they produced distinctive ceramics; many characteristics of the culture suggest strong influence, if not actual immigration, from Mesoamerica. The Hohokam disappear from the archaeological record about A.D. 1450, but it is

widely believed that the O'odham (formerly known as Pima and Papago) are their biological and cultural descendants (Ezell 1963).

The Hohokam Rock Art Tradition is more or less synonymous with what Schaafsma (1980) has called the Gila Petroglyph Style. The change from "style" to "tradition" was made on the grounds of the art's widespread distribution, apparent longevity, and obvious internal regional variations. All of these attributes, as well as the fact that in recent years a great deal of survey and documentation work has pinpointed many individual Hohokam rock art locales, suggest that a number of new stylistic classifications may become necessary as study of this tradition intensifies. Images are overwhelmingly petroglyphic and show a high incidence of representational motifs in the Phoenix region, whereas geometrics reportedly prevail in the Tucson area (Thiel 1995). In any case, craftsmanship of the rock art is extremely variable, with crudely pecked glyphs often occurring next to exquisitely incised images. Hohokam pictograph sites are few, scattered throughout the province, and are generally done in red, although black is used at times.

The dividing line between the Hohokam Tradition and two traditions of the adjacent Southwest Province is very fluid, if indeed it actually exists or can be pinpointed for any general time period. For example, many sites in the western portion of the Riverine Province contain numerous examples not only of typical Hohokam Tradition iconography but also motifs diagnostic of the Patayan Tradition. This pattern is especially evident as one travels west from the Phoenix area along the Gila River valley. Furthermore, the Lower Colorado/Gila Ground Figure Tradition, so prevalent throughout

Figure 13. *Riverine Rock Art Province.*

most of the Southwest Province, has penetrated deep into the heart of the Riverine Province. In both cases these overlaps may be attributable to the movement of relatively large populations up and down the Gila River valley in late prehistoric and early historic times, probably due to instability among the Colorado River Yuman groups, especially the Maricopa and Halchidoma (Harwell and Kelley 1983). A more likely scenario, however, for the mixture of traditions is co-residence. Historically, the people living in the Gila Bend area were

139
▼

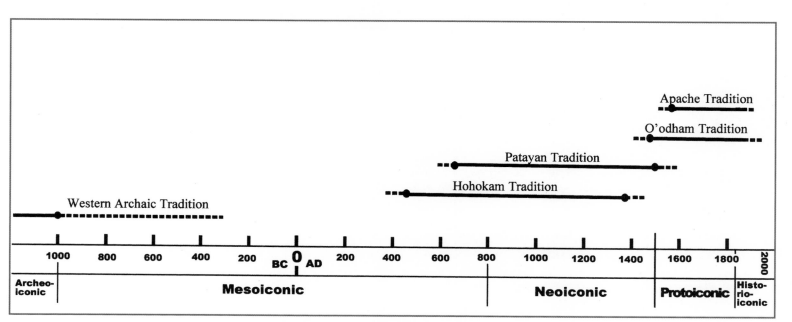

Figure 14. *Riverine Rock Art Province: Approximate time spans of currently known styles and traditions.*

bilingual, so it is safe to assume that the region was also a significant cultural contact point through the ages (Wallace, personal communication 2005).

During the Protoiconic and Historioiconic periods, Yavapai Tradition rock art was probably produced in the northern portion of the province. Similarly, O'odham and Maricopa Tradition rock art may have been made in the central and southern regions. Apache Tradition rock art sites, also produced in these periods, have been identified as well across the southern areas and along the Santa Cruz and San Pedro rivers. Some scratched elements found superimposed over and juxtaposed to Hohokam Tradition pecked iconography are assumed to have been produced, at least in part, by members of these later cultural groups. Scratched Hohokam petroglyphs are very rare and are generally add-ons to pecked glyphs. Most of the remaining scratched imagery resembles that of the Western Archaic Tradition and is usually found at sites where designs of this tradition occur.

140 ▼

None of the Protoiconic and Historioiconic period rock art traditions have been clearly delineated in the Riverine Province. However, since a well-defined Yavapai Tradition has been described for the adjacent Central Province, one can assume that the Riverine Yavapai Tradition is similar, although not identical. Only additional

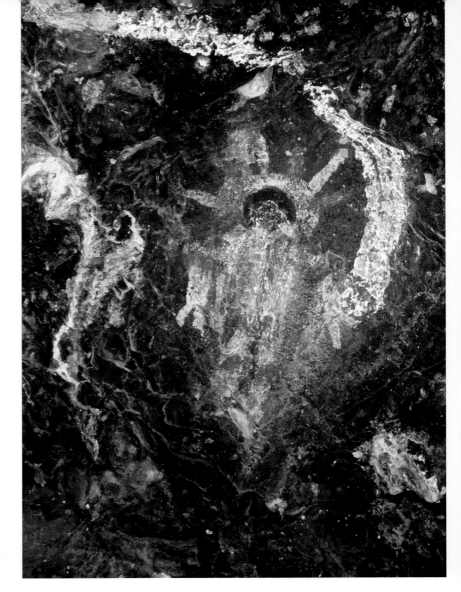

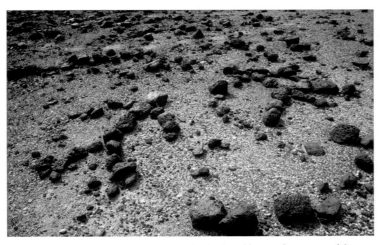

285 Ground Figure Tradition (above). *A pair of rock-aligned human figures, one of them phallic, in a context of nondescript petroforms. Maricopa Co.*

286 Apache Tradition (right). *This multi-colored human image with a dramatic headdress may represent a supernatural Gaan, popularly known as Crown Dancer. Cochise Co.*

investigative work in the northern portion of the province will determine whether or not a separate identifiable Yavapai Tradition can be posited there. The O'odham and Maricopa Traditions, on the other hand, may turn out to so closely resemble each other that they cannot be differentiated. If this is the case, a combined tradition name, for example, the Pima-Maricopa Rock Art Tradition, may be appropriate. The Apache Tradition in the Riverine Province, which is primarily pictographic, appears to be very similar to that described for the Southeast Rock Art Province.

287 **Hohokam Tradition (top left).** *A ventral-node "lizard man" and multiple ringed concentric circles form an organizational whole. Pima Co.*

288 **Hohokam Tradition (top right).** *A rare depiction of a human involved in the everyday task of carrying a load; note the realistic portrayal of knee and elbow joints. Pinal Co.*

289 **Hohokam Tradition (bottom left).** *Several quadrupeds and an anthropomorphic stick figure integrated into a maze of roving lines. Pinal Co.*

290 **Hohokam Tradition (bottom right).** *A semi-circular loopline may represent a game trap; note double crenelated design on extreme right. Pinal Co.*

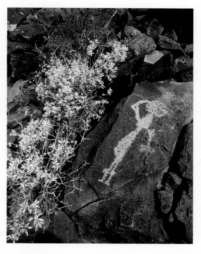

141

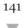

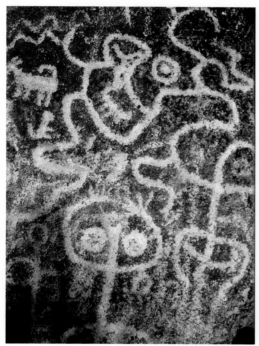

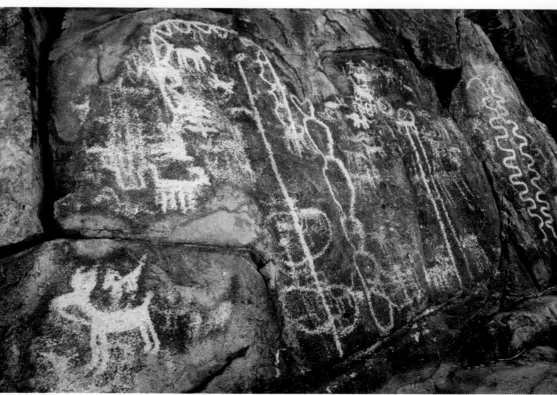

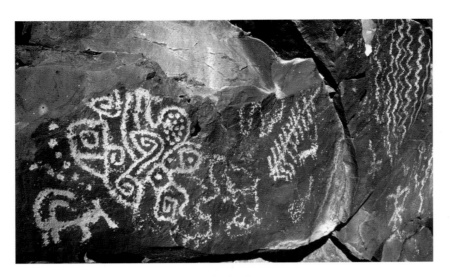

142

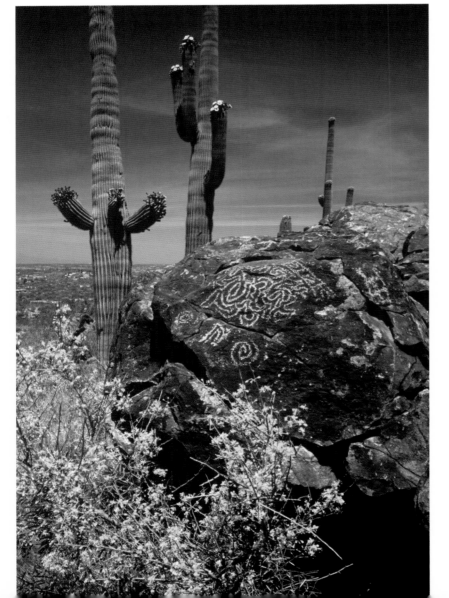

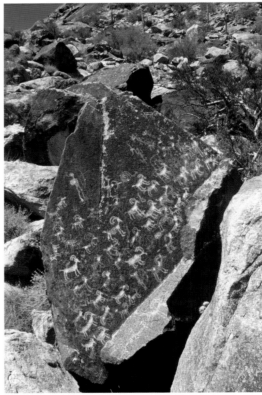

291 Hohokam Tradition (top). *Scrolls, dot patterns, a herringbone motif, and a set of parallel meanders decorate these cliffs. Maricopa Co.*

292 Hohokam Tradition (left). *An ornate squiggle maze and other simple geometrics decorate a boulder face. Pima Co.*

293 Hohokam Tradition (right). *A hunting scene with several bowmen and a flock of mountain sheep, their intended prey; note the fresh punctations on every animal, likely related to hunting magic. Pinal Co.*

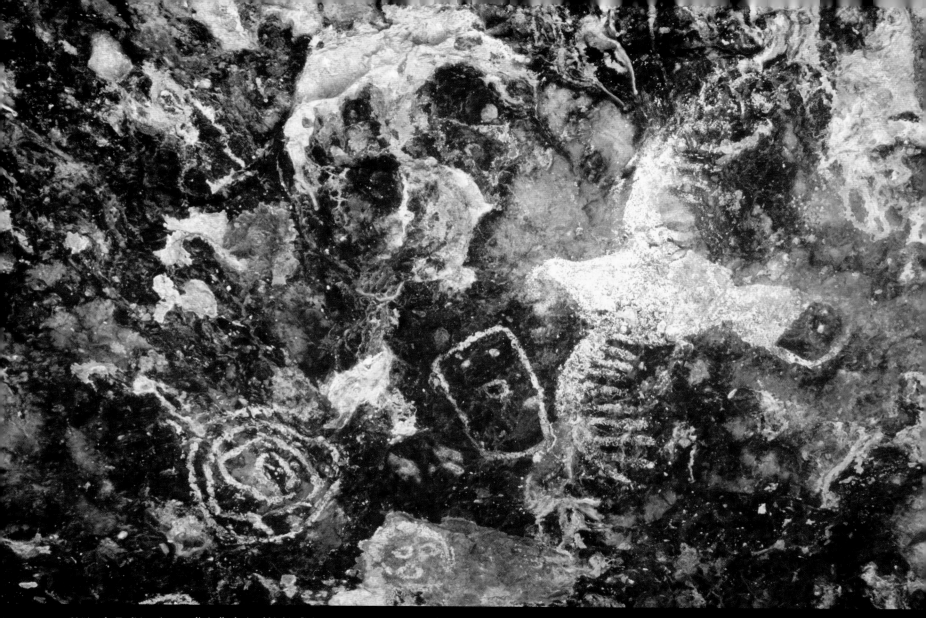

294 Apache Tradition *A naturalistically depicted bird in flight over two masks and a motif of concentric circles, Cochise Co.*

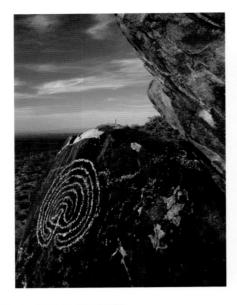

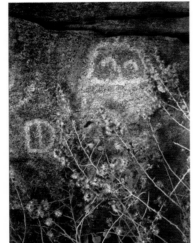

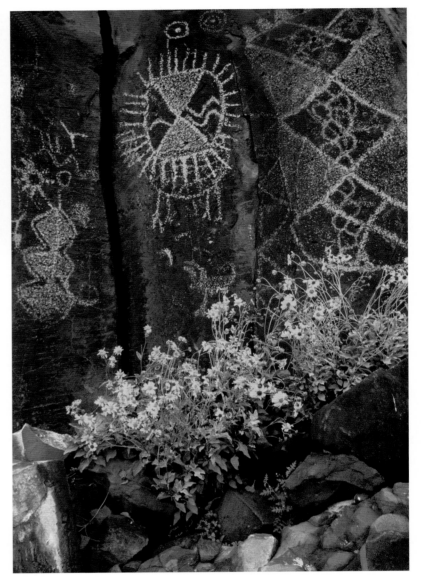

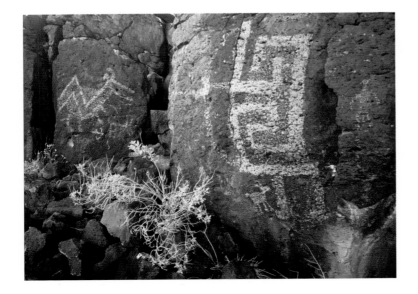

295 O'odham Tradition (top left). *This labyrinthine pattern, found worldwide and known as "Troy Town" after the ancient city of Troy, was used by Pima Indians for their basket designs until modern times. Pima Co.*

296 Patayan Tradition (top right). *Sophisticated diamond chains flanking a rayed hourglass design, superimposed on a quadruped. Maricopa Co.*

297 Hohokam Tradition (left center). *A ghostlike figure hovering next to a bisected oval. Pima Co.*

298 Hohokam Tradition (bottom left). *A boldly stylized archer aiming his bow and arrow at an equally geometrized quadruped. Maricopa Co.*

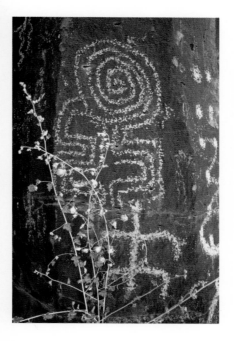

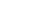

299 Ground Figure Tradition (**top left**). *An anthropomorphic rock alignment of unknown age and cultural affiliation. Maricopa Co.*

300 Patayan Tradition (**top right**). *A spiral connected to a pair of opposed crenelated designs suggests a maze. Maricopa Co.*

301 Hohokam Tradition (**below**). *Animated sheep next to an immobile anthropomorph; note swastikalike design with round instead of angular bends. Pinal Co.*

145
▼

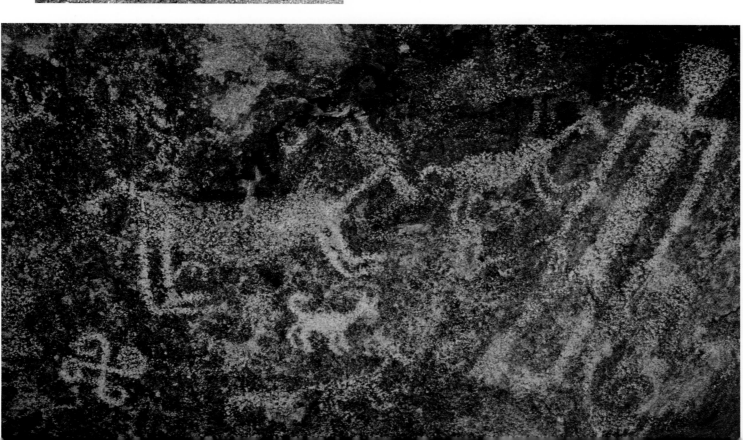

302 Hohokam Tradition. *Believed to be among the oldest rock art in the world, cupules have been made throughout time. Pima Co.*

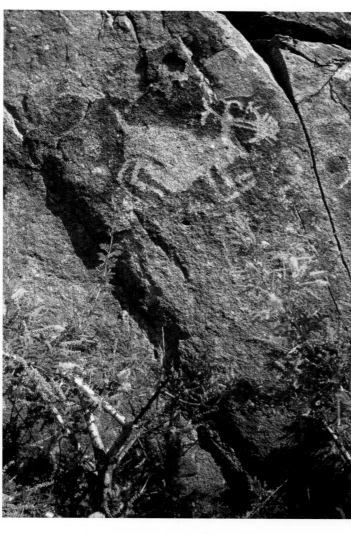

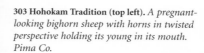

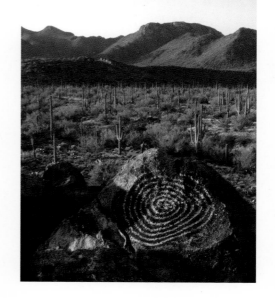

303 Hohokam Tradition (top left). *A pregnant-looking bighorn sheep with horns in twisted perspective holding its young in its mouth. Pima Co.*

304 Hohokam Tradition (top right). *An archaeoastronomical calendar station in the Tucson Mountains; on the morning of summer solstice, a shadow dagger briefly moves to the center of the spiral and then retracts. Pima Co.*

305 O'odham Tradition (bottom left). *This pair of stylized frontal and naturalistic lateral faces creates a nice contrast with the saguaro-studded desertscape; note light repatination which betrays historical origin. Pima Co.*

306 Hohokam Tradition (bottom right). *An enclosed pipette with circular decorations, a motif believed by some to be a stylized emblem of the Mesoamerican rain god Tlaloc. Maricopa Co.*

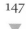

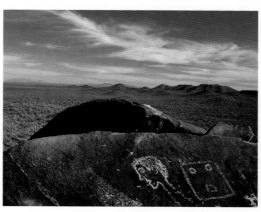

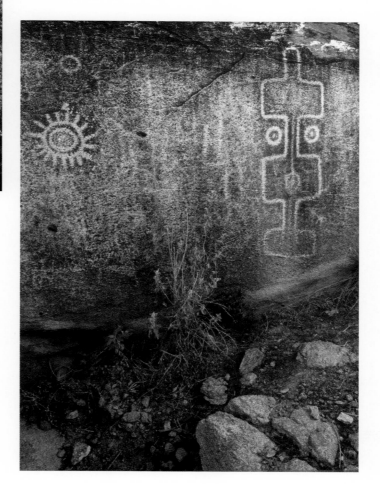

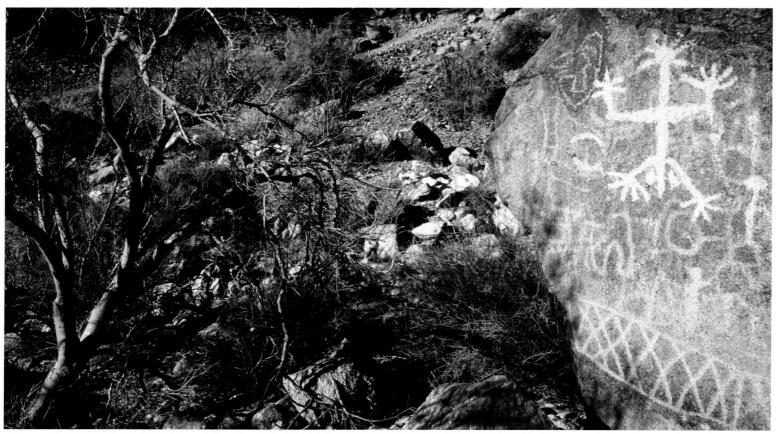

307 **Patayan Tradition.** *A large phallic anthropomorph with rayed head dominates underlying Western Archaic petroglyphs. La Paz Co.*

THE SOUTHWEST ROCK ART PROVINCE

With the lowest elevation and the hottest and driest climate in the state, the Southwest Rock Art Province exhibits typical Basin-and-Range characteristics, with small, rocky, low mountain ranges separated by wide linear basins. The province encompasses all of Yuma County, most of La Paz County, southwestern Yavapai and Pinal counties, and the western areas of Maricopa, Pima, and Santa Cruz counties (Figure 15).

The most prominent paleoart in the Southwest Province is that of the Patayan Rock Art Tradition, named after the archaeologically defined cultural group which occupied much of the region from about A.D. 700 to the time of European contact in the late 1500s

(Cordell 1997). As in the neighboring Northwest Province, changes from the earlier, predominantly abstract-geometric motifs typical of the Archeoiconic Period were very gradual—so gradual, in fact, that it is not possible to identify the transition from late Archaic to early Patayan iconography (Hedges and Hamann 1992). Only relatively late Patayan art can be singled out as distinctive, because abstract-geometric designs reminiscent of the earlier Western Archaic rock art prevail at the majority of the province's petroglyph sites.

With the adoption of agriculture and the production of ceramics about A.D. 700, the tribal groups who became the Lowland or River Patayan began to rely almost exclusively on farming the flood plains

of the Colorado and Gila rivers, living in perishable earth-covered structures scattered along river terraces. They appear to be the immediate ancestors of the present-day Mohave, Quechan, Yuma, Halchidoma, Maricopa, and Cocopa (Stone 1991).

Rock art attributed to the Lowland Patayan, primarily petroglyphic, is widespread in southwestern Arizona. Not surprisingly, the most impressive sites are located along the two river valleys mentioned above and around permanent water sources. Most of the current information about the Patayan Tradition derives from a suite of sites along the lower Gila River between Gila Bend and Yuma, among them the well-known quartet of Quail, Sears, Oatman, and Hummingbird Points. Anthropomorphs with oversized fingers and toes are considered diagnostic. Also common are various avian species, among them spread-winged eagles and water fowl. Additional biomorphs depicted are quadrupeds, including deer and bighorn sheep, featuring idiosyncratic D-shaped bodies, vertical postures, and ball feet in various combinations. Diamond motifs, some with appendages, shieldlike designs, and other geometrics round out the stylistic inventory (Thiel 1995: 80-81). Because of shared iconography at the four above-mentioned locations, a novel style name—Sears Point Style—has been proposed by Hedges and Hamann (1995:

Figure 15. *Southwest Rock Art Province.*

93). Nevertheless, they also concede that there exists, as posited here, a broadly defined Patayan Rock Art Tradition comprising paleoart of similar content extending from the Gila River to the southern California deserts. Pictographic sites which seem to belong to this tradition are few and widely scattered.

Another significant rupestrian expression concentrated in the Southwest Province is the Lower Colorado/Gila Ground Figure Tradition (Stone 1991), examples of which have been found as far afield as Southern California and northern Mexico. This tradition consists of two distinctive types of earth works: geoglyphs or intaglios, and rock alignments or petroforms.

Geoglyphs are found in areas of developed desert pavement. Manufacturing techniques involve tamping or packing down surface gravels into the underlying soil and/or scraping desert pavement peb-

149

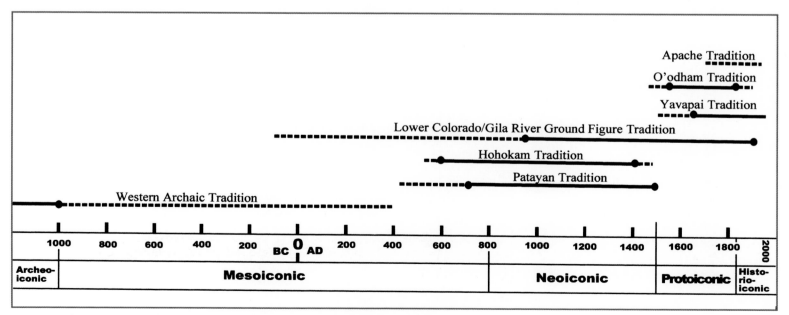

Figure 16. *Southwest Rock Art Province: Approximate time spans of currently known styles and traditions.*

bles and rocks aside to expose the lighter colored subsurface. These geoglyphs are extremely variable in size, ranging in length from about 5 to 195 m (16 to 650 ft.), with the majority falling in the 10 to 50 m (32 to 165 ft.) bracket (Johnson 1985).

Rock alignments are much less common than geoglyphs but are more restricted thematically and show an equal variability in size. They are created by purposefully moving and placing boulders in various configurations. Such images have only recently been recognized in Arizona (Mellinger 2000a; 2000b), and thus far fewer than a dozen have been reported. In this context, several types of rock alignments are excluded: trails or so-called avenues; nonfigurative rock arrangements such as room walls or check dams; boulder piles or gravel mounds that may have served as trail shrines; and cleared areas, referred to as sleeping-circles, all of which do not constitute actual designs.

The distribution of this Ground Figure Tradition suggests that Yuman groups and/or their ancestors living along the lower Colorado and Gila Rivers were most likely responsible for creation of the figures. Ethnographic accounts back up this supposition (Johnson 1985), pointing to the Mohave, Halchidoma, Quechan, and Maricopa as the creators. As yet, there are no definitive clues to determine when the tradition first began. Various researchers differ on when these figures may have been made, with dates ranging between A.D.

1000 and 1860. Some of the ground figures may be of somewhat greater antiquity, particularly the noniconic images, and may be the product of earlier hunter-gatherer bands that roamed the region. Unfortunately, no reliable dating techniques have yet been developed for geoglyphs or petroforms, and chronometric questions will probably not be answered until such techniques become available.

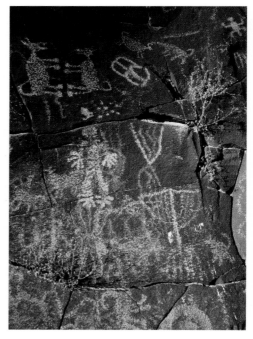

309 Patayan Tradition. *A complex panel with a mix of Patayan and Hohokam elements over an Archaic substrate testifies to the repeated use of the site for perhaps thousands of years. Maricopa Co.*

In later times (A.D. 1500 to 1800), the Southwest Province was most likely dominated by a Yavapai Rock Art Tradition in the north and a Tohono O'odham Tradition in the south. To date, Yavapai Tradition sites are few and have not been recorded in detail or published. However, a well-developed Yavapai Tradition has been identified in the neighboring Central Province and examples will probably eventually be found in the northern part of the Southwest Province as well.

The Tohono O'odham Rock Art Tradition is also not well documented in Arizona because only a few petroglyph sites have been identified and even fewer have been reported (Martynec and Martynec 2003). Pictographs are even less well known, although some thought to belong to this tradition have been noted at a few other sites in the Papagueria, the area occupied by the Papago (now known as Tohono O'odham) at the time of Euro-American contact.

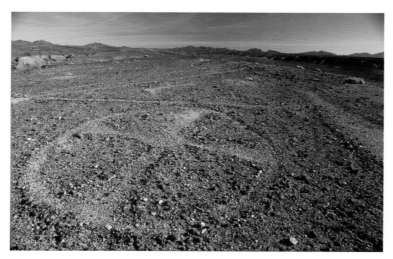

308 Ground Figure Tradition. *A large shieldlike intaglio, probably Patayan, and associated trails typical of Arizona's monumental earth art. La Paz Co.*

150

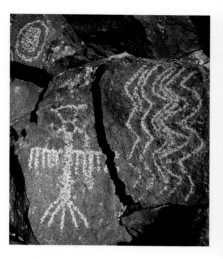

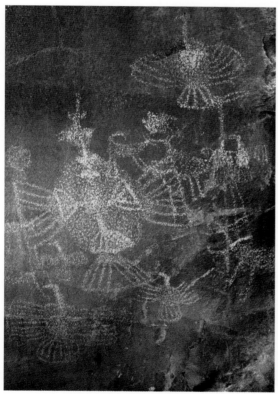

310 Patayan Tradition (top left). *A therianthropic creature combining human and avian features reminiscent of the mythological "thunderbird" motif. Pima Co.*

311 Hohokam Tradition (right). *A perched boulder with a panel of petroglyphs on top of Cumero Mountain. Pima Co.*

312 Patayan Tradition (bottom left). *A flock of spread-winged birds of heraldic quality, distinctive of the Sears Point substyle. Maricopa Co.*

152
▼

313 Hohokam Tradition.
*Various quadrupeds,
some identifiable as
bighorn sheep, in the
context of a possible
hunting scene. Yavapai
Co.*

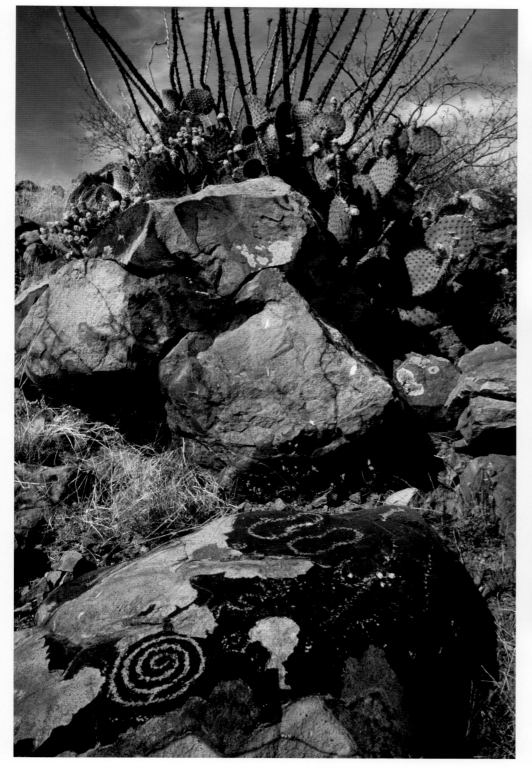

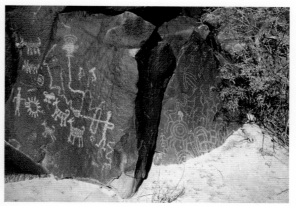

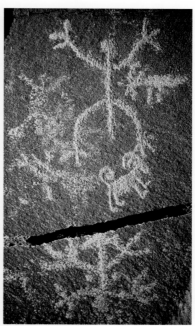

314 Hohokam Tradition (left). *A spiral and a pair of simple, sandalform outlines atop a boulder with exfoliating patina. Pima Co.*

315 Patayan Tradition (top right). *Radically different motif inventories—biocentric Patayan (left) and geocentric Western Archaic (right)—decorate these boulder halves. Maricopa Co.*

316 Patayan Tradition (bottom right). *The anthropomorphic blueprint of this style includes digitate hands and feet. Maricopa Co.*

317 O'odham Tradition (top left). *This disembodied head-neck image with obvious facial features comes close to the art of portraiture. Pima Co.*

318 Patayan Tradition (top right). *A haphazard arrangement of life-forms and abstract curvilinear designs cover this boulder on a talus slope. Yuma Co.*

319 Patayan Tradition (below). *An anthropomorph with large digitate hands commanding a spectacular view of the landscape along the southern Arizona border. Pima Co.*

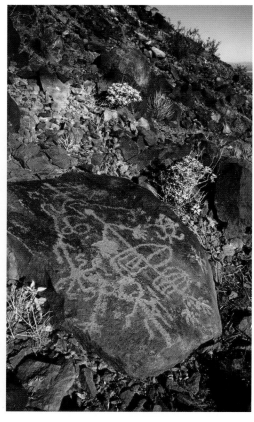

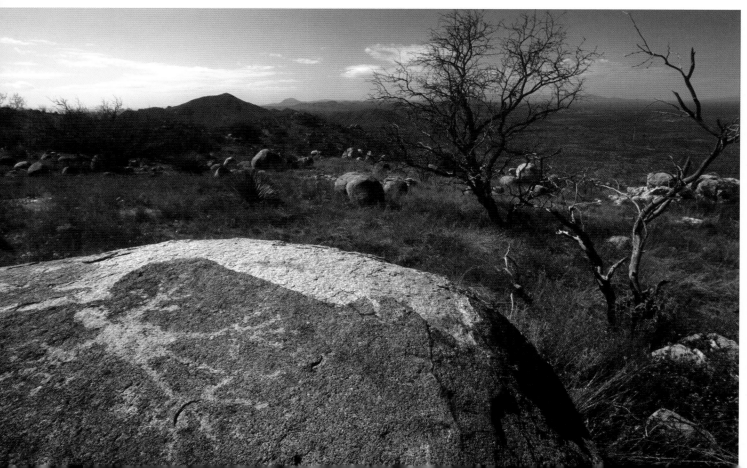

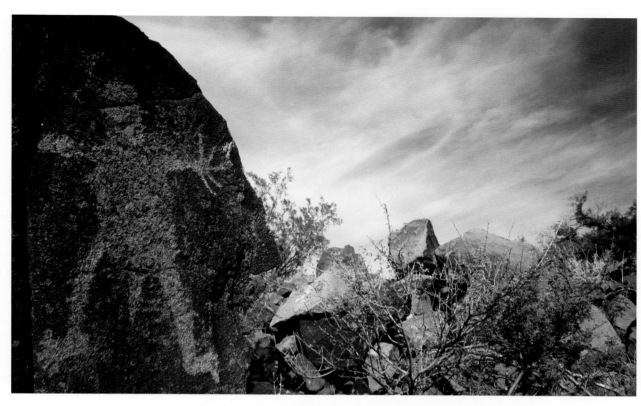

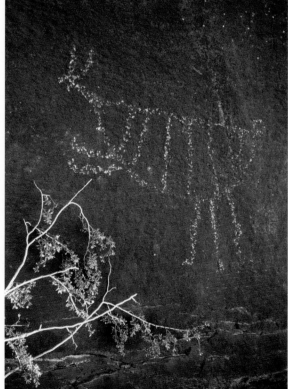

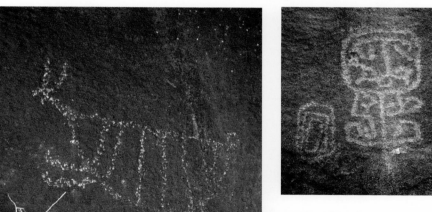

320 Patayan Tradition (top). *A large phallic anthropomorph of nearly life-size dimensions. Yavapai Co.*

321 Patayan Tradition (bottom left). *A dynamic quadruped with D-shaped body diagnostic of the Sears Point substyle. Maricopa Co.*

322 Patayan Tradition (center). *The psychological phenomenon of pareidolia, the misperception of an ambiguous image as something specific, may be responsible for "seeing" a face in this complex geomorph. Yuma Co.*

155

323 O'odham Tradition (bottom right). *A stylized depiction of a rattlesnake with flicking tongue. Pima Co.*

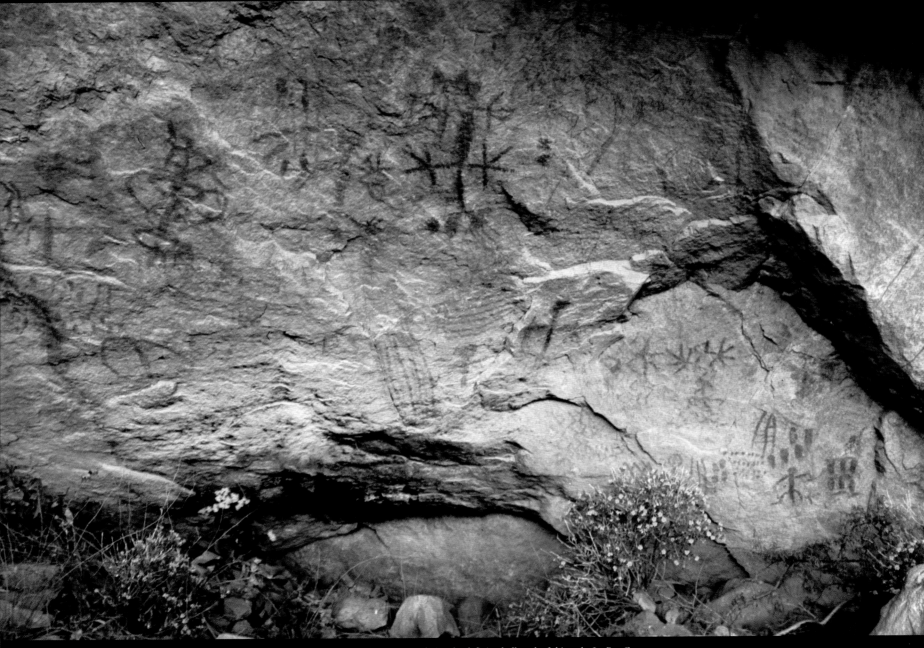

324 Patayan Tradition. *Rare painted versions of anthropomorphs with prominent digits, the defining hallmark of this style. La Paz Co.*

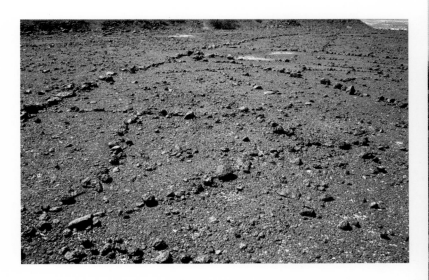

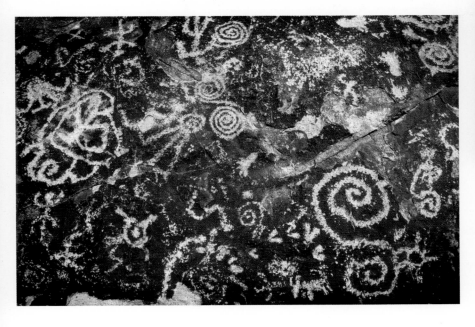

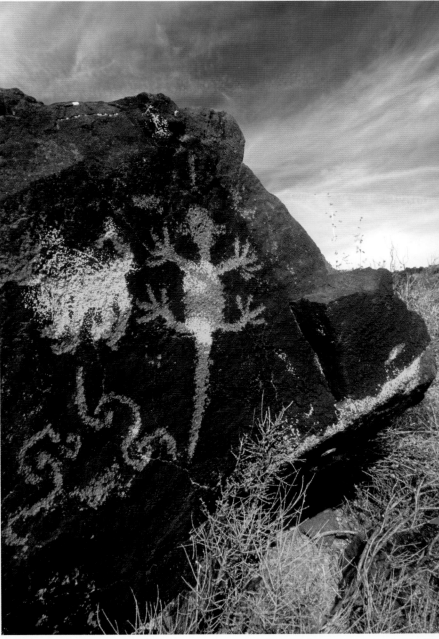

325 Ground Figure Tradition (top left). *Age estimates for noniconic rock alignments of this kind range from several millennia to late prehistoric times. Maricopa Co.*

326 Patayan Tradition (top right). *Invading lichen adds a striking dimension to this grouping of life-forms and scroll-like elements. Yavapai Co.*

327 Hohokam Tradition (left). *Double spirals with antithetical scrolls stand out in this aggregate of engravings. Pima Co.*

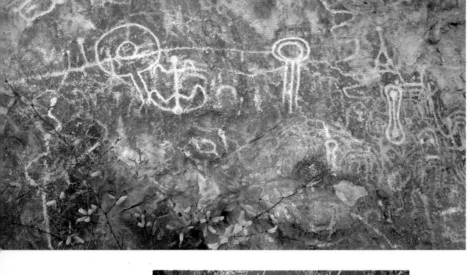

158

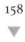

328 Hohokam Tradition (top left). *An assortment of repecked glyphs combines with older, possibly Archaic images, into an eclectic assemblage. Pima Co.*

329 Patayan Tradition (bottom left). *A roving-line abstract next to an iconic upside-down anthropomorph demonstrates the continuous use of basic geomorphs into late prehistoric times. Pima Co.*

330 Ground Figure Tradition (right). *A portion of a monumental snake geoglyph believed to be from the historic era. La Paz Co.*

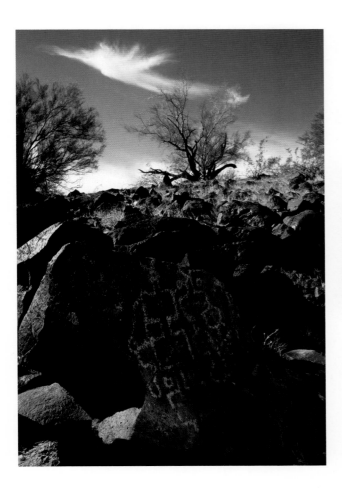

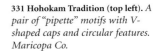

331 **Hohokam Tradition (top left).** *A pair of "pipette" motifs with V-shaped caps and circular features. Maricopa Co.*

332 **Patayan Tradition (top right).** *Elements in black, including a fat-bodied lizard reminiscent of a chuckwalla, superimposed on Western Archaic geometrics in red. Yuma Co.*

333 **Patayan Tradition (bottom left).** *Stick-figure anthropomorphs differing sharply in the graphic conceptualization of their hands and feet. Yuma Co.*

334 **Patayan Tradition (bottom right).** *Abstract geometrics featuring diamond- and chainlike motifs; note serpentine line in negative technique. Maricopa Co.*

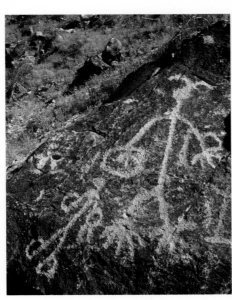

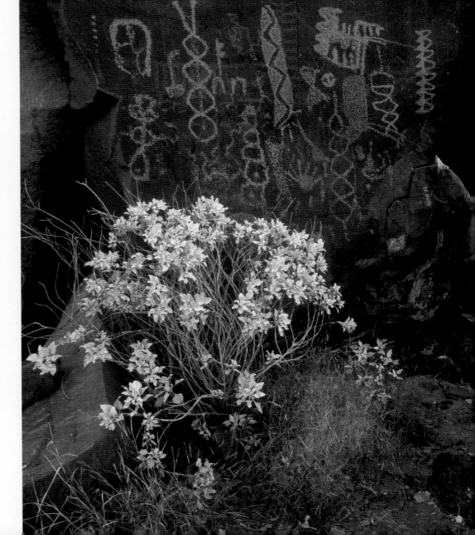

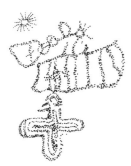

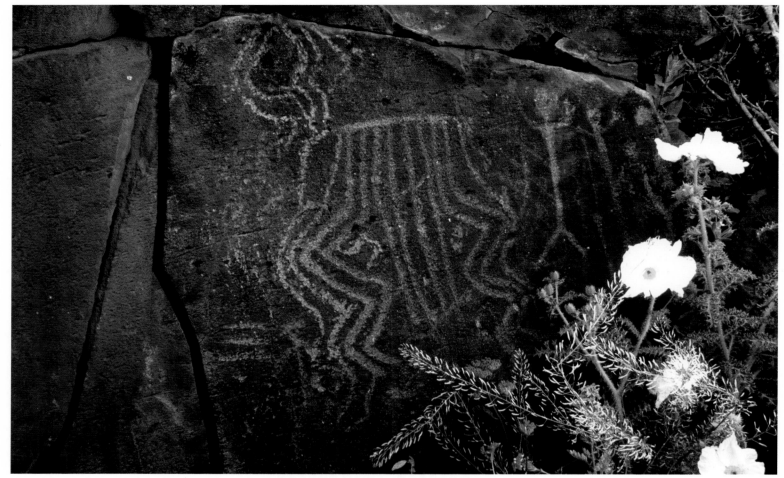

335 Mogollon Tradition. *Stick-figure anthropomorphs with a rake motif featuring symmetrically arranged curvilinear and rectilinear tines. Cochise Co.*

THE SOUTHEAST ROCK ART PROVINCE

A comparatively small region, the Southeast Rock Art Province is a high altitude plateau of more than 1,300 m (4,000 ft.) elevation, dominated by grasslands and mountains. These ranges, including peaks of over 2,750 m (9,000 ft.), make up nearly half of the province's surface area. Despite the elevated topography, there is only sparse permanent surface water, with the only major drainage in the province, the San Simon River, flowing intermittently northwest into the Gila River near Safford. The province encompasses nearly all of Cochise County, the southern portions of Graham and Greenlee counties, and the southeast corner of Pinal County (Figure 17).

The most prevalent rock art in the Southeast Province in the post-Archeoiconic era belongs to the Mountain Mogollon Rock Art Tradition, alluding to the archaeologically defined culture that occupied the region and adjacent areas in southwest New Mexico and northern Mexico from at least 100 B.C. to post-A.D. 1350 (Schaafsma 1980). This tradition includes the Mogollon Red Pictograph and the San Simon Petroglyph Styles and perhaps others yet to be discovered. The Mogollon Red Pictograph Style is the most abundant and widespread, occurring also in the neighboring Mountain Province to the north.

Petroglyphs in the Southeast Province differ from those in the Mountain Province. For example, thus far, no evidence of typical Reserve Style petroglyphs, common in the Mountain Province, has

been reported in the southeast. More characteristic of the Southeast Province is an incised style named the San Simon Petroglyph Style (Weaver, personal communication 2005). It consists of seemingly randomly placed engravings that are generally crudely executed and faint in appearance. Sites classifiable in this style are most often small and widely interspersed, although a few large ones are known.

Scattered along the borders and occasionally stretching into the interior of the Southeast Province are examples of prehistoric styles and traditions that are typically considered foreign to the region. For example, apparent Hohokam Rock Art Tradition motifs, panels, and even whole sites have been noted within the northwestern and western boundary areas (Rucks 1983). Additionally, in the southeastern corner of the province in the foothills of the Chiricahua Mountains and in the San Bernardino Valley, perceived examples of Jornada iconography, a late (post-A.D. 1050) Desert Mogollon Style, are found. This latter style is dominant over a large area of southern New Mexico, parts of west Texas, and northern Mexico (Schaafsma 1980). Sites currently known in Arizona attributable to the Jornada Style contain only petroglyphs and display a limited repertoire of design elements strongly evocative of the Mimbres branch of the Mogollon culture (Riggs 2005). Individual motifs include highly stylized

quadrupeds with decorated bodies and other zoomorphs with surreal traits. Also found are insects, lizards and/or toads, small anthropomorphs with horned headdresses and wands, and elaborate rectilinear and curvilinear designs, including clusters of spirals and zigzag lines. Absent are large ornate anthropomorphs, humanlike faces and masks, horned or plumed serpents, fish, and terraced pyramids known as cloud terraces, all diagnostic of Jornada Style rock art in New Mexico. Whether these relatively sparse Jornada Style elements are the result of Mimbres and/or Jornada Mogollon people inhabiting portions of the Southeast Province, or are graphic mementos of visiting travelers from other regions or the result of some other form of cultural interaction, is impossible to determine at this time. Following the recommendations of Gene Riggs (personal communication, 2006), I am classifying some of the art at the Chiricahua Mountains sites

Figure 17. *Southeast Rock Art Province.*

161

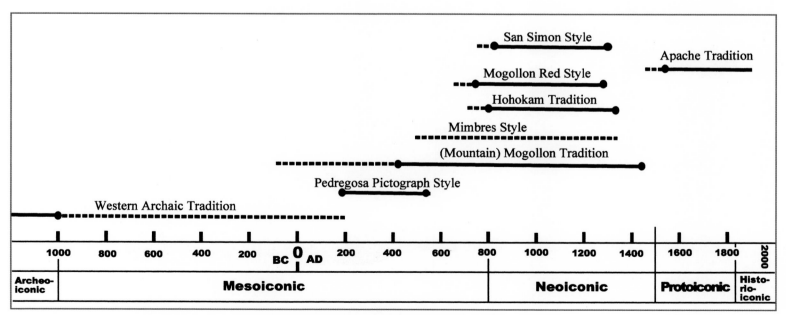

Figure 18. *Southeast Rock Art Province: Approximate time spans of currently known styles and traditions.*

Mimbres Style and am adopting his broad umbrella term Mogollon Tradition for the majority of the images hailing from the Black Draw drainage in the San Bernardino Valley. Future study of the latter area should reveal whether its rupestrian manifestations will merit a more distinct style or tradition name of its own.

An apparently unique rupestrian expression, finally, are the black charcoal-based pictographs from Tom Ketchup Cave for which AMS radiocarbon dates between A.D. 250 and 400 were obtained. Since these dates do not agree with the time frame attributable to several of the diagnostic traits of the imagery and the paintings do not fit any previously described style or tradition, Mary Farrell and Jeffery Burton (1992) have suggested a new, localized style, the Pedregosa Pictograph Style, whose true nature and geographic extent is presently unknown.

In later periods, beginning about A.D. 1550, the Southeast Rock Art Province was the domain of the Chiricahua, San Carlos, and White Mountain Apache, who, like their Athapascan-speaking relatives, the Navajo, were newcomers to Arizona, arriving in the region around A.D. 1500 (Basso 1983). As expected, there is documented evidence for an Apache Rock Art Tradition. Apache images are generally painted, often using a finger-painting technique employing thick white or black paint, although buff, red, yellow, orange, and green pigments were used as well. Dry charcoal drawings and a few pecked designs have also been recorded. At some sites, apparent Apache motifs occur next to or are superimposed on earlier polychrome elements, such as Mogollon Red images or Western Archaic Geocentric Painted images, making differentiation of one element from another difficult. Virtually all the known Apache Tradition sites, which are usually small with relatively few elements, are located in rock shelters and under shallow overhangs. Large Apache sites do exist, however, outside the boundaries of the province, for example, in the Riverine Province to the west, along the Gila River Valley in the Mountain Province to the north, and in New Mexico to the east.

Upper Pima groups, such as the Sobaipuri, also inhabited small portions of the Southeast Province during the Protoiconic and Historioiconic periods. However, although some Upper Pima are presumed to have produced rock art based on their likely direct connection to the prehistoric Hohokam (Ezell 1963), no rupestrian images definitely attributed to them have yet been identified. According to Burton (1988), painted paired anthropomorphs, which occur occasionally in the Southeast Province, may be of Sobaipuri origin.

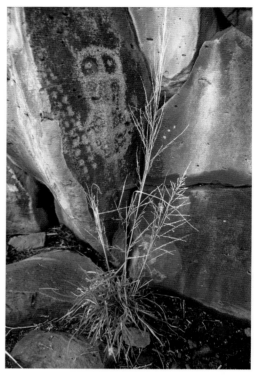

337 Mogollon Tradition. *An owl-like creature with goggle-eyes flanked by parallel dotted lines. Cochise Co.*

162

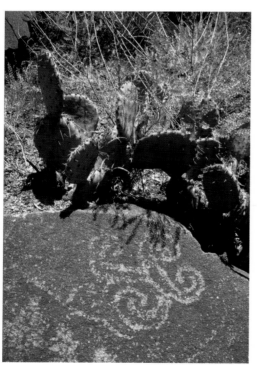

336 Mimbres Style. *These semi-spiral elements form a nice contrast to the harsh environment of this desert setting. Cochise Co.*

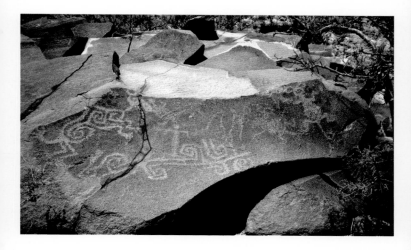

338 Mimbres Style (top left). *A phantasmomorph with geometrized body and realistic extremities evoking fantastical Mimbres-type imagery. Cochise Co.*

339 Mogollon Tradition (above). *To form the eye of this birdlike creature, the artist made use of an existing hole in the rock. Cochise Co.*

340 Pedregosa Pictograph Style (bottom left). *A large ungulate, probably a deer, pierced by a fletched arrow. Cochise Co.*

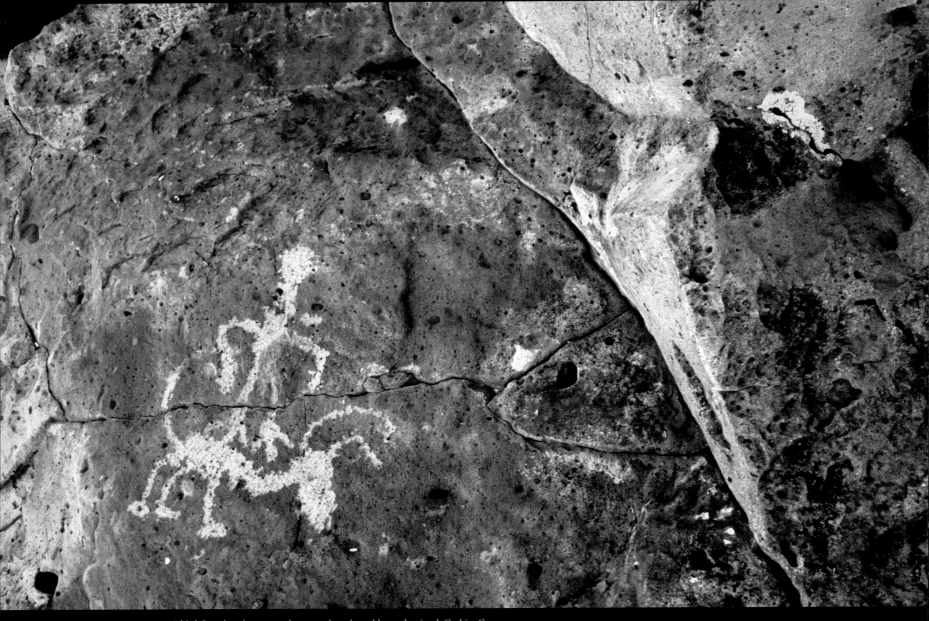

341 Unknown Style. *A bird-footed anthropomorph atop a three-legged horned animal. Cochise Co.*

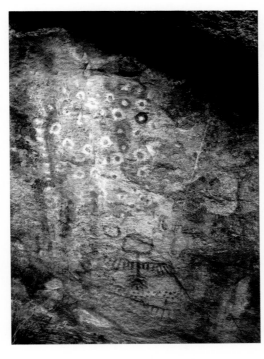

342 Apache Tradition (above). *A shieldlike design with circles and fringes, flanked by a dot-patterned snake and a spread-eagled thunderbird motif. Cochise Co.*

343 Mogollon Tradition (right). *Elaborate configurations of spiralform geometrics. Cochise Co.*

344 Mogollon Red Style (below). *Paired stick-figure anthropomorphic and concentric circles characteristic of the style. Cochise Co.*

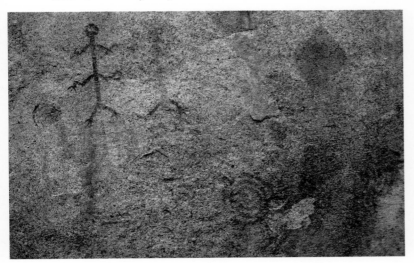

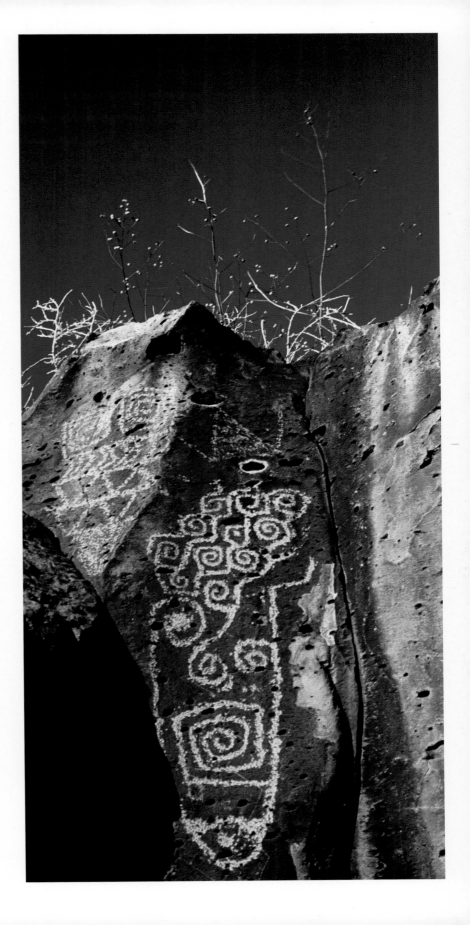

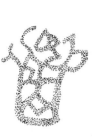

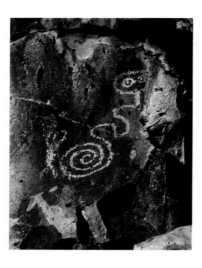

345 Mogollon Tradition (above). *An anthropomorphized serpent next to a human figure may represent a mythical being. Cochise Co..*

346 Pedregosa Pictograph Style (right). *A grouping of mostly solid-bodied biomorphs painted with a charcoal-based pigment. Cochise Co.*

347 Mogollon Tradition (below). *A sawtoothed halo surrounding a set of concentric circles suggests a sun disk. Cochise Co.*

166

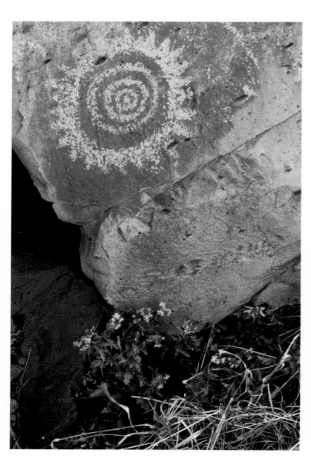

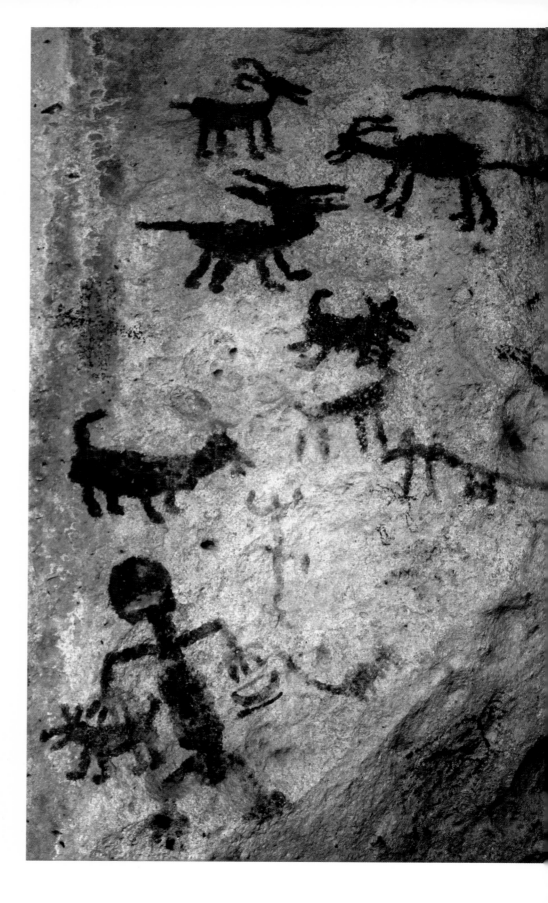

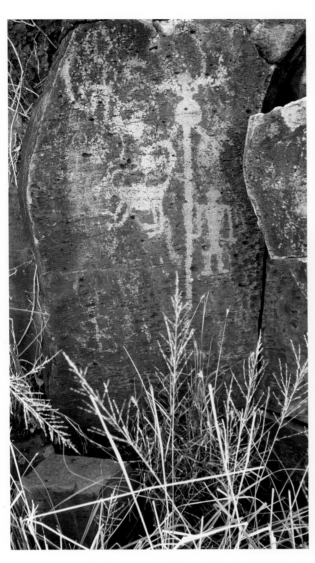

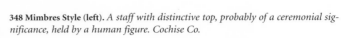

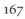

348 Mimbres Style (left). *A staff with distinctive top, probably of a ceremonial significance, held by a human figure. Cochise Co.*

349 Mogollon Tradition (bottom right). *Two insectlike figures with human features, reminiscent of hybrid motifs in Mimbres iconography. Cochise Co.*

350 Pedregosa Pictograph Style (bottom left). *Graffiti, including a masklike face, partially crosscut a possible mountain lion standing over a staff- or atlatl-like object. Cochise Co.*

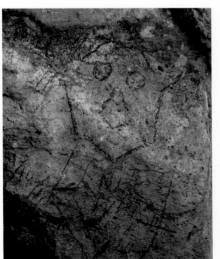

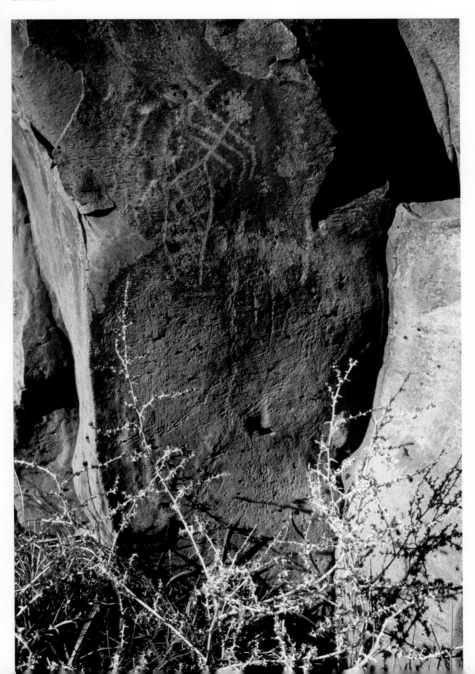

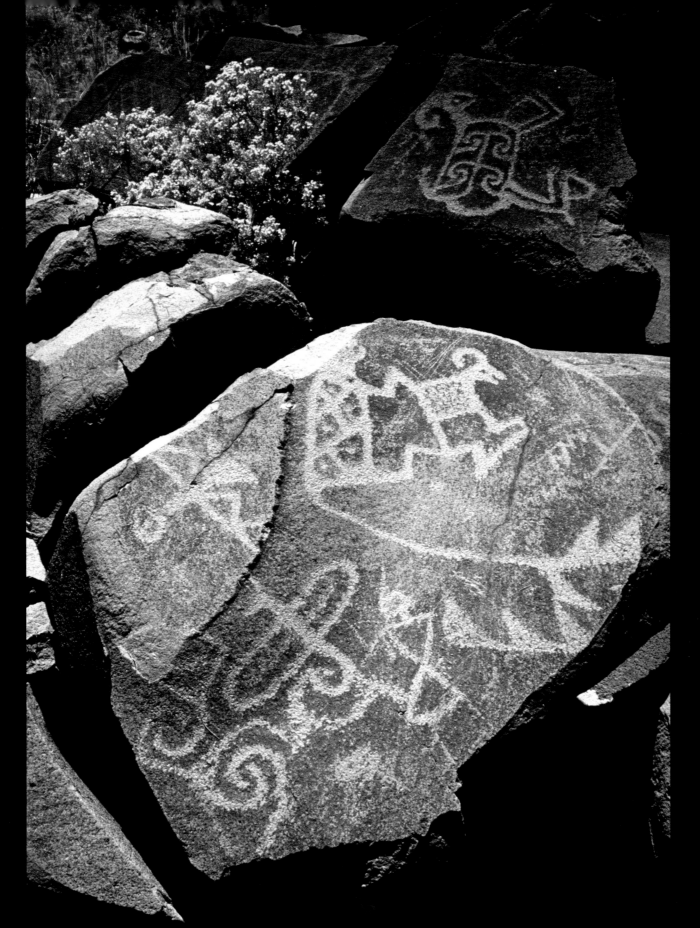

168
▼

351 Mimbres Style. *A boulder cluster covered with images showing all the hallmarks of classic Mimbres iconography; note dragonfly motif. Cochise Co.*

352 Mogollon Red Style (top left). *A simple phallic stick-figure in red, characteristic of this style. Cochise Co.*

353 Mogollon Red Style (top right). *A rare painted petroglyph known as a pictoglyph, here in the form of a stick-figure anthropomorph. Cochise Co.*

354 Cienega Style (bottom). *A collection of dart points, detailed enough to suggest a possible identification as a Cienega type of the Late Archaic (ca. 800 B.C. to A.D. 150). Cochise Co.*

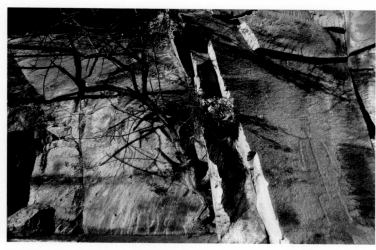

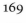

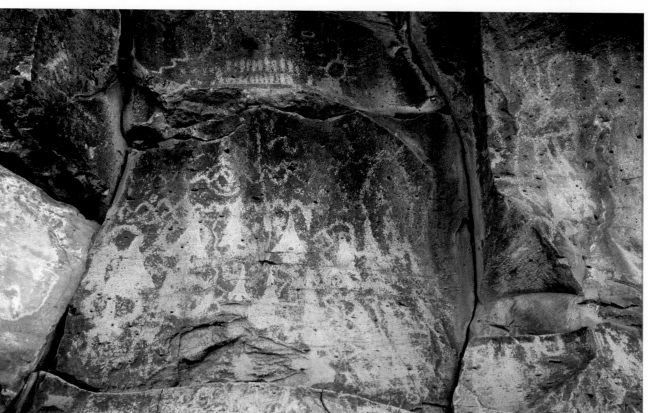

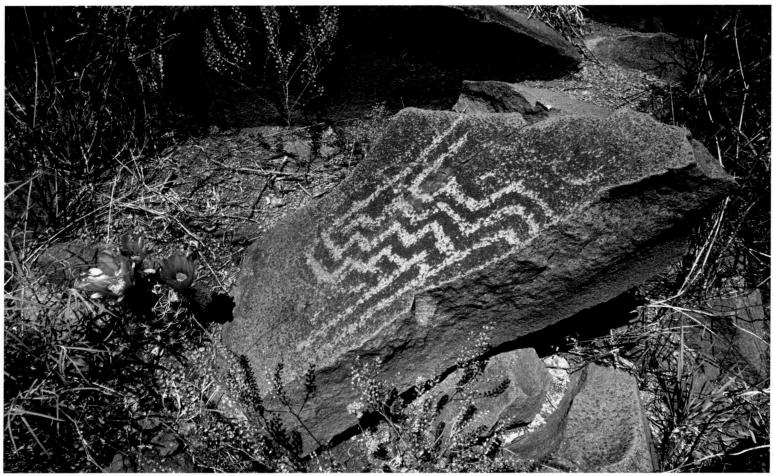

355 **Mogollon Tradition.** *"What does it mean?" is perhaps the most frequently asked question about rock art; it is also the most challenging to answer. Cochise Co.*

INTERPRETATION OF ARIZONA'S POST-ARCHAIC ROCK ART

With the proliferation of regional rock art styles in the post-1000 B.C. period, it is no longer practical, within the scope of this book, to address each style individually in terms of possible function and motivation. Instead, I will sketch an overview of some of the most prevalent theoretical positions that have been advanced to shed light on the various post-Archaic iconographies. As mentioned earlier, this interpretive approach will be governed in part by the concept of human universals, those commonalities that underlie the physical and psychological make-up of human beings. Analogies with relatively recent cultures, where traditional knowledge is still alive, will also be cited and will be applied to more ancient populations that

have long since disappeared. In doing so, I will draw primarily on the large corpus of ethnological information I collected during my work with the Hopi, as well as on other present-day Native American groups in Arizona. I am well aware, of course, that there exists a vast temporal gulf between their cultural conventions and those of the prehistoric artists, despite the fact that the Hopi are generally considered to be distant descendants of the Ancestral Puebloan people of the Mesoiconic era. According to Hopi oral tradition, however, a sizable number of their clans trace their roots back to the Hohokam culture of the Neoiconic period (Ferguson 2003).

For at least tens of thousands of years, all humans, equipped with

the same model brain and born into the same model universe, are thought to have behaved fundamentally in the same manner, experienced the same emotions and displayed the same drives and needs. It would be curious, indeed, if these universal characteristics had not shaped human perception of the world and hence been "externalized and probably communicated" (Bednarik 1993b:71) in such cultural artifacts as rock art. Dissanayake (1992a:34) goes further and in essence argues that the making of art, including such images as rock art, is a natural behavior of human beings, that is, "something that humans do because it helps them to survive, and to survive better than they would without it." This can also be assumed to be true for religion or spirituality; that is, the propensity to believe in gods or the supernatural, which is a quintessential trait of the human condition. While humans themselves are regarded as a product of biological evolution, the notion that religious behavior, spirituality, and the ability to experience various religious states could also have arisen from the process of natural selection has only recently been accepted. Religion, considered a societal universal with "a strong genetic basis" (Ramachandran and Blakeslee 1998), is generally seen by evolution-

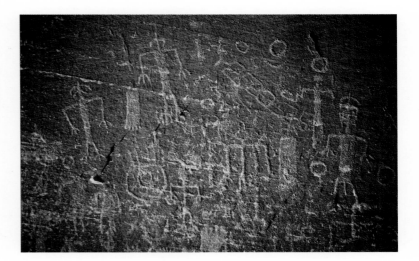

ary psychologists as having had beneficial adaptive value in the struggle for survival, and to have conveyed selective advantages to those who developed a propensity for it. While it is unrealistic to see religious elements in all actions, behaviors, and experiences of traditional societies, as, for example, advocated by Mircea Eliade's (1959:202) notion of *homo religiosus,* I strongly believe that much of the world's paleoart was motivated by what is traditionally called "religion." The etymology of the Latin word *religio—re* "back" and *ligare* "to tie, fasten"—implies that people, rather than being spiritual drifters, are instead spiritually "tied back," that is, oriented towards greater-than-human configurations of reality. Religion, used here in a very broad sense, is perhaps best defined as a "magico-spiritual strategy for life's sake."

Shamanism

As mentioned previously, it is generally accepted that the oldest and most prevalent of humankind's religious ideologies was of a shamanistic nature. Biologically grounded in the neuropsychological constant of the human nervous system (Winkelman 2002), shamanism is widely held as the basis for rupestrian art, with many of its motifs attributed to hallucinatory visions resulting from altered states of consciousness. Although some researchers see these altered states as the source of practically every aspect of the art, and interpret virtually all motifs as metaphorical and symbolic of the shaman's ecstatic experiences, I view shamanism as merely an interpretive "key" to imagery of

356 Apache Tradition (above). *There is no globally valid blueprint for determining the meaning of rock art, so only a broad explanatory framework can be advanced. Pima Co.*

357 Chinle Representational Style (top right). *It is unrealistic to expect that a single interpretive hypothesis can explain a corpus of art consisting of hundreds of thousands of images produced over many millennia. Coconino Co.*

a surrealistic nature. Not every shamanistically appearing aspect of the art necessarily originated in trance-induced altered states. Ordinary dreams and vision quests may also have inspired nonreligious specialists in their creation of rock art.

Although dominant thinking links shamanism almost solely with hunter-gatherer societies, the gradual demise of Archaic hunting and gathering bands and the emergence of horticulturists and farmers in the post-Archeoiconic era did not necessarily lead to the extinction of shamanism, at least not in Arizona. The development of priestly societies engaged in fertility and rainmaking ceremonies, especially in the Neoiconic era, may have decreased the power that shamans enjoyed in earlier times, but the shaman's survival was assured because agriculturalists had the same metaphysical, psychic, healing, and fertility needs as their Archaic ancestors. As La Barre (1970:136) has pointed out, shamanism continued to live on among the agricultural Pueblos of North America because weather control, an attribute of the old shaman, was now needed more than ever. Tribal shamans inevitably became rain priests. The same idea is echoed by Louise

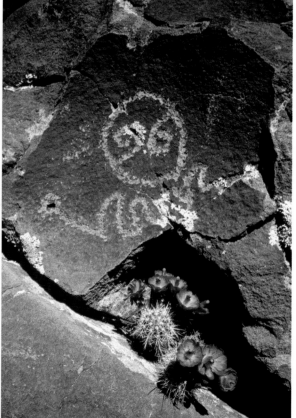

358 Puebloan Tradition. *The interpretation of rock art imagery is essentially limited to postulating a range of possible functions and motivations for the art. Gila Co.*

359 Central Arizona Petroglyph Tradition. *Insights from such diverse fields as general anthropology, neuroscience, and evolutionary psychology are useful in shedding light on the phenomenon of rock art. Yavapai Co.*

Lamphere (1983:755) when she states that "Pueblo religion seems to be based on an essentially shamanistic world view adapted to the needs of an agricultural people," except that among sedentary farmers "priests of powerful societies rather than shamans" became the most influential in their respective communities.

Ample proof for the longevity of shamanistic influence in the American Southwest comes from an ethnographic review of Hopi oral literature, religion, and mythology (Malotki and Gary 2001). Direct ethnographic data for Hopi shamanic practices are tantalizingly few, but shamanic specialists, linguistically clearly differentiated from medicine-men and healers in the Hopi language, were still performing in the early part of the 20th century. A great deal more indirect evidence can be garnered from a larger body of surviving witchcraft lore that clearly demonstrates that shamanism was once firmly institutionalized among these agriculturalists. Thus sorcerers and witches, the "black magic" counterparts to the "white magic" practicing shamans, are portrayed in their ability to transmogrify themselves into various animals, travel nocturnally in the guise of birds and insects, acquire power from their "pets" or animal familiars, employ charming songs to allure game animals and sexually desirable females, influence the weather, and cause crop failures (Malotki 1993:149-184). Additional motifs, embedded more specifically in shamanic scenarios, can be filtered out from the large body of Hopi narratives. Notable among these are magical flight, healing and the power to restore life, human-animal transformation, tiered cosmolo-

173
▼

360 Central Arizona Petroglyph Tradition. *While the rock art researcher may deplore the gradual invasion of lichen on this canvas, in the eyes of the photographer the splashes of color enhance these mono-chrome petroglyphs. Maricopa Co.*

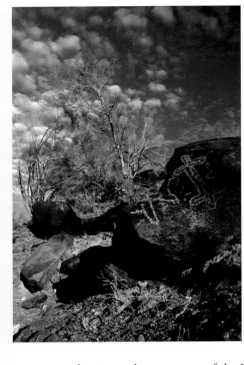

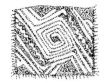

gy, world tree or *axis mundi*, dismemberment and skeletonization, and guardian spirits and conductors of departed souls (Malotki and Gary 2001).

In addition to those of the Hopi, religious practices performed by shamans are also reported to have survived in Arizona into the historic era among the Yuman-speaking groups of the Colorado River. These were, according to Lamphere (1983:744), "both the agricultural peoples of the Lower Colorado (Mohave, Maricopa, Quechan, and Cocopa) and the predominantly hunter-gatherer groups of the Upland area (Havasupai, Walapai, and Yavapai)." She also mentions the characteristics of a shamanistic ideology: for example, in the importance of obtaining power through a dream or a visionary experience; in the idea of a tiered cosmos; in descriptions of Apache curing; and "in the spectacular magical feats performed by members of the Zuni medicine societies" (1983:746; 755). An extensive body of shamanic lore is further cited by Ruth Underhill (1946:263-283) for the Papago (Tohono O'odham).

According to Ken Hedges (1982), evidence that "the visionary imagery experienced by the shaman may be the source of design elements, motifs, and compositions" is found in many types of rock art, including Archaic. His observation also holds for Arizona's post-Archaic paleoart and, although not scientifically testable

174
▼

or refutable, shamanistic themes of the kind listed previously occur prolifically, often in the form of symbols and metaphors, in much of the state's post-Archaic iconography. In particular, they are encountered in styles of the Mesoiconic period when post-Archaic populations were not yet full-fledged farmers and, for this reason, are sometimes characterized as "forager farmers" or "farming foragers" (Smiley 1993:252).

Sympathetic Magic

Sympathetic magic, also known as compulsive magic, is a general anthropological hypothesis that, within a broadly conceived framework of religion, humans strive to attain certain desired results or events by ritually impersonating them, acting them out dramatically, or, in the case of rock art, depicting them graphically. Based on the principle of "like begets like" and the notion that an image can stand as a substitute for its subject, the most obviously practical objective behind this magico-religious strategy was that of aiding in survival. Thus, the abstract motif of the rake, so frequently encountered in Arizona's rock art corpora of the Archaic but also attested throughout the post-Archaic era, may have been employed for the hoped-for occurrence of rain. The same outcome might have been envisaged when later Puebloan people depicted water beings such as frogs, tad-

361 Hohokam Tradition (top left). *Human universals, those features of culture, behavior, and psyche that all people share without exception, are especially helpful in illuminating the emergence and function of rock art. La Paz Co.*

362 Hopi Tradition (right). *Information on contemporary Hopi iconography such as the horned-serpent motif or the falling-rain symbol allows one to plausibly interpret much of the imagery of this early historic panel. Navajo Co.*

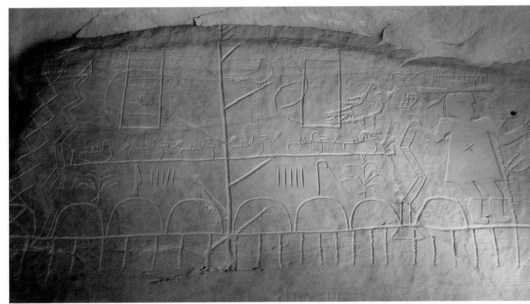

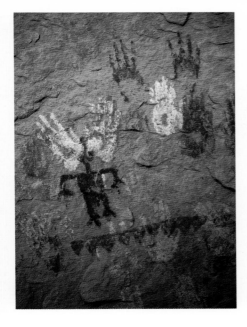

poles, and toads. Because these creatures live near water, their rupestrian images may have "aimed at encouraging rainfall" (Young 1985:13). Finally, even the occasional portrayal of a human figure transfixed by an arrow may not have been intended as a literal depiction of an act of violence but, reminiscent of the voodoo practice of sticking pins in wax figures, may have been designed as an evil spell casting injury or death on an enemy.

It is in regard to rupestrian game animals that the concept of sympathetic magic is most often mentioned. Generally referred to as the sympathetic hunting magic hypothesis, it was one of the first theories attempting to explain the nature and purpose of European Ice Age paintings, and later came to dominate interpretations of hunter-gatherer art of the American West as well. Eventually sharply criticized, primarily because it was applied in wholesale fashion to explain the existence of entire bodies of rock art, it fell into disfavor and was rarely mentioned in interpretive paradigms. The theory certainly does not apply to Arizona's Archeoiconic iconography. In the Western Archaic Tradition, animals are basically nonexistent, and many of the rock art sites are not located along game migration trails or in the proximity of hunting blinds. In Arizona's later biocentric Archaic art, potential game animals, while occurring in great profusion and together with human figures, have never been found embedded in obvious hunting contexts symbolizing hunter and prey.

The situation changes considerably, though, in post-Archeoiconic times, especially during the Neoiconic period when hunting-themed motifs abound. To be sure, based on faunal analyses from excavated habitation sites, two of the most important food animals, rabbits and rodents, are rarely if ever shown. However, ungulates such as deer, bighorn sheep, elk, and pronghorn occur in abundance and often in situations that, quite lit-

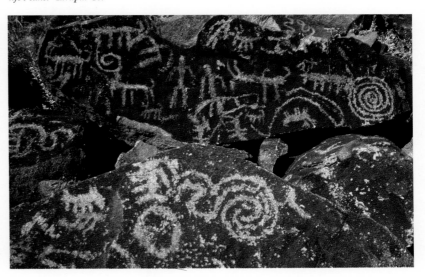

erally, may be suggestive of a kill or may represent magical attempts to control the game and ensure the hunter's luck. Other images may have functioned to propitiate the spirits of the slain animals or commemorate hunting success. Additional scenes, clearly open to literal interpretation, depict archers aiming at creatures, animals actually speared and wounded, game drives, and animals being herded into or trapped in hunting corrals (McCreery and Malotki 1994: Figures 5.4, 5.6, and 5.7). Sympathetic magic, in this context, may also have been employed to help increase the availability and long-term proliferation of game animals. This may be seen in the portrayal of obviously pregnant ungulates with extremely distended or bow-shaped bodies and, perhaps, in the maternal scenes where these quadrupeds are shown with their young.

Interestingly, most zoomorphs lack sexual characteristics, and scenes of animal couplings are extremely sparse, a likely indication that animal fecundity was not a primary concern.

Many researchers have criticized the hunting magic theory as too simplistic, especially when reduced to merely an adaptive stratagem

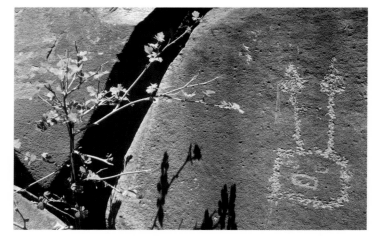

365 Springerville Miniature Style. *People of traditional societies everywhere and throughout time have combined the arts and ritual to promote their most vital needs: physical survival, health, food, and fertility. Apache Co.*

for food procurement, and have argued for more complex explanations generally influenced by shamanistic notions. To this end, hunt scenes are thought to depict activities taking place not on a physical level but rather on a spiritual plane. The animals themselves are believed to symbolize shamans transformed into their tutelary spirits, and specific killing scenes are seen as metaphorical renditions of the shaman's deathlike trance upon entering the supernatural world (Whitley 1998:30). Some imagery, however, is best interpreted in the context of the supposedly outmoded sympathetic magic model. As Angus Quinlan (2004) suggests, "hunting magic is not as theoretically implausible as its critics sometimes imply since the use of magic as an aid to economic reproduction is well documented in both hunter-gatherer and farming societies."

Evidence for the principle of compulsive magic, the intention of bringing about specific wished-for results by mimetic means, is easily found in ethnographic accounts of present-day Puebloan cultures. For example, Hopi ceremonial foot races are meant to hasten the growth of crops, and the blowing of smoke in smoking rituals is intended to imitate and encourage the coming of rain-bringing clouds (McCreery 1996:7). Within the large body of Hopi hunting lore, ritual played an important role in an effort to control the forces in charge of wildlife and to ensure that fortune in the hunt would not be capricious (Beaglehole 1936:23). At one time, priests in charge of the game at Acoma Pueblo made cornhusk effigies of deer and other potential prey and scattered them on

the morning of the hunt to ensure an ample supply of game (White 1943:306). It is thus not unreasonable to assume that similar magic was attempted in prehistoric Puebloan times and may have resulted in the plethora of big-game animals populating the rupestrian art of the Neoiconic era.

Fertility Magic and Sexuality

Sympathetic magic may also underlie some of the imagery relating to human sexuality, fertility, and procreation. While, unquestionably, concern for offspring and survival of the group must have been a constant issue not only for hunter-gatherer bands but also for later sedentary farmers, the percentage of sexually oriented themes in Arizona's rock art is astonishingly small. Nor is sexual imagery equally distributed across the various styles and traditions. For example, Western Archaic engraved and painted iconography of Arizona's Archeoiconic period is practically devoid of sexual references, although occasionally isolated elements interpretable as disembodied vulvae are seen in the form of ovals with short interior lines, split circle motifs, and renditions of inverted Vs or Us partly bisected by short vertical marks. Some researchers claim that many of the humanoid figures of later biocentric styles in the Southwest represent

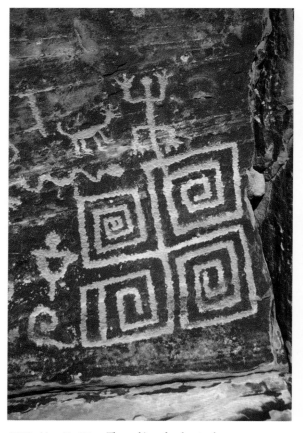

366 Puebloan Tradition. *The making of rock art, when seen in the context of religious behavior, may have had beneficial adaptive value in the human struggle for survival. Coconino Co.*

supernaturals assisting shamans that are sexually unmarked "because the sex of such spirit beings was evidently not a particularly important or relevant feature" (Hays-Gilpin 2000:168), but this is only partially true for northern Arizona's Palavayu Anthropomorphic, Glen Canyon Linear, and Grand Canyon Polychrome Styles. Interestingly, all the figures in these styles that are overtly sexed are easily recognized as masculine by their pendant phalli, although a few ithyphallic poses also occur. No obviously female images have been found.

Although still vastly outnumbered by male depictions, clearly gendered females become more easily identifiable beginning with the Mesoiconic period and then increasingly during the various phases of the Neoiconic. Most revealing of the primary sexual characteristics are stylized depictions of the genitalia (pubic triangle, vulvar cleft, pendant labia, uterine cavity, hole between the thighs). Suggestions of breasts, on the other hand, are virtually nonexistent. Secondary clues are seen in images of pregnancy and birthing, hair styles distinguished by "butterfly" hair whorls, round or pear-shaped body types, possible menstrual emissions or menstrual aprons, and receptive spread-legged posture. Overall, however, the percentage of gendered figures is relatively low, considering the tens of thousands of asexually portrayed anthropomorphs that populate Arizona's rupestrian art.

Scenes illustrating explicit sexual activities are very rare. For example, the entire rock art corpus of the Palavayu in east-central Arizona contains but two graphic depictions of human intercourse (McCreery and Malotki 2004: Figures 6.3 and 6.4). This extreme scarcity of images of human coitus and other sexual acts likely

reflects a possible magical and mythological significance of such depictions, although in some cases erotic overtones or even pornographic intent cannot be ruled out for the makers of the sexual themes. From a mythic-religious perspective, ritual intercourse is generally interpreted as a "sacred marriage" symbolic of a primordial union that brought about the creation of the world (Hunger 1983). Exaggerated phalli or blatant erections may stand for masculine energy vital for the sustaining of life, and stylized vulvae, symbolizing the life-force par excellence, may represent the progenerative power of women. Oversized genitalia seen in a few figures are believed by some to express their divine status as male and female fertility personages that were perhaps prayed to and venerated. Evidence of this comes from Hopi culture where both kachina gods and goddesses—Kookopölö, Kokopölmana, and Mastopkatsina— embody not only human sexuality but were once sought out in an attempt to combat infertility and enhance sexual potency (Malotki 2000b).

The fact that an overwhelming majority of gendered rock art is

177

367 Springerville Miniature Style (top). *Some researchers interpret virtually all rock art motifs as metaphorical and symbolic of shamanic trance; such an approach is much too narrow—rock art was a multifunctional medium of communication. Apache Co.*

368 Puebloan Tradition (bottom). *Dreams, visions, and hallucinations, resulting from the neuropsychological sameness of the human nervous system, may have served as inspirational sources for some of the imagery. Apache Co.*

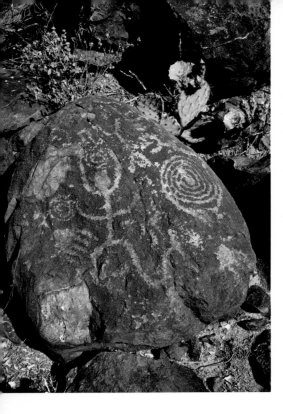

distinctly male has reinforced the widely held assumption that men were the principal creators of the art. For the same reason, those who insist that only male shamans were the makers, both of Archaic and post-Archaic images, cite menstruation as the main "impediment to female shamanism" (Whitley 1996:122). Critics of such androcentric prejudice concede that ultimately it will be impossible to determine the gender of rupestrian artists and suggest that there is a need to apply a "de-gendered inquiry" to rock art interpretation (Bass 1994:68).

▼ More Secular Motivations

That rock art was principally art for life's sake and through its magico-religious aspects was likely helpful to humans in bettering their chances of survival does not preclude the possibility that other, more mundane purposes might have played a role in the production of the images. In some cases, the deep-seated human desire to express the self creatively may explain an image made for purely decorative reasons. Such pictures would constitute art-as-pleasure. It is also possible some images were the aimless, although difficult and time-consuming, doodling of adults or the crudely executed engravings or paintings by children. In other cases, the motivation may have been our inherent propensity for marking places of significance with a personal memento. All such markings might be characterized as "archaeograffiti."

The fact that the scope of depicted subjects is astonishingly narrow, however, seems to speak against a wide-spread use of such banal practices. Indeed, not just in Arizona, but around the world, the limited spectrum of recurring rock art motifs is quite homogenous and, despite an incredible diversity of styles, is easily classified into a few major categories: anthropomorphs

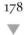

(running the gamut from "citizen figures" to imaginary beings); zoomorphs (mostly quadrupeds, but also including reptiles and insects); objects ranging from utilitarian to ceremonial; and geometric designs. Plantlike images are relatively rare and certain topics are completely absent. For instance, landscapes with their natural features of trees, rivers, and mountains do not occur at all. Also missing are basic human essentials, such as fire and various types of housing (lean-tos, tents, huts, or cliff-dwellings), as well as most tools, with the exception of weapons. Nor does the imagery contain scenes of daily life, portraying hunter-gatherers in such routine activities as picking fruit, tanning hides, or building fire, and later farmers involved in the mundane duties of planting, hoeing, and harvesting. Thus, absent is the large body of subject-matter illustrating "the normality or ordinariness of life" (Garlake 1994).

Finally, a whole range of more prosaic explanations may clearly suggest that some of the art was not esoteric at all and need not be viewed from a symbolic, metaphorical, or mystical perspective. For example, rock art images might have served as territorial markings or boundary signs of both tribal and clan lands, as orientational landmarks along trails or points of entry or exit in difficult terrain, or even perhaps as attempts at cartographic

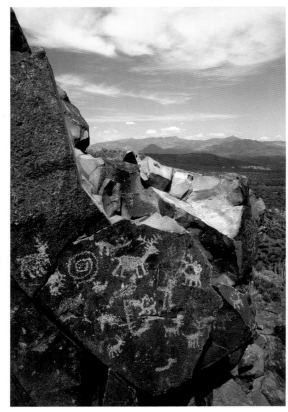

369 Hohokam Tradition (top). *While most rock art was probably created to assure positive outcomes, it may also have been used as a form of black magic with the intent of harming others. Pima Co.*

370 Hohokam Tradition (right). *There is no need to see all rock art iconography as sacred or to view it from a symbolic, metaphorical, or mystical perspective. Maricopa Co.*

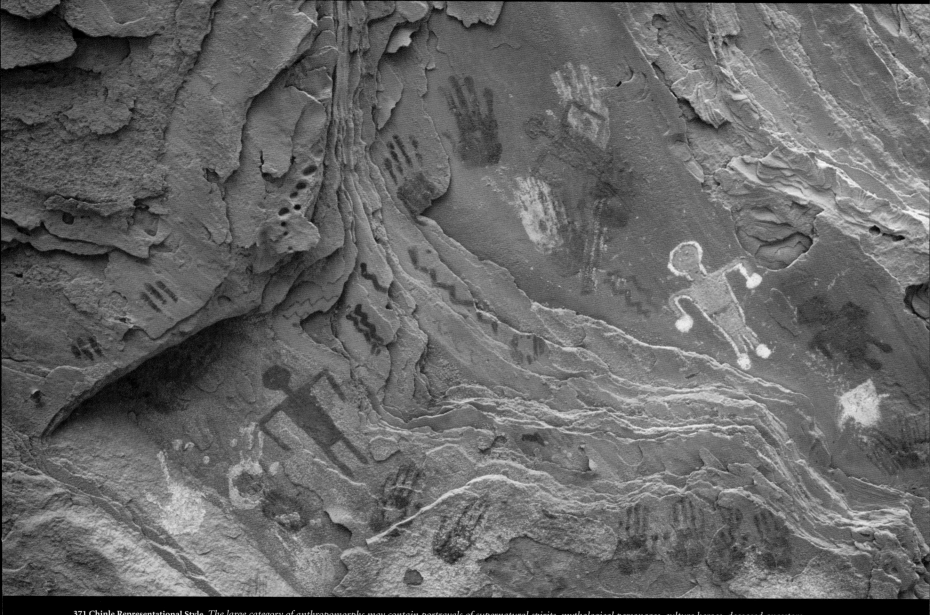

371 Chinle Representational Style. *The large category of anthropomorphs may contain portrayals of supernatural spirits, mythological personages, culture heroes, deceased ancestors, shamans and priests, hunters and warriors, as well as the occasional citizen figure. Apache Co.*

representations. In this context, Hopi ethnography testifies to the fact that boundary markers placed at strategic locations in cultivated fields were sometimes incised with clan symbols (Forde 1931:368). Similarly, Hopi salt farers engraved their totemic emblems at Willow Springs near Tuba City to memorialize their dangerous journeys into the Grand Canyon (Simmons 1942:235).

A portion of the imagery may, quite literally, represent memory aids or may reflect tallies and record-keeping. Along these lines, author Edward Abbey (1984:91-92), somewhat tongue-in-cheek, paints a scenario in which a group of deer hunters, sitting at camp with nothing to do, fabricate lies about their hunting prowess and, to preserve the stories for posterity, depict them on the cliff walls. In a more serious vein, Paul Bahn (Bahn and Vertut 1988:153) mentions "trophyism," that is, "the hunting and display of trophies by men in order to impress and get the girls," as a possible explanation for the depiction of prized game animals.

A growing body of evidence suggests that numerous rock art sites were likely linked with celestial phenomena for the purpose of calendric determinations. It has been ethnographically documented that the Hopi resorted to a whole range of temporal orientation techniques that involved the sun, the moon, and the stars. By far the most significant of the heavenly luminaries was the sun.

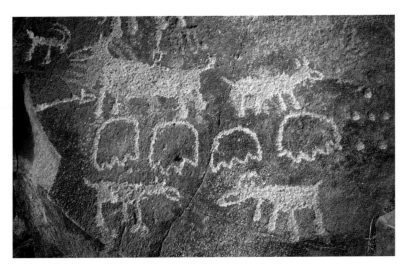

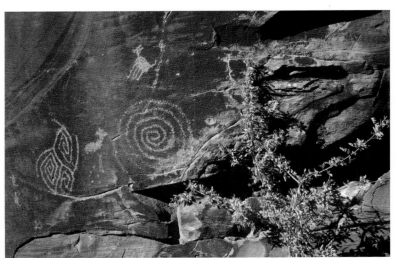

372 Central Arizona Petroglyph Tradition (top). *The frequent depiction of game animals suggests that a belief in sympathetic hunting and animal increase magic may have been one of the incentives for their creation. Yavapai Co.*

373 Beaver Creek Pecked Style (bottom). *A purely secular motivation, such as the human desire to express the self creatively, cannot be ruled out for some of the images. Yavapai Co.*

It functions as a chronometer not only during the span of an individual day but also throughout the year. In regard to the latter, the Hopi relied on a monumental horizon calendar that permitted a designated sun watcher to time and/or schedule both secular and ritual events or activities by tracking the rising and setting sun along prominent points of the horizon (Malotki 1983:427-441). In similar fashion, though on a smaller scale, certain rock art images, in particular spirals and concentric circles, may have been employed by prehistoric people to monitor the sun's position at strategic points in its annual cycle. For example, on the days of the winter and summer solstices or spring and autumn equinoxes, sun or shadow "daggers" can be observed to bisect concentric rock art circles or, with their tips, to briefly touch the center of a spiral and then retract. Critics of these sky-watching or archaeoastronomical functions insist that sun-shadow interactions with certain rupestrian elements may be purely coincidental. John Fountain (personal communication 2004) has pointed out that the large percentage of rock art sites with such astronomical findings may actually have constituted shrines to the sun and not calendric timing stations.

Other possible secular functions of more practical

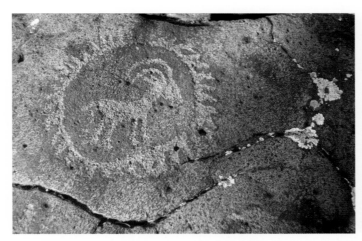

374 Central Arizona Petroglyph Tradition (above). *The widely held notion that rock art was foremost the result of "doodling" and a means of whiling away leisure time is completely untenable. Yavapai Co.*

375 Hohokam Tradition (right). *Depending on context, a recurrent rock art symbol such as the outlined cross may have multiple meanings, a phenomenon known as polysemy or multivocality. Maricopa Co.*

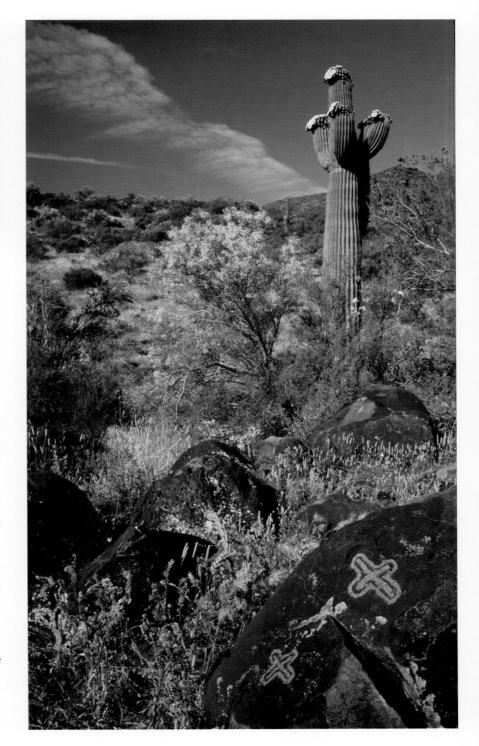

iconography include some images that are didactic, biographical, or identifying in nature. While I know of no examples in Arizona illustrating the first two, the use of totems to indicate an individual's or group's ancestral descent may be reflected in the occasional depiction of clan symbols. Specific ethnographic information corroborates the use, during the Historioiconic period, of clan signatures at the Hopi site of Willow Springs. Famous for its rows of totemic emblems, many of which appear related to specific clans, the site is, however, quite atypical when compared with rupestrian imagery in other parts of Arizona. Totemic identity may also have motivated artists to prominently display icons near habitation sites, sometimes directly above the living quarters, as is the case at numerous cliff-dwellings in northeastern Arizona.

Some rock art of more recent vintage appears to have been manufactured to mark specific historic events. For instance, a rupestrian site in Kanab Creek Canyon has been associated with the performance of a Ghost Dance ceremony by Southern Paiute and perhaps the Hualapai people in the 1800s (Stoffle et al. 2000:11). In Canyon de Chelly National Monument, a painted panel is said to depict Antonio Narbona and his Spanish cavalcade

on their 1805 mission to subjugate the Navajo in that area (Grant 1978:89). A rock carving below the ruins of Awatovi near First Mesa, featuring the depiction of several stick-figured humans carrying long poles above their heads, may actually substantiate Hopi narratives telling of enslaved Hopi men forced to transport pine logs from the mountains near Flagstaff for the construction of the Franciscan mission at Awatovi (Dongoske and Dongoske 2002:128). Overall, however, the depiction of such identifiable events is rare. In fact, there are no indications that such spectacular natural occurrences as the eruption of Sunset Crater in A.D. 1065, were ever recorded in stone. Unlike Hopi oral tradition, which has handed down a tale of this geologic cataclysm for nearly a thousand years (Malotki 2005), rock art production clearly seems to have been reserved for matters of the sacred and supernatural, not the natural and profane. This may be one reason literal interpretation of rupestrian art is generally criticized as naive, trivializing or simplistic, and why preference is given to more esoteric or mystical exegesis (Bahn 1998:221). Still, literal reading of some of the art must be acknowledged in a number of cases as legitimate and valid as partial explanation.

182
▼

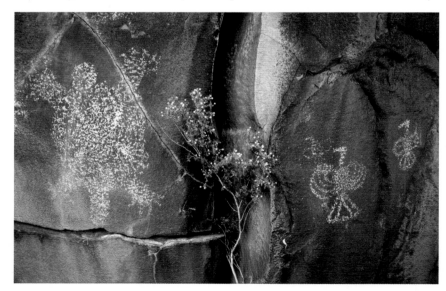

376 Patayan Tradition (above). *Some images may have served as totemic emblems or territorial markers; others may have been created for didactic, biographical, or mnemonic purposes. Maricopa Co.*

377 Central Arizona Petroglyph Tradition (right). *Ordinary people likely used rupestrian sites as shrines where offerings could be deposited, as at these cupules. Yavapai Co.*

The issue of interpretation is complicated further by the fact that rock art, even when approached from a metaphorical or symbolic perspective, can have multiple meanings. Indeed, several theories of symbolism agree that central elements that occur in a wide variety of contexts typically have a potentially unlimited range of connotations (Sperber 1975). This polyvalence is what, in part, gives symbols their special power. The legion of snake images that pervade Arizona's rock art are a case in point. Outnumbering all other rupestrian zoomorphs with the exception of the ubiquitous horned and hoofed game animals, snakes are attested in every style and tradition in a multitude of conceptual configurations, from "headless" zigzags or sinuous lines to realistically conceived rattlesnakes, and even to

anthropomorphized or other phantasmagorical portrayals. While dread of the creature's venom, "fixed in man's psyche during anthropogenesis" (Mundkur 1983:XVI), may ultimately be the reason a fear of snakes is one of the biologically and genetically grounded human universals (Brown 1991:135), awe and fascination with these reptiles are also obvious in Arizona's rock imagery.

Outside its "literal," that is, physical rendition, the powerful emblem of the serpent evokes a multitude of symbolic associations that embrace such diverse themes as water, regeneration and renewal, vitality and energy, human fecundity, and sexual potency. Embodying "life force," the snake's primary linkage with moisture is clearly understandable in a desert environment where the paramount concern is rain and water. As mentioned earlier, in a shamanic context, then, snakes may be interpreted as "rain animals" and helping spirits or visual metaphors of the shaman who, like the reptile roving back and forth between an under- and above-ground world, commutes between the realms of

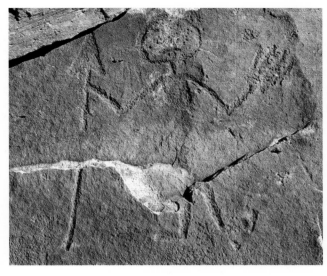

the sacred and profane. Additional functions for serpentine images, gleaned from the large body of Hopi ethnography and literature (Malotki 2001:248-250), can only be summarized here. For instance, serpent-handling scenes, though infrequently portrayed, are reminiscent of the Snake dance of the Hopi, the rain ritual *extraordinaire* in the American Southwest. Of the many Hopi clans, one regards the rattlesnake as its mythological ancestor. In Hopi narratives and myths of shamanic content, formidable serpents assume the role of protectors or guardians of special places, a function that may also be attributed to their portrayal in the landscape. To this end, snakes may have been carved or painted on rock to ward off the danger of snake bite. Finally, that the Hopi pantheon of supernatural beings contains several kachina gods that represent identifiable snakes makes it likely that certain snake species may also have enjoyed divine status in the past.

Landscape and Site Function

While, traditionally, the interpretation of rock art has focused primarily on the imagery's style and motifs, the fact that the art is fundamentally situated in the land has led to an understanding that landscape and site features, too, need to become part of the interpretive scope. Among the many universals that humans share is their tendency to humanize and enculturate the land in which they live. This process of enculturation usually takes different forms, ranging from the physical and material to the metaphysical, mythic, and divine. Thus, the construction of

camp and habitation sites, the establishment of trail systems, and the selection of areas for hunting, fuel-gathering, mining, foraging, and other mundane activities generally entail visible changes in the land. Naming, "storying," and ritualizing, on the other hand, are far less intrusive. As a result of these humanizing endeavors, people create what has been called a "mindscape," which renders their environment familiar and ultimately facilitates its ideological control (Ouzman 1998b:419).

Basic to imposing a particular mindscape on the land is the human habit of developing an attachment for certain aspects of the environment, such as high mountain tops, caves, springs, dramatic rock formations, places with impressive natural scenery, unusual acoustical properties (echoes), sweeping vistas, and other extraordinary topographical features.

378 Puebloan Tradition (top). *Identification of a representational image should not be equated with its meaning; this man with a spear may denote a hunter, warrior, mythic hero or, metaphorically, a shaman ready to battle evil spirits. Apache Co.*

183

379 Navajo Tradition (below). *The use of ethnographic analogy with more recent imagery whose meaning is still within living memory is one key to unlocking the potential significance of earlier art. Apache Co.*

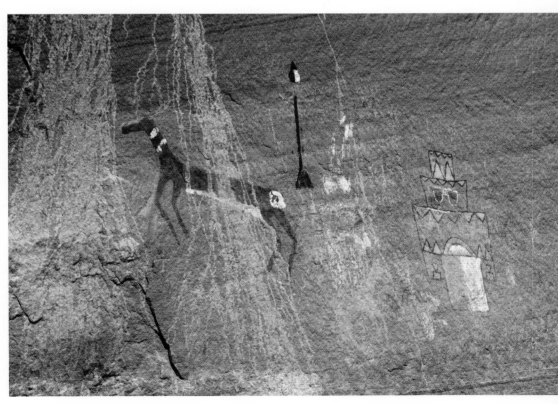

Known by the term *topophilia*, this special relationship between man and nature, when manifested as reverence for the earth, is called *geopiety*. Such places the world over, believed to be endowed with supernatural power, typically become part of a sacred geography where contact can be made with the spirit world. By enhancing the power of the place through rock art, these locations take on the aura of the sacred.

Whatever the motivating factors for the selection of a rock art site, once established, its range of possible functions must have been manifold. Shamanic cultures, as known from ethnographic sources, suggest that sites served as vision quest locales where religious practitioners obtained spiritual insights and harnessed the power of magic through dreams, trances, or other revelatory experiences. In the context of shamanic cosmology, usually stratified into an ordinary, real world, and an upper and/or lower otherworld, natural crevices and holes in the rock are regarded as portals or passageways to the sacred, supernatural realm. The site itself thus becomes an interface where these worlds interconnect, and the faces of the rock can be viewed as two-way "doors" (Clottes 1998:26), permitting gods and supernatural spirits to emerge and shamans to enter the otherworld in order to interact with the forces of that realm. On the other hand, rock art sites may simply have functioned as shrines and depositories of offerings. Inscribed or painted on the rock, such "rupestrian prayers" would have been more permanent than ephemeral spoken words and would have been "visible" for long periods to the spirits residing at the site. Similar thinking may be evident in the Hopi custom of leaving prayer feathers and prayer sticks at shrines where, according to Hopi belief, the Sun god is compelled to "pick them up" and respond to them on his daily journey across the sky (Malotki 1994). Interestingly, the majority of Arizona's rock art sites, not only in canyons but also at large clusters of boulders, show a heliotropic orientation; that is, they are not located in a north-facing direction, an orientation likely to be covered by dense lichen and showing less rock varnish. The belief that the sites were concentrations of spiritual energy that did not diminish over time may furthermore have been an incentive for later people and cultures to add their own images at these locations.

Finally, as shrines, devotional centers, or ceremonial retreats, rock art sites may have marked sacred space for both individuals and entire groups. This assumption seems to be borne out by the fact that many sites, difficult to access or not readily noticeable, are characterized by seclusion and secrecy. Many others, including so-called supersites, display "billboard quality" art and might have been intended to be visible from afar. Accordingly, some researchers distinguish between public or private sites (Bruder 1983:216-217), speculating that large groups might have converged at the former, perhaps seasonally, for both communal ritual activities and more secular, social and economic purposes, such as trading, exchanging information, and seeking out potential mates. Unfortunately, as is the case for most rock art, we do not know. In general, the supernatural was likely considered inherently perilous, and exposure to the sacred typically feared. Certain behavioral proscriptions as well as taboos thus may have barred the uninitiated and common people from nearing the site. Conversely, deep grinding basins that are frequently found in the vicinity of rock art sites would indicate that food-processing was apparently sanctioned in the presence of the imagery. Indeed, some images are found directly engraved on the milling stations.

As the preceding pages have shown, we will never know the full extent of the significance or functions of Arizona's paleoart or what motivated its earliest artists. At best, one can probably say that rock art, at its deepest level, constitutes a means of graphic communication in which the psychobiological needs of art and religion, shared universally by the human species, come together with the goal of enhancing survival. Arizona's and the world's rupestrian art may, indeed, be seen as "art for life's sake." Testimonial to this claim are the tens of thousands of painted and engraved images that make up the manifold styles and traditions of Arizona's rock art patrimony which ranks among the finest in the world.

380 Central Arizona Petroglyph Tradition. *Some rock art sites, believed to be endowed with supernatural power, may have served shamans as vision quest locales where they made contact with the spirit realm. Yavapai Co.*

GLOSSARY

abstract image—nonfigurative motif not recognizable as an object of the real world.

altered state of consciousness (ASC)—universal human experience that differs from the "normal" state of consciousness along a continuum ranging from daydreaming and sleep to euphoria, deep trance, and near-death experience. Altered states of consciousness are generally accompanied by visions and hallucinations. Inducements include various pathological conditions, sensory deprivation, meditation, and ingestion of hallucinogenic substances.

anthropic—pertaining to human form.

anthropocentric—relating to imagery that predominantly depicts humanlike figures.

anthropomorph—motif with a humanlike shape and appearance.

atlatl—throwing stick or board designed to add greater propulsion to a dart or spear by extending the thrower's arm; replaced by bow and arrow ca. A.D. 500 in western North America.

biocentric—pertaining to imagery that emphasizes human and animal life-forms.

biomorph—figure resembling a biological form—human, animal, or plant.

cupule—hemispherical depression or pit pecked or ground into the rock surface; also called cup mark.

curvilinear—consisting of curved lines.

entoptic—relating to geometric light patterns or images generated within the optical field of the human nervous system in the absence of outside visual stimuli.

ethnographic analogy—comparative technique in which information about historic period or extant cultures is used to gain insights about the archaeological past, based on the assumption that if two cultures are similar in some respects, they may be similar in others.

ethology—the scientific study of animal behavior in its natural habitat; human ethology investigates the universal behavior of the human animal and seeks explanations for phenomena usually thought of as entirely culturally derived.

form constant—see phosphene.

geocentric—relating to imagery that thematically consists primarily of nonfigurative, abstract-geometric configurations.

geoglyph—a ground figure created by scraping away the patinated surface material of desert pavement to expose the underlying lighter colored soil; also known as intaglio.

geomorph—rock art motif that is essentially geometric in shape, both curvilinear and rectilinear.

glyph—short form for petroglyph, that is, a carved or engraved rock art image.

ground figure—design created on the ground surface by various techniques or combinations of techniques; see geoglyph and petroform.

hallucinogen—mind- or mood-altering drug or substance that induces hallucinations.

iconic—resembling the figurative or representational form of an object from the real or imagined world.

iconography—collected visual representations or imagery relating to a particular subject, style, or body of art.

intaglio—see geoglyph

kachina—masked supernatural personage or god prayed to by Puebloan agriculturalists for rain, health, and other life-sustaining blessings.

macropsia—visual hallucination evoking the perception of objects larger than in reality.

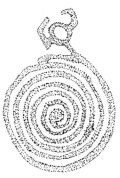

micropsia—visual hallucination evoking the perception of objects smaller than in reality.

neuropsychology—integrated scientific study of the human nervous system (neurology) and the study of the mind and behavior (psychology).

neuropsychological model—explanatory model for the creation of rock art based on the idea that all humans have the same nervous system, resulting in the same or similar internally generated designs in persons undergoing a trance; based on the assumption that shamans routinely experienced trance and were the primary producers of rock art.

panel—arbitrary assemblage of rock art elements spatially confined to a particular area and set off from neighboring groupings.

paleoart—collective term relating to manifestations of art from the distant past.

parietal—of or relating to a wall, as of a cliff or in a rock shelter; often used interchangeably with rupestrian.

petroform—see rock alignment

petroglyph—rock art produced by carving, engraving, chipping, pecking, or scratching into the darkly varnished surface of the natural rock, thereby effecting a high contrast with the lighter underlying matrix.

phantasmomorph—rock art motif of fantastical form, typically combining human and animal characteristics.

phosphene—term referring to abstract design elements (set of parallel lines, pattern of dots, grids, spirals, zigzags, filigrees, etc.), occurring in the visual cortex of the human brain without the presence of visual stimuli; also known as form constants, they are induced by a variety of means, including pressure on the eye, fatigue, trauma to the head, fasting, sensory deprivation, migraine, or the ingestion of hallucinogenic substances.

phytomorph—rock art motif of plantlike shape.

pictoglyph—painted petroglyph.

pictograph—rock art produced by painting or drawing an image on a rock surface.

piloerection—tactile hallucination of abnormal skin sensation resulting in "hair standing up;" perhaps responsible for the phenomenon of lycanthropy, i.e., the werewolf transformation.

pipette—a bilaterally symmetrical design consisting of two or more tiered rectangular enclosures and/or curvilinear bulges that are connected by sets of constricted parallel lines, usually vertically aligned; diagnostic of the late Hohokam rock art.

Pleistocene—of or belonging to the geologic era known as the Ice Ace, terminating ca. 10,500 years ago.

psychobiological—relating to the study of interaction between mental and biological processes.

psychopomp—a person who conducts souls to the afterworld

psychotropic—affecting the mind, mood, or other mental processes, such as that produced by psychotropic drugs.

quadruped—any four-legged image resembling an animal.

radiocarbon dating—an absolute dating method applicable for organic, carbon-containing substances by measuring the decay rate of the carbon isotope, carbon 14, to stable nitrogen.

rectilinear—consisting of straight lines.

relative dating—a method of estimating age through association with other features, thus yielding no precise numerical results.

reomorph—rock art motif portraying an identifiable object or image that actually occurs in the real world. Manipulable reomorphs (crook staff, medicine pouch, scalp) are transferable to the ownership of another; nonmanipulable (handprint, bird track) are not transferable.

rock alignment—design formed on the ground surface by moving and arranging rocks or boulder; also called petroform.

rupestrian—relating to, composed of, or inscribed on rock, as in rupestrian imagery or site.

381 Sinagua Pictograph Style. *Apparently not an act of modern vandalism, the removal of paint from this mountain lion may have resulted from a belief in the "medicine" power of the animal and the pigment used in its depiction. Yavapai Co.*

shaman—religious practitioner of an animistically oriented belief system in which natural phenomena and objects have souls and spirits. As a mediator between the sacred and the profane, the shaman is thought to have direct access to the spirit world through trance or altered states of consciousness.

skeletonization—depiction of anthropomorphic figures in X-ray fashion, that is, with stylized bones and/or organs; may symbolically relate to the death-and-resurrection experience of the trancing shaman.

solarization—emanation of radial lines from circular objects, especially human heads; rayed head projections may symbolize somatic hallucinations experienced in trance.

spirit helper—a shaman's supernatural assistant, tutelary, or guide, often in the guise of an animal, obtained during a vision quest.

stick figure—an anthropomorphic or zoomorphic motif in which body parts are depicted as single lines.

style—a standard classification defined by common techniques and attributes, including the range of subjects depicted, the way those subjects are illustrated, and the manner in which the basic elements are combined and organized into compositions. Styles are geographically localized, temporally limited, and generally refer to art of a single cultural entity.

superimposition—overlapping of rock art elements, one on top of another, earlier motif.

sympathetic magic—strategy for success that assumes that an action performed on a substitute or image will produce the same effect on the real thing; in rock art, depiction of a desired event in order to make it actually happen.

therianthrope—a hybrid being, usually composed of human and animal traits.

totem—object, animal, plant, or supernatural personage serving families or clans of certain traditional societies as an emblem of their mythical ancestry.

tradition—classificatory designation indicating long-term continuity in motifs, techniques, expressions, and styles. Traditions have an extended duration and involve large areas geographically. A specific tradition usually refers to a single culture, but can refer to multiple cultural entities or even portions of defined cultural groups.

trance—altered state of consciousness achieved through the use of psychedelic and narcotic properties of certain plants, as well as through nonchemical means such as exposure to the elements, sensory deprivation, hyperventilation, meditative isolation, prolonged dancing, drumming and singing of prayers, and self-torture.

varnish—the dark discoloration of a rock surface due to long-term natural chemical alteration, the accretion of tiny wind-born dust particles, and other weathering phenomena.

ventral-node figure—anthropomorphic stick figure whose torso, in the region of the stomach, is marked by a solidly pecked disk.

vision quest—intentionally sought spiritual experience in which the trancing individual hopes to obtain supernatural power from a spirit helper. Shamanic vision quests may have taken place at rock art sites that were held to be numinous, that is, inhabited by potent spirit beings.

X-ray motif—art form that typically portrays human or animal figures with schematized depictions of bones and/or internal organs.

zoomorph—rock art motif resembling an animal.

189

BIBLIOGRAPHY

Abbey, E. 1984. *Beyond the Wall: Essays from the Outside.* New York: Holt, Rinehart & Winston.

Allen, M.K. 1991. Grand Canyon Polychrome Pictographs. *Utah Rock Art Papers* 8: 1-16.

Allen, M.K. 1994. Grand Canyon Pictographs: Comments on the Grand Canyon Polychrome Style. *Rock Art Papers* 11: 95-105.

Anati, E. 1981. The Origins of Art. *Museum* 33: 200-210.

Anati, E. 2004. Introducing the World Archives of Rock Art (WARA): 50,000 Years of Visual Arts. In *New Discoveries, New Interpretations, New Research Methods, XXI Valcamonica Symposium,* pp. 51-69. Capo di Ponte: Edizioni del Centro.

Armitage, R.A., Hyman, M., Rowe, M.W., Loendorf, L.L., & Southon, J.R. 2000. Dated Rock Art Paintings at Red Cliffs, Arizona. *Kiva* 65(3): 253-266.

Bahn, P.G. 1998. *The Cambridge Illustrated History of Prehistoric Art.* Cambridge: Cambridge University Press.

Bahn, P.G., & Vertut, J. 1988. *Images of the Ice Age.* London: Bellew.

Bass, P.M. 1994. A Gendered Search Through Some East Texas Rock Art. In *New Light on Old Art: Recent Advances in Hunter-Gatherer Rock Art Research,* ed. D.S. Whitley & L.L. Loendorf, pp. 67-74. Institute of Archaeology Monograph 36. Los Angeles: University of California Press.

Basso, K.H. 1983. Western Apache. In *Handbook of North American Indians,* vol. 10, *Southwest,* ed. A. Ortiz, pp. 462-488. Washington, DC: Smithsonian Institution.

Beaglehole, E. 1936. *Hopi Hunting and Hunting Ritual.* Yale University Publications in Anthropology 4. New Haven, CT: Yale University Press.

Bean, L.J., & Vane, S.B. 1978. Shamanism: An Introduction. In *Art of the Huichol Indians,* ed. K. Berrin, pp. 118-128. New York: Abrams.

Bednarik, R.G. 1990. On Neuropsychology and Shamanism in Rock Art. *Current Anthropology* 31(1): 77-80.

Bednarik, R.G. 1993a. European Palaeolithic Art—Typical or Exceptional? *Oxford Journal of Archaeology* 12(1): 1-8.

Bednarik, R.G. 1993b. Review of *Wiege der Kunst und des Geistes* by E. Anati. 1991. U. Bär Verlag, Zürich. *Rock Art Research* 10(1): 70-71.

Bednarik, R.G. 1994a. Art Origins. *Anthropos* 89: 169-180.

Bednarik, R.G. 1994b. On the Scientific Study of Paleoart. *Semiotica* 100(2/4): 141-168.

Bednarik, R.G. 1998. The First Stirrings of Creation. *The UNESCO Courier* 51(4): 4-9.

Bednarik, R.G. 2003. Concerns in Rock Art Science. *AURA Newsletter* 20(1): 1-4.

Biesele, M. 1986. Bushman Art: A Preoccupation with Transformation. In *Ancient Texans: Rock Art and Lifeways Along the Lower Pecos,* ed. H.J. Shafer, pp. 200-209. Austin, TX: Texas Monthly Press.

Bourguignon, E. 1974. Cross-Cultural Perspectives on the Religious Uses of Altered States of Consciousness. In *Religious Movements in Contemporary America,* ed. I. Zaretsky & M. Leone, pp. 228-243. Princeton, NJ: Princeton University Press.

Bradley, R. 1997. *Rock Art and the Prehistory of Atlantic Europe: Signing the Land.* London: Routledge.

Brown, D.E. 1991. *Human Universals.* Philadelphia: Temple University Press.

Brown, D.E. 1999. Human Universals. In *MIT Encyclopedia of the Cognitive Sciences,* ed. R.A. Wilson & F.C. Keil. Cambridge, MA: MIT Press.

Bruder, J.S. 1983. *Archaeological Investigations at the Hedgepeth Hills Petroglyph Site.* Research Report No. 28. Flagstaff: Museum of Northern Arizona.

Brugge, D.M. 1983. Navajo Prehistory and History to 1850. In *Handbook of North American Indians,* vol. 10, ed. A. Ortiz, pp. 489-501. Washington, DC: Smithsonian Institution.

Burton, J.F. 1988. *Prehistoric Rock Art of the Southeast Arizona Uplands: A Formal Record of 53 Rock Art Sites on the Coronado National Forest.* Reprinted. Tucson, AZ: Trans-Sierran Archaeological Research.

Burton, J.F. 1993. Days in the Painted Desert and the Petrified Forests of Northern Arizona. *Western Archaeological and Conservation Center Publications in Anthropology* 54. Tucson, AZ: National Park Service.

Carroll, J. 1998. Steven Pinker's Cheesecake For the Mind. *Philosophy and Literature* 22: 478-485.

Christensen, D.D. 1998. The Rock Art of Jumpup Canyon, Kanab Plateau, Arizona. *Rock Art Papers* 13: 108-125.

Christensen, D.D., & Dickey, J. 1998. Rock Art with Prehistoric Trail Associations: A Study in the Needles Region, Mohave Desert, California. *Rock Art Papers* 13: 31-44.

Christensen, D.D., & Dickey, J. 2001. The Grapevine Style of the Eastern Mojave Desert of California and Nevada. *American Indian Rock Art* 27: 185-200.

Christensen, D.D., & Dickey, J. 2004. The Esplanade Style: A Reappraisal of Polychrome Rock Art in the Grand Canyon Region, Arizona. *American Indian Rock Art* 30: 69-85.

Christensen, D.D., & Dickey, J. 2006a. Beyond the Rim: An Overview of Rock Art on the South Rim of the Grand Canyon National Park and the Tusayan District of the Kaibab National Forest, Arizona. Ms. on file, Kaibab National Forest District, Williams, AZ, and the Grand Canyon National Park.

Christensen, D.D., & Dickey, J. 2006b. The Tusayan Style: Archaic Rock Art in the Grand Canyon Region, Arizona. *American Indian Rock Art* 32: 1-14.

Clottes, J. 1993. Post-Stylistic? In *Rock-Art Studies: The Post-Stylistic Era or Where Do we Go from Here?,* ed. M. Lorblanchet & P.G. Bahn, pp. 19-25. Oxford: Oxbow Monograph 35.

Clottes, J. 1998. The Shaman's Journey. *UNESCO Courier* 51(4): 24-28.

Clottes, J. 2002. *World Rock Art.* Translated by G. Bennett. Los Angeles: Getty Publications.

190

Clottes, J., & Lewis-Williams, D. 1998. *The Shamans of Prehistory: Trance and Magic in the Painted Caves.* Translated by S. Hawkes. New York: Abrams.

Coder, C.M. 2000. *An Introduction to Grand Canyon Prehistory.* Grand Canyon, AZ: Grand Canyon Association.

Cole, S.J. 1990. *Legacy on Stone: Rock Art of the Colorado Plateau and Four Corners Region.* Boulder, CO: Johnson Books.

Conkey, M.W. 2001. Hunting for Images, Gathering Up Meanings: Art for Life in Hunting-Gathering Societies. In *Hunter-Gatherers: An Interdisciplinary Perspective,* ed. C. Panter-Brick, R.H. Layton & P. Rowley-Conwy, pp. 267-291. Cambridge: Cambridge University Press.

Cordell, L. 1997. *Archaeology of the Southwest.* 2nd ed. San Diego: Academic Press.

Diaz-Granados, C., & Duncan, J.R. 2000. *The Petroglyphs and Pictographs of Missouri.* Tuscaloosa: University of Alabama Press.

Dickey, J., & Christensen, D.D. 2004. A Functional Analysis of the Esplanade Style. *American Indian Rock Art* 30: 89-102.

Dissanayake, E. 1992a. *Homo Aestheticus: Where Art Comes From and Why.* New York: The Free Press.

Dissanayake, E. 1992b. Art for Life's Sake. *Art Therapy: Journal of the American Art Therapy Association* 9(4): 169-175.

Dissanayake, E. 1995a. Chimera, Spandrel, or Adaptation: Conceptualizing Art in Human Evolution. *Human Nature* 6(2): 99-117.

Dissanayake, E. 1995b. The Pleasure and Meaning of Making. *American Craft* 55(2): 40-45.

Dissanayake, E. 1999. "Making Special": An Undescribed Human Universal and the Core of a Behavior of Art. In *Biopoetics: Evolutionary Explorations in the Arts,* ed. B. Cooke & F. Turner, pp. 27-46. Lexington, KY: Icus.

Dissanayake, E. 2000. *Art and Intimacy: How the Arts Began.* Seattle: University of Washington Press.

Dissanayake, E. 2006. In the Beginning: Pleistocene and Infant Aesthetics and 21st Century Education in the Arts. In *International Handbook on Research in Arts Education,* ed. L. Bresler. In preparation.

Dongoske, K.E., & Dongoske, C.K. 2002. History in Stone: Evaluating Spanish Conversion Efforts through Hopi Rock Art. In *Archaeology of the Pueblo Revolt,* ed. R.W. Prencel, pp. 114-131. Salt Lake City: University of Utah Press.

Eibl-Eibesfeldt, I. 1988. The Biological Foundation of Aesthetics. In *Beauty and the Brain: Biological Aspects of Aesthetics.* Basel: Birkhäuser Verlag.

Eliade, M. 1959. *The Sacred and the Profane: The Nature of Religion.* Translated by W.R. Trask. New York: Harcourt, Brace & Co.

Eliade, M. 1964. *Shamanism: Archaic Techniques of Ecstasy.* Princeton, NJ: Princeton University Press.

Elias, S.A. 2002. Setting the Stage: Environmental Conditions in Beringia As People Entered the New World. In *The First Americans: The Pleistocene Colonization of the New World,* ed. N.G. Jablonski, pp. 9-25. Memoirs of the California Academy of Sciences 27. San Francisco, CA.

Ezell, P.H. 1963. The Maricopas: An Identification from Documentary Sources. *Archaeological Papers of the University of Arizona* 6.

Fairley, H.C. 2003. *Changing River: Time, Culture, and the Transformation of Landscape in the Grand Canyon.* Statistical Research Technical Series 79, Tucson, AZ.

Farrell, M.M., & Burton, J.F. 1992. Dating Tom Ketchum: The Role of Chronometric Determinations in Rock Art Analysis. *North American Archaeologist* 13(3): 219-247.

Fein, S. 1993. *First Drawings: Genesis of Visual Thinking.* Pleasant Hill, CA: Exelrod Press.

Ferg, A. 1974. Petroglyphs of the Silver Creek-Five Mile Draw Confluence, Snowflake, Arizona. Ms. on file, Arizona State Museum, University of Arizona, Tucson.

Ferguson, T.J. (Compiler). 2003. *Yep Hisat Hoopoq'yaqam Yeesiwa (Hopi Ancestors Were Once Here).* Kykotsmovi, AZ: Hopi Cultural Preservation Office.

Forde, C.D. 1931. Hopi Agriculture and Land Ownership. *Journal of the Royal Anthropological Institute* 61: 357-405.

Francfort, H.-P., & Hamayon, R. 2001. *The Concept of Shamanism: Uses and Abuses.* Bibliotheca Shamanistica 10. Budapest: Akadémiai Kiadó.

Furst, P.T. 1976. *Hallucinogens and Culture.* Novato, CA: Chandler & Sharp.

Garlake, P. 1994. Archetypes and Attributes: Rock Paintings in Zimbabwe. *World Archaeology* 25(3): 346-355.

Gibson, M.F. 2002. Reading the Mind Before It Could Read. *New York Times,* April 21.

Grant, C. 1978. *Canyon de Chelly: Its People and Rock Art.* Tucson: University of Arizona Press.

Harrod, J. 2003. Lower Palaeolithic Palaeoart, Religion, and Protolanguage. *Rock Art Research* 20(2): 115-116.

Harwell, H.O., & Kelly, M. 1983. Maricopa. In *Handbook of North American Indians,* vol. 10, ed. A. Ortiz, pp. 71-85. Washington, DC: Smithsonian Institution.

Haury, E.W. 1934. The Canyon Creek Ruins and the Cliff Dwellings of the Sierra Ancha. Medallion Papers No. 14. Globe, AZ.

Hayden, J.D. 1972. Hohokam Petroglyphs of the Sierra Pinacate, Sonora and the Hohokam Shell Expeditions. *Kiva* 37(2): 74-83.

Hays-Gilpin, K. 2000. Beyond Mother Earth and Father Sky: Sex and Gender in Ancient Southwestern Visual Arts. In *Reading the Body: Representations and Remains in the Archaeological Record,* ed. A. Rautman, pp. 165-186. Philadelphia: University of Pennsylvania Press.

Hedges, K. 1982. Phosphenes in the Context of Native American Rock Art. *American Indian Rock Art* 7-8: 1-10.

Hedges, K. 1985. Rock Art Portrayals of Shamanic Transformation and Magical Flight. *Rock Art Papers* 2: 83-94.

Hedges, K. 1987. Patterned Body Anthropomorphs and the Concept of Phosphenes in Rock Art. *Rock Art Papers* 5: 17-24.

Hedges, K. & Hamann, D. 1992. Look to the Mountain Top: Rock Art at Texas Hill, Arizona. *American Indian Rock Art* 17: 45-55.

Hedges, K., & Hamann, D. 1993. The Rock Art of White Tanks, Arizona. *American Indian Rock Art* 19: 57-69.

Hedges, K., & Hamann, D. 1995. Petroglyphs at Quail Point, Southwestern Arizona. *Rock Art Papers* 12: 89-94.

Heizer, R.F., & Baumhoff, M.A. 1962. *Prehistoric Rock Art of Nevada and Eastern California.* Berkeley: University of California Press.

Heizer, R.F., & Clewlow, C.W., Jr. 1973. *Prehistoric Rock Art of California.* Ramona, CA: Ballena Press.

Helvenston, P.A., & Bahn, P.G. 2005. *Waking the Trance Fixed.* Louisville, KY: Wasteland Press.

Hodgson, D. 2000. Art, Perception and Information Processing: An Evolutionary Perspective. *Rock Art Research* 17: 3-34.

Hunger, H. 1983. Ritual Coition as Sacred Marriage in the Rock Art of North America. *American Indian Rock Art* 9: 1-9.

Johnson, B. 1985. Earth Figures of the Lower Colorado and Gila River Deserts: A Functional Analysis. Arizona Archaeologist No. 20. Phoenix: Arizona Archaeological Society.

Kehoe, A.B. 2000. *Shamans and Religion: An Anthropological Exploration in Critical Thinking.* Prospect Heights, IL: Waveland Press.

Kellogg, R., Knoll, M., & Kügler, J. 1965. Form-Similarity between Phosphenes of Adults and Pre-School Children's Scribblings. *Nature* 208: 1129-1130.

Khera, S., & Mariella, P.S. 1983. Yavapai. In *Handbook of North American Indians,* vol.10, ed. A. Ortiz, pp. 38-54. Washington, DC: Smithsonian Institution.

Knoll, M., & Kügler, J. 1959. Subjective Light Pattern Spectroscopy in the Encephalographic Frequency Range. *Nature* 184: 1823-1824.

La Barre, W. 1972. Hallucinogens and the Shamanic Origins of Religion. In *Flesh of the Gods: The Ritual Use of Hallucinogens,* ed. P. Furst. New York: Praeger.

La Barre, W. 1970. *The Ghost Dance: Origins of Religion.* Prospect Heights, IL: Waveland Press.

Lamphere, L. 1983. Southwestern Ceremonialism. In *Handbook of North American Indians,* vol. 10, ed. A. Ortiz, pp. 743-763. Washington, DC: Smithsonian Institution.

Lewis-Williams, J.D. 1994. Rock Art and Ritual: Southern Africa and Beyond. *Complutum* 5: 277-289.

Lewis-Williams, J.D. 1996. Light and Darkness: Earliest Rock Art Evidence for an Archetypal Metaphor. *Bolletino del Centro Camuno di Studi Preistorici* 29: 125-132.

Lewis-Williams, J.D., & Dowson, T.A. 1988. The Signs of All Times: Entoptic Phenomena in Upper Palaeolithic Art. *Current Anthropology* 29(2): 201-245.

Lister, R.H., & Lister, F.C. 1983. *Those Who Came Before: Southwestern Archaeology in the National Park System.* Tucson: University of Arizona Press.

Lorblanchet, M., & Bahn P.G., eds. 1993. *Rock Art Studies: The Post-Stylistic Era or Where Do we Go from Here?* Oxford: Oxbow Monograph 35.

Malotki, E. 1983. *Hopi Time: A Linguistic Analysis of the Temporal Concepts in the Hopi Language.* Trends in Linguistics. Studies and Monographs 20. New York: Mouton.

Malotki, E. 1993. *Hopi Ruin Legends. Kiqötutuwutsi.* Narrated by M. Lomatuway'ma, L. Lomatuway'ma, & S. Namingha, Jr. Lincoln: University of Nebraska Press.

Malotki, E. 1994. The Boy Who Went in Search of His Father. In *Coming to Light: Contemporary Translations of the Native Literatures of North America,* ed. B. Swann, pp. 657-678. New York: Random House.

Malotki, E. 1997. The Dragonfly: A Shamanistic Motif in the Archaic Rock Art of the Palavayu Region in Northeastern Arizona. *American Indian Rock Art* 23: 57-72.

Malotki, E. 1998. The Owl: A Shamanistic Motif in the Archaic Rock Art Iconography of the Palavayu Anthropomorphic Style, Northeastern Arizona. *American Indian Rock Art* 22: 1-18.

Malotki, E. 1999. The Use of Hallucinogenic Plants by the Archaic-Basketmaker Rock Art Creators of the Palavayu, Northeast Arizona: The Case for Datura. *American Indian Rock Art* 25: 101-120.

Malotki, E. 2000a. The Rake: A Polysemous Motif in the Shamanistic Rock Art Iconography of the Palavayu Anthropomorphic Style, Northeast Arizona. *American Indian Rock Art* 26: 13-28.

Malotki, E. 2000b. *Kokopelli: The Making of an Icon.* Lincoln: University of Nebraska Press.

Malotki, E. 2001. The Serpent: A Shamanistic Motif in the Archaic/Basketmaker Rock Art Imagery of the Palavayu Anthropomorphic Style (Pastyle), Arizona. *American Indian Rock Art* 27: 237-252.

Malotki, E. 2005. *Earth Fire: A Hopi Legend of the Sunset Crater Eruption.* Walnut, CA: Kiva Publishing.

Malotki, E., & Gary, K. 1996. Yoynawakna: A Petroglyphic Rain Payer at a Post-Spanish Hopi Site in Northeastern Arizona. *European Review of Native American Studies* 10(1): 13-17.

Malotki, E., & Gary, K. 2001. *Hopi Stories of Witchcraft, Shamanism, and Magic.* Lincoln: University of Nebraska Press.

Malotki, E., & Weaver, D.E., Jr. 2002. *Stone Chisel and Yucca Brush: Colorado Plateau Rock Art.* Walnut, CA: Kiva Publishing.

Martynec, R., & Martynec, S. 2003. Petroglyphs at a Temporal Site in the Growler Mountains, Southwest Arizona. *Rock Art Papers* 16: 39-46.

McCreery, P. 1996. Another Look at Hunting Magic. *La Pintura* 23(2): 6-8.

McCreery, P., & Malotki, E. 1994. *Tapamveni: The Rock Art Galleries of Petrified Forest and Beyond.* Petrified Forest, AZ: Petrified Forest Museum Association.

Mellinger, K. 2000a. Mellinger Mesa—Prehistoric Site. *The Gila Bend Sun,* February 3.

Mellinger, K. 2000b. The Mellinger Mesa—Part Two. *The Gila Bend Sun,* March 23.

Mundkur, B. 1983. *The Cult of the Serpent.* Albany: State of New York Press.

Nichols, J. 2002. The First American Languages. In *The First Americans: The Pleistocene Colonization of the New World,* ed. N. Jablonski, pp. 273-293. San Francisco: Memoirs of the California Academy of Sciences 27.

Ouzman, S. 1998a. Towards a Mindscape of Landscape: Rock-Art as Expression of World-Understanding. In *The Archaeology of Rock-Art,* ed. C. Chippindale & P.S.C. Taçon, pp. 30-41. Cambridge: Cambridge University Press.

Ouzman, S. 1998b. Mindscape. In *Encyclopedia of Semiotics,* ed. O. Bouissac, pp. 419-421. New York: Oxford University Press.

Pettitt, P., & Bahn, P.G. 2003. Current Problems in Dating Palaeolithic Cave Art: Candamo and Chauvet. *Antiquity* 77: 134-141.

Pilles, P.J., Jr. 1975. Petroglyphs of the Little Colorado River Valley, Arizona. *American Indian Rock Art* 1: 1-26.

Pilles, P.J., Jr. 1994. Rock Art of the Red Rock Canyons, Sedona, Arizona. Paper presented at the 1994 International Rock Art Congress, Flagstaff, AZ.

Pilles, P.J., Jr. 1998. Sinagua Tradition. In *Archaeology of Prehistoric Native America: An Encyclopedia,* ed. G. Gibbon, pp. 770-772. New York: Garland.

Pinker, S. 1997. *How the Mind Works.* New York: Norton.

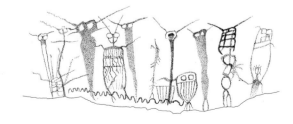

Pinker, S. 2002. *The Blank Slate: The Modern Denial of Human Nature.* New York: Viking.

Plog, S. 1997. *Ancient Peoples of the American Southwest.* London: Thames & Hudson.

Quinlan, A.R. 2004. Overview of Rock Art Interpretation, Nevada Rock Art Foundation. Electronic Document *http://nevadarockart.org/publications.htm.*

Quinlan, A.R., & Woody, A. 2003. Marks of Distinction: Rock Art and Ethnic Identification in the Great Basin. *American Antiquity* 68(2): 372-390.

Ramachandran, V.S., & Blakeslee, S. 1998. *Phantoms in the Brain.* New York: William Morrow.

Riggs, G. 2001. Late Archaic Projectile Point Petroglyphs. *American Indian Rock Art* 27: 279-284.

Riggs, G. 2005. Rock Art Frontiers of the Classic Mimbres. *American Indian Rock Art* 31: 155-163.

Rucks, M.M. 1983. Safford District Rock Art: Cultural Resource Management Plan. Ms. on file, Bureau of Land Management, Safford District, AZ.

Schaafsma, P. 1980. *Indian Rock Art of the Southwest.* Santa Fe: School of American Research, and Albuquerque: University of New Mexico Press.

Schaafsma, P. 1990. Shamans' Gallery: A Grand Canyon Rock Art Site. *Kiva* 55(3): 213-234.

Schaafsma, P. 1992. *Rock Art in New Mexico.* Santa Fe: School of American Research.

Schaafsma, P. 1994. Trance and Transformation in the Canyons: Shamanism and Early Rock Art on the Colorado Plateau. In *Shamanism and Rock Art in North America,* ed. S.A. Turpin. San Antonio, TX: Rock Art Foundation, Special Publication 1.

Schroedl, A.R. 1977. The Grand Canyon Figurine Complex. *American Antiquity* 42(2): 254-265.

Schroedl, A.R. 1989. The Power and the Glory: Shamanistic Arts of the Archaic Period. *Canyon Legacy* 1(1): 13-17.

Scupin, R. 2003. *Cultural Anthropology: A Global Perspective.* 5th edition. Upper Saddle River, NJ: Prentice Hall.

Simmons, L.W. 1942. *Sun Chief: The Autobiography of a Hopi Indian.* New Haven, CT: Yale University Press.

Smiley, F.E. 1993. Early Farmers in the Northern Southwest: A View from Marsh Pass. In *Anasazi Basketmaker: Papers from the 1990 Wetherill-Grand Gulch Symposium,* ed. V.M. Atkins, pp. 243-254. Cultural Resource Series 24. Salt Lake City: United States Department of the Interior, Bureau of Land Management.

Sperber, D. 1975. *Rethinking Symbolism.* Cambridge: Cambridge University Press.

Stephenson, C.M. 1997. Shamanism and the Rock Art of Bigelow Crossing. *American Indian Rock Art* 23: 127-136.

Stoffle, R.W., Loendorf, L.L., Austin, D.E., Halmo, D.B., & Bulletts, A. 2000. Ghost Dancing the Grand Canyon. *Current Anthropology* 41(1): 11-38.

Stone, C.L. 1991. The Linear Oasis: Managing Cultural Resources Along the Lower Colorado. Cultural Resource Series No. 6. United States Bureau of Land Management, Arizona State Office.

Thiel, J.H. 1995. *Rock Art in Arizona.* Technical Report No. 94-6. Tucson, AZ: Center for Desert Archaeology.

Turner, C.G., III. 1963. Petrographs of the Glen Canyon Region. Museum of Northern Arizona Bulletin 38. Glen Canyon Series No. 4.

Turner, C.G., III. 1971. Revised Dating for Early Rock Art of the Glen Canyon Region. *American Antiquity* 36(4): 469-471.

Turpin, S.A. 2001. Archaic North America. In *Handbook of Rock Art Research,* ed. D. S. Whitley, pp. 361-413. Walnut Creek: Alta Mira Press.

Underhill, R.M. 1946. *Papago Indian Religion.* New York: Columbia University Press.

Von Sommers, P. 1984. *Drawings and Cognition.* Cambridge: Cambridge University Press.

Wallace, H.D. 2006. The Petroglyphs of Atlatl Ridge, Tortolita Mountains, Pima County, Arizona. In *Life in the Foothills: Archaeological Investigations in the Tortolita Mountains of Southern Arizona,* ed. D.L. Swartz. Anthropological Papers No. 46. Tucson, AZ: Center for Desert Archaeology.

Wallace, H.D., & Holmlund, J.P. 1986. *Petroglyphs of the Picacho Mountains, South-Central Arizona.* Anthropological Papers No. 6. Tucson, AZ: Institute for American Research.

Wallace, H.D., Heidke, J.M., & Doelle, W.H. 1995. Hohokam Origins. *Kiva* 60: 575-618.

Weaver, D.E., Jr. 1993. The Rock Art of the White Mountains-Mogollon Rim of Eastern Arizona. *American Indian Rock Art* 19: 71-88.

White, L. 1943. *New Material from Acoma.* Bureau of American Ethnology Bulletin 136. Anthropological Papers 32: 301-359. Washington, DC: U.S. Government Printing Office.

White, R. 2003. *Prehistoric Art: The Symbolic Journey of Humankind.* New York: Abrams.

Whitley, D.S. 1996. *A Guide to Rock Art Sites: Southern California and Southern Nevada.* Missoula, MT: Mountain Press.

Whitley, D.S. 1998. Cognitive Neuroscience, Shamanism and the Rock Art of Native California. *Anthropology of Consciousness* 9: 22-37.

Whitley, D.S. 2000. *The Art of the Shaman: Rock Art in California.* Salt Lake City: University of Utah Press.

Wilson, E.O. 1998. *Consilience: The Unity of Knowledge.* New York: Knopf.

Winkelman, M. 2002. Shamanism and Cognitive Evolution. *Cambridge Archaeological Journal* 12(1): 71-101.

Wood, J.S. 1987. Checklist of Pottery Types for the Tonto National Forest: An Introduction to the Archaeological Ceramics of Central Arizona. The Arizona Archaeologist No. 21. Phoenix, AZ.

Young, J. 1985. Images of Power and the Power of Images: The Significance of Rock Art for Contemporary Zunis. *Journal of American Folklore* 98(387): 3-48.

ABOUT THE AUTHOR

EKKEHART MALOTKI is professor emeritus of languages at Northern Arizona University where he taught German, Latin, and Hopi from 1977 until 2004. For more than twenty-five years, his work as an ethnolinguist focused on the preservation of Hopi language and culture. In addition to over a dozen bilingual works on Hopi semantics and oral literature, he has published three children's books based on authentic Hopi stories. For over ten years, he was the principal data contributor to the *Hopi Dictionary/Hopìikwa Lavàytutuveni.* He also provided the Hopi titles, including that of *Koyaanisqatsi,* to Godfrey Reggio's movie trilogy on our destructive behavior toward this planet. Among his most recent publications are *Earth Fire: A Hopi Legend of the Sunset Crater Eruption, Hopi Tales of Destruction,* and *Kokopelli: The Making of an Icon.*

Photograph by LeRoy Unglaub

During the last fifteen years, his passion for rock art has taken him to the Sahara, to the Paleolithic caves in France, to Italy, Scandinavia and Mexico, and twice to Australia. In addition, he has devoted much of his time to the photography and interpretation of the rock art of the American Southwest. Both of his rock art works have received prestigious awards. *Tapamveni: The Rock Art Galleries of Petrified Forest and Beyond,* co-authored by Patricia McCreery, won an award of excellence from the National Park Service, and *Stone Chisel and Yucca Brush: Colorado Plateau Rock Art,* co-authored by Donald E. Weaver, was a Benjamin Franklin Award winner.

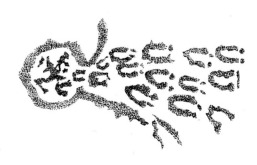